TYPOGRAPHICSTHREEGLOBALVISION
OGR
APH
ICST
HRE
EGL
OBA
LVIS
ION

3

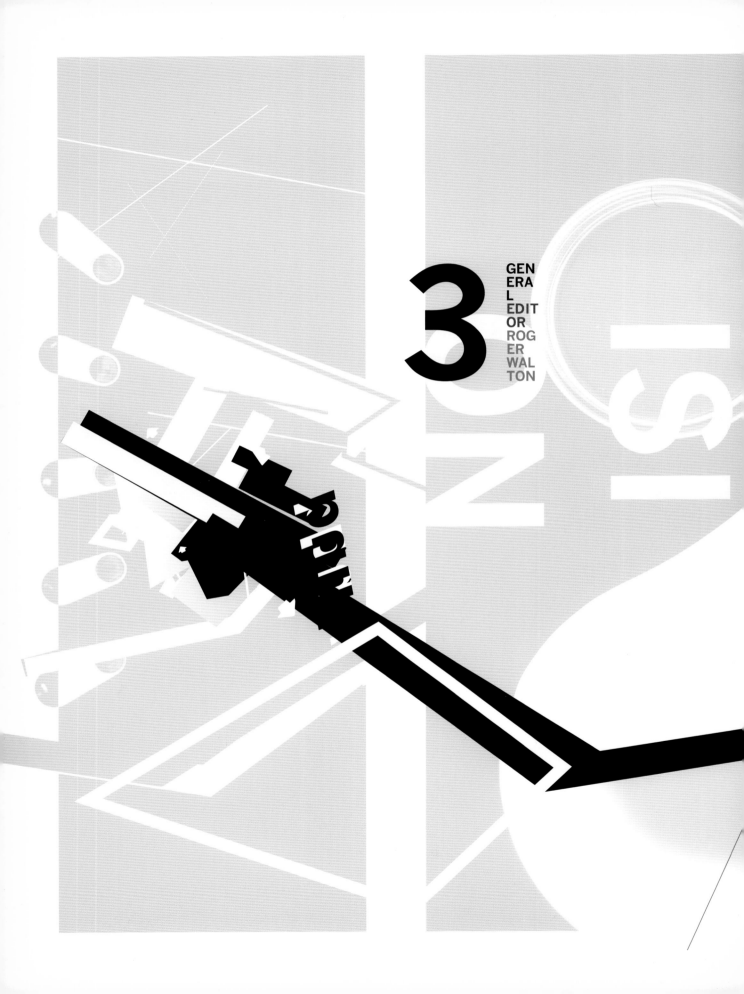

3

GEN
ERA
L
EDIT
OR
ROG
ER
WAL
TON

TYPOGRAPHICS**THREE**GLOBALVISION
OGR
APH
ICST
HRE
EGL
OBA
LVIS
ION

TYPOGRAPHICS 3

FIRST PUBLISHED IN 1998 BY
HEARST BOOKS INTERNATIONAL,
NOW HBI, AN IMPRINT OF HARPERCOLLINS PUBLISHERS
10 EAST 53RD STREET
NEW YORK, NY 10022-5299
UNITED STATES OF AMERICA

DISTRIBUTED TO THE TRADE AND ART MARKETS IN THE U.S. BY
NORTH LIGHT BOOKS,
AN IMPRINT OF F&W PUBLICATIONS, INC.
1507 DANA AVENUE
CINCINNATI, OH 45207
(800) 289-0963

DISTRIBUTED THROUGHOUT THE REST
OF THE WORLD BY HARPERCOLLINS INTERNATIONAL
10 EAST 53RD STREET
NEW YORK, NY 10022-5299
ISBN 0-688-17973-8

FIRST PUBLISHED IN GERMANY BY NIPPAN
NIPPON SHUPPAN HANBAI DEUTSCHLAND GMBH
KREFELDER STR. 85
D-40549 DÜSSELDORF
TEL: (0211) 504 80 80/89
FAX: (0211) 504 93 26
E-MAIL: NIPPAN@T-ONLINE.DE
ISBN 3-931884-58-9

EDITED AND DESIGNED BY
DUNCAN BAIRD PUBLISHERS
6TH FLOOR, CASTLE HOUSE
75–76 WELLS STREET, LONDON W1P 3RE

MANAGING DESIGNER: GABRIELLA LE GRAZIE
DESIGNER: STEFAN KRAUS
EDITOR: CLARE RICHARDS
PROJECT CO-ORDINATOR: TARA SOLESBURY

COVER, PRELIMS, ENDPAPERS, AND CHAPTER OPENERS
DESIGNED BY IAIN CADBY
PHOTOGRAPHY BY CAROLIN KURZ

10 9 8 7 6 5 4 3 2 1

TYPESET IN OFFICINASANS BOOK
COLOR REPRODUCTION BY COLOURSCAN, SINGAPORE
PRINTED IN HONG KONG

NOTE
DIMENSIONS FOR SPREAD FORMATS ARE SINGLE
PAGE MEASUREMENTS; ALL MEASUREMENTS ARE FOR WIDTH
FOLLOWED BY HEIGHT.

TYPOGRAPHICS 3 – GLOBAL VISION. THIS COLLECTION WILL ILLUMINATE, INFURIATE, ENTERTAIN, CAUSE DISAGREEMENT, INSPIRE. BE INTERPRETED, DEBATED, MISINTERPRETED, REFERRED TO, IGNORED, RESPECTED, DISREGARDED, CONSIDERED UNREADABLE, RELEVANT, INNOVATIVE, DENSE, SMART, PARTIAL, VERY USEFUL, TRANSPARENT, BRILLIANT, PRETENTIOUS, IRRELEVANT, DESIRABLE, OF NO PRACTICAL APPLICATION WHATSOEVER, INVALUABLE. TYPOGRAPHICS 3 GLOBAL VISION MAY BE THE LAST CHANCE FOR YOU TO SEE MUCH OF THIS WORK, AND THE ONLY CHANCE TO SEE SOME OF IT. THINK OF IT AS A PERMANENT AND PORTABLE EXHIBITION OF SOME OF THE MOST PROVOCATIVE INTERNATIONAL DESIGN WORK CURRENTLY BEING PRODUCED – TO VIEW WHEREVER, WHENEVER, HOWEVER, AS OFTEN AS, YOU WISH. RW.

FORE WO RD.

10

DESIGNERS
Scott Stowell, Chip Wass
ART DIRECTOR
Scott Stowell
DESIGN COMPANY
Wassco/Open
ILLUSTRATOR
Chip Wass
COUNTRY OF ORIGIN
USA
WORK DESCRIPTION
Promotional poster for
'Chippies by Wassco'
dingbat font
DIMENSIONS
610 x 457 mm
24 x 18 in

PERIODIC TABLE OF

CHIPPI

by WASSCO

OD

| 1 Offset: 62 Width: 850 |
| (1) |

| g Offset: 42 Width: 907 | T Offset: 49 Width: 1011 |
| (g) | (T) |

| d Offset: 34 Width: 878 | D Offset: 44 Width: 914 |
| (d) | (D) |

| : Offset: 52 Width: 883 | c Offset: 41 Width: 832 | k Offset: 101 Width: 1001 | 7 Offset: 71 Width: 547 | E Offset: 38 Width: 785 | F Offset: 92 Width: 1011 | H Offset: Width: |
| (:) | (c) | (k) | (7) | (E) | (F) | (H) |

| b Offset: 30 Width: 1011 | I Offset: 46 Width: 892 | 6 Offset: 19 Width: 1173 | l Offset: 137 Width: 872 | m Offset: 49 Width: 972 | n Offset: 96 Width: 1000 | o Offset: Width: |
| (b) | (l) | (6) | (l) | (m) | (n) | (o) |

| C Offset: 33 Width: 712 | TM Offset: 40 Width: 770 | | | p Offset: 86 Width: 1011 | y Offset: 60 Width: 864 | z Offset: 84 Width: 922 | ~ Offset: Width: |
| (C) | (option-2) | | | (p) | (y) | (z) | (~) |

| A Offset: 79 Width: 1011 | e Offset: 36 Width: 859 | | | L Offset: 65 Width: 1290 | M Offset: 74 Width: 519 | N Offset: 43 Width: 623 | O Offset: Width: |
| (A) | (e) | | | (L) | (M) | (N) | (O) |

└ PEOPLE ┘
(& animals acting
like people)

── POLYNESIAN INTERLUDE ──

ABSTRACT I

| ! Offset: 5 Width: 969 | ¢ Offset: 60 Width: 935 | $ Offset: 29 Width: 1011 | < Offset: 75 Width: 1005 | & Offset: Width: |
| (!) | (option-c) | ($) | (<) | (&) |

ABSTRACT II
(& misc.)

| % Offset: 48 Width: 928 | 0 Offset: 73 Width: 1014 | (Offset: 35 Width: 1011 |) Offset: 49 Width: 796 | ^ Offset: Width: |
| (%) | (0) | (() | ()) | (^) |

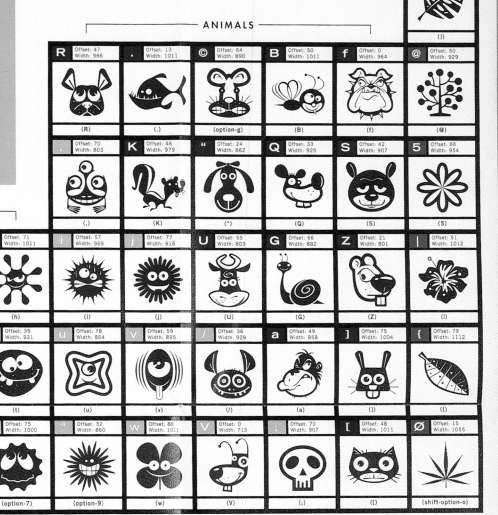

— ANIMALS —

└ PLANTS ┘

INSTRUCTIONS FOR USE: These 108 Chippies™ may be accessed by purchasing a copy of the Chippies by Wassco™ font from T-26, 1110 North Milwaukee Avenue, Chicago, Illinois 60622, U.S.A. Orders may also be placed by telephone at (773) 862-1201, or by fax at (773) 862-1214. Orders received before 3:00 pm C.S.T. will be fulfilled the same day. Refer to this chart for keyboard placement of Chippies™. For external use only.

ALSO FROM WASSCO: Logotypes, character design, icons, book and compact disc jackets, posters, editorial and advertising illustration, as well as custom Chippies™ made to your exact specifications. For more information, or to obtain an estimate, contact your sales representative, Kirby "Chip" Wass, via telephone or fax at (718) 596-0864. Inquiries also accepted by electronic mail at chipwass@aol.com. Serious inquiries only, please.

SCOTT STOWELL: DESIGN

©1997 WASSCO, BROOKLYN, N.Y.

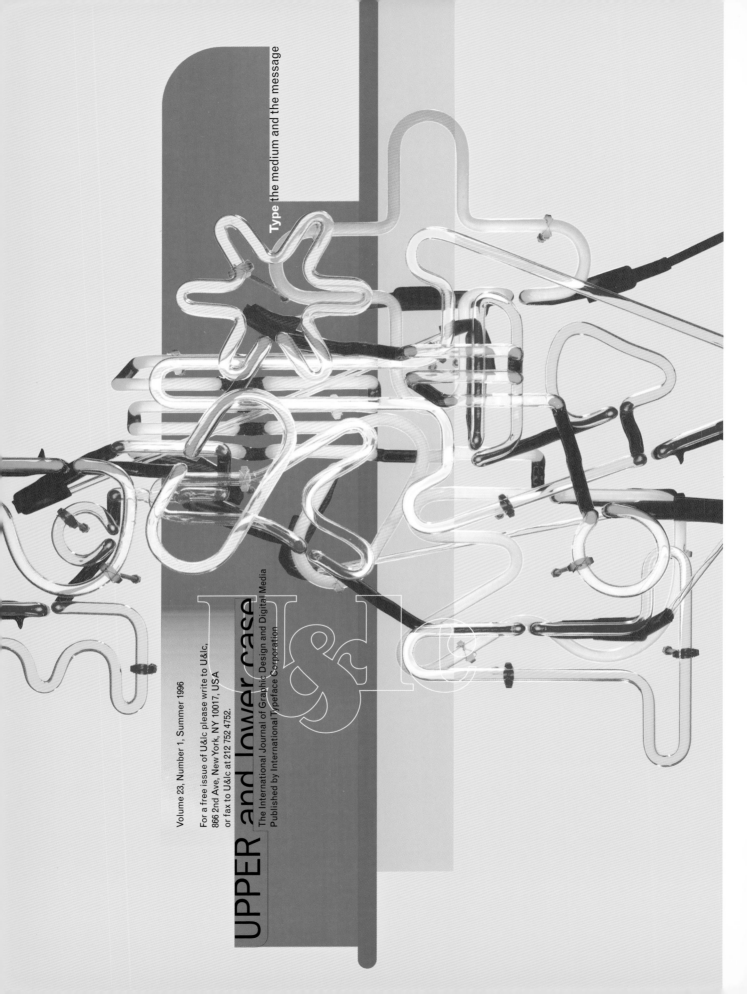

Volume 23, Number 1, Summer 1996

For a free issue of U&lc please write to U&lc,
866 2nd Ave, New York, NY 10017, USA
or fax to U&lc at 212 752 4752.

The International Journal of Graphic Design and Digital Media
Published by International Typeface Corporation

Type the medium and the message

UPPER and lower case

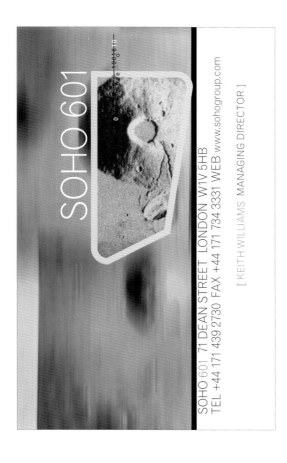

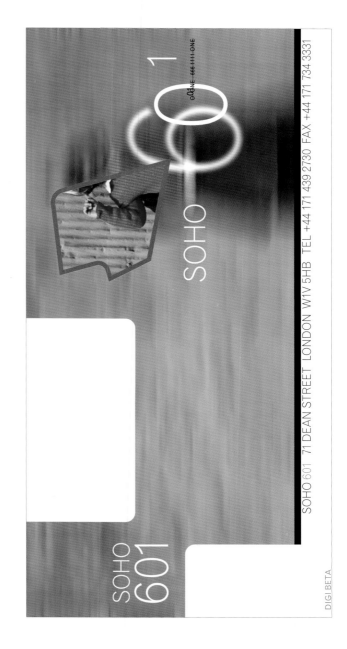

OPPOSITE
DESIGNERS
Andrew Altmann, David Ellis,
Patrick Morrissey
DESIGN COMPANY
Why Not Associates
PHOTOGRAPHER
Rocco Redondo
COUNTRY OF ORIGIN
UK
WORK DESCRIPTION
Front cover for *U&lc* magazine
DIMENSIONS
277 x 375 mm
10⅞ x 14¾ in

DESIGNERS
Andrew Altmann, David Ellis
DESIGN COMPANY
Why Not Associates
PHOTOGRAPHER
Photodisc
COUNTRY OF ORIGIN
UK
WORK DESCRIPTION
Business card (left) and video label
(right) for SOHO 601, television
post production company
DIMENSIONS
Various

PAGES 14–15
DESIGNERS
Andrew Altmann, David Ellis,
Patrick Morrissey
DESIGN COMPANY
Why Not Associates
PHOTOGRAPHERS
Rocco Redondo, Photodisc,
Hulton Deutsch
COUNTRY OF ORIGIN
UK
WORK DESCRIPTION
Audio-visual installation for
Kobe Fashion Museum
consisting of 1,500 slides
projected onto the museum's
floor, ceiling and walls
DIMENSIONS
Various

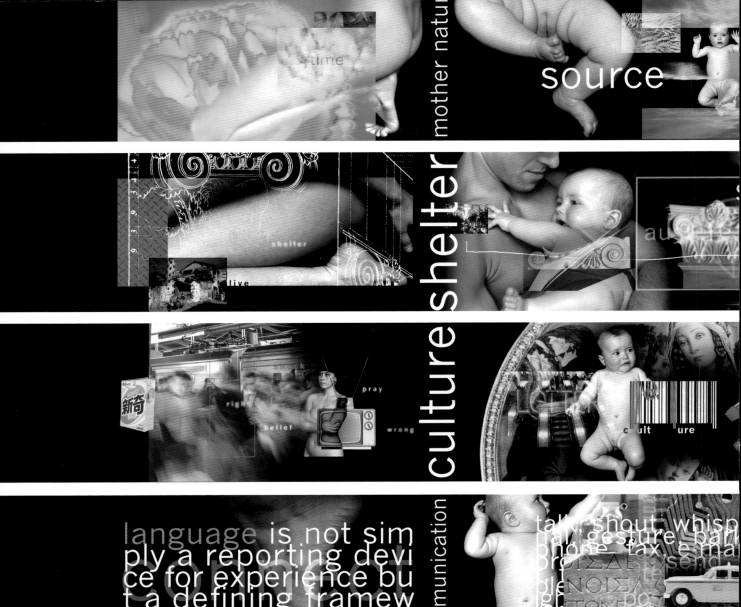
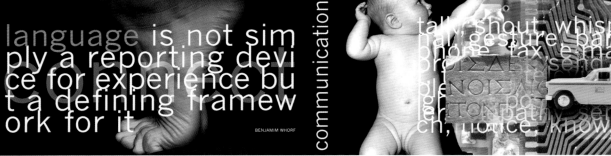
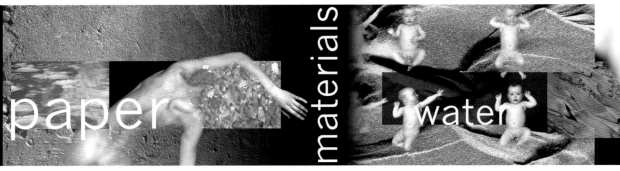
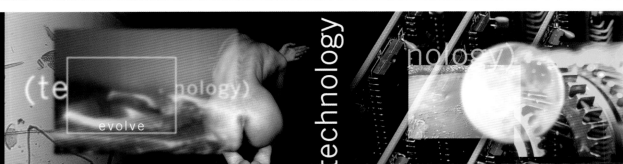

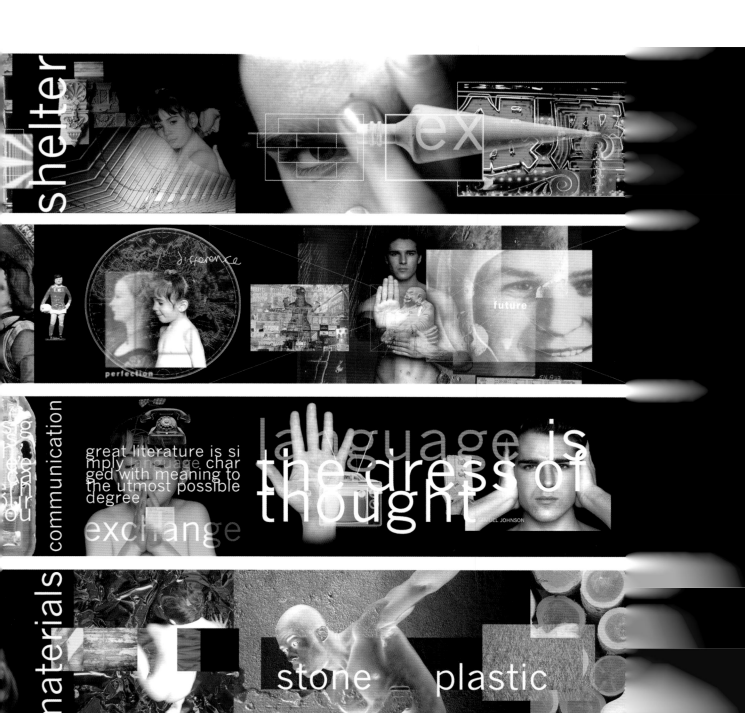

shelter

ex

difference

perfection

future

communication

great literature is simply language charged with meaning to the utmost possible degree

exchange

language is the dress of thought

SAMUEL JOHNSON

materials

stone plastic

technology

harness

invent

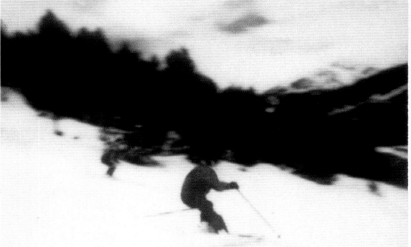

THE SLOPES

For all those skiers who have achieved an intermediate level of proficiency the station offers more than 34 Km of slopes distributed in 11 green slopes, 5 blue, and 7 red, a total of 23 slopes. In Soldeu El Tarter the skier will always find a slope suitable for his level. This great variety of slopes, one of the characteristics of the station most highly valued by our clients, allows the skier to progress constantly. The ski enthusiast can therefore leave the interesting green slopes of the Soldeu area for the excellent blue and red lines of El Tarter, for example the "Guineu" (2,100 metres), the "Llop" (2,000 metres) or the "Miquel Baró" (2,500 metres).

INSTALLATIONS AND SERVICES

THE SKI SCHOOL

The ski school of Soldeu El Tarter has developed a programme of courses especially designed for those skiers who have obtained a fair level of competence and who are interested in correcting and improving their technique. In this programme, the school organises group courses of 20 hours duration (4 hours daily during 5 days), but, at the same time, offers the student the chance to book private lessons, that is, a teacher exclusively dedicated to one person during the period that the student desires. This is undoubtedly an excellent way for the skier to work in depth on specific aspects of his style, and therefore, to progress more rapidly and effectively. Of course, classes are given in the language chosen by the student.

The fundamental conditions that allow a fairly proficient skier to continue progressing are two: On the one hand, to have access to a great variety of slopes suitable for his level, and on the other, to be able to count on a comprehensive and advanced system of ski lifts. The network of ski lifts of Soldeu El Tarter (1 cable-car, 7 chair-lifts and 14 button-lifts) can carry 21,000 people an hour, making access easy to all slopes. Additionally, the station also has 244 snow canons which cover a total of 14 Km of slopes and permanently guarantee the optimum conditions for skiing.

INTERMEDIATE SKIING

The process that starts with the introduction to skiing and continues to intermediate level proficiency is, very often, a rapid one, especially if the student has had a good instructor.

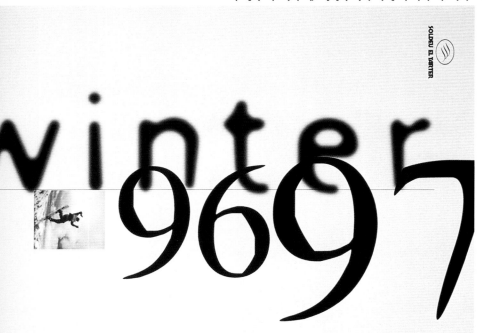

SOLDEU EL TARTER

winter 9695

DESIGNERS
Marina Company, David Ruíz
ART DIRECTOR
David Ruíz
DESIGN COMPANY
David Ruíz + Marina Company
PHOTOGRAPHERS
Rafael Vargas, Frank Aleu
COUNTRY OF ORIGIN
Spain
WORK DESCRIPTION
Brochure for Soldeu el Tarter
ski resort
DIMENSIONS
390 x 280 mm
15⅜ x 11 in

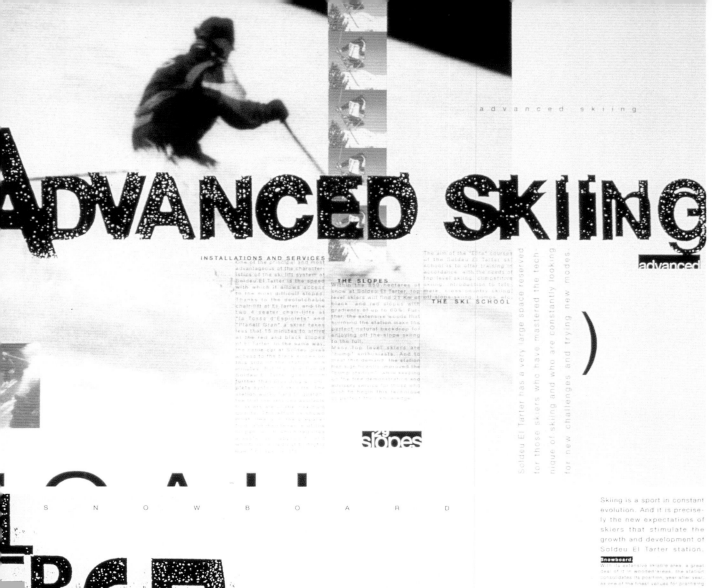

ADVANCED SKIING

advanced

INSTALLATIONS AND SERVICES

One of the principal and most advantageous of the characteristics of the ski lift system of Soldeu El Tarter is the speed with which it allows access to the most difficult slopes. Thanks to the detachable chair-lift at El Tarter, and the two 4-seater chair-lifts at 'Pla Tossa d'Espiolets' and 'Planell Gran', a skier takes less than 15 minutes to arrive at the red and black slopes of El Tarter. In the same way, the cable car at Soldeu gives access to the black slopes of this area in only a few minutes. [...]

THE SLOPES

Within the 850 hectares of snow at Soldeu El Tarter, top level skiers will find 21 Km of black- and red-slopes with gradients of up to 60%. Further, the extensive woods that surround the station make the perfect natural backdrop for enjoying off-the-slope skiing to the full.

Many top level skiers are 'bump' enthusiasts. And to meet this demand, the station has continuously improved the 'bump station' [...]

The aim of the 'Elite' courses of the Soldeu El Tarter ski school is to offer training in accordance with the needs of top-level skiing: competitive skiing, introduction to telemark, cross-country skiing, off-slope skiing, bumps, etc.

THE SKI SCHOOL

Soldeu El Tarter has a very large space reserved for those skiers who have mastered the technique of skiing and who are constantly looking for new challenges and trying new modes.

21 slopes

SNOWBOARD

Skiing is a sport in constant evolution. And it is precisely the new expectations of skiers that stimulate the growth and development of Soldeu El Tarter station.

Snowboard
With its extensive skiable area, a great deal of it in wooded areas, the station consolidates its position, year after year, as one of the finest venues for practising snowboard.

Bumps
In addition to extending the length of the 'bump run', the station makes it possible for all bump enthusiasts to try out specific equipment, take introductory or master classes, and to participate for competitions.

Cross-country skiing
Between el Pla dels Espiolets, in Soldeu, and Riu de la Riba Escorxada, in the El Tarter area, is found the station's cross-country ski area. The signposted route, 3 Km long, is now accessible directly and in comfort by the new cable car [...]

Telemark
Over the last few years, telemark, one of the oldest since sport disciplines, has become fashionable once again. The large number of slopes surrounded by unspoilt countryside and the opportunity to learn the sport from specialised monitors makes Soldeu El Tarter the ideal place to try this elegant sport.

Ski school
The Soldeu El Tarter ski school offers all skiers a large team of fully qualified ski monitors who will assist with the introduction to or perfecting of any of these alternative ski techniques.

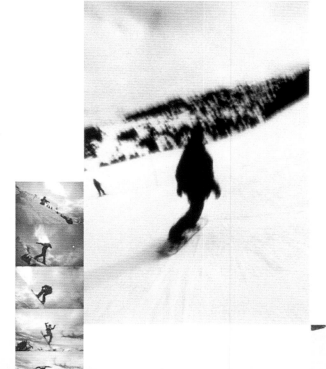

telemark

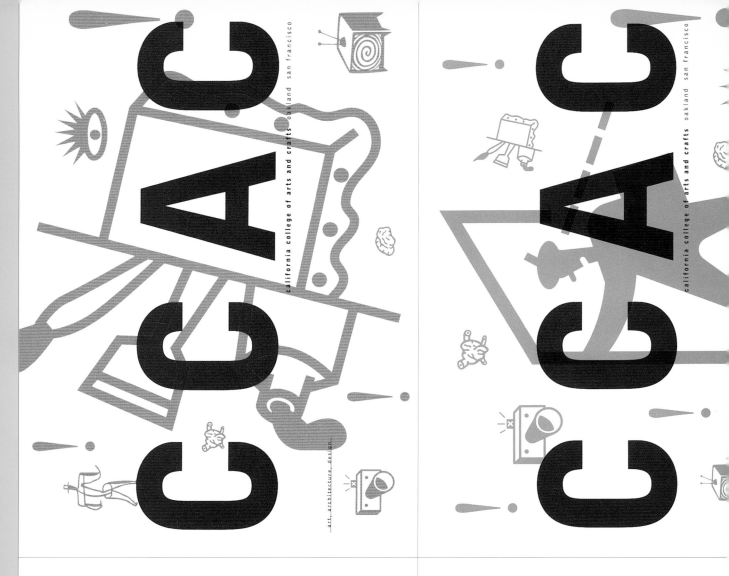

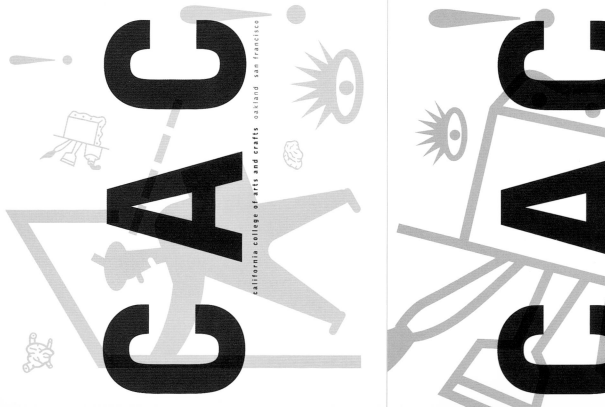

california college of arts and crafts · oakland · san francisco

art · architecture · design

C C A C office of enrollment services
450 irwin street, san francisco, california 94107
415.703.9523 1.800.447.1.ART

california college of arts and crafts oakland, san francisco

DESIGNER
Bob Aufuldish
DESIGN COMPANY
Aufuldish & Warinner
ILLUSTRATOR
John Hersey, dingbat fonts
COUNTRY OF ORIGIN
USA

WORK DESCRIPTION
Stationery for California College
of Arts and Crafts Office of
Enrollment Services
DIMENSIONS
Postcards (opposite):
229 x 153 mm
9⅛ x 6⅛ in
Letterhead (above):
216 x 279 mm
8½ x 11⅛ in

DESIGNERS
Tamar Cohen, David Slatoff
ART DIRECTORS
Tamar Cohen, David Slatoff,
Kenna Kay
DESIGN COMPANY
Slatoff + Cohen Partners Inc.
ILLUSTRATORS
George Bates, Joe Fernandez
PHOTOGRAPHER
Christopher Gallo

COUNTRY OF ORIGIN
USA
WORK DESCRIPTION
Promotional brochure for Nick
at Nite's new television
network, 'TV Land'
DIMENSIONS
108 x 153 mm
6 x 4¼ in

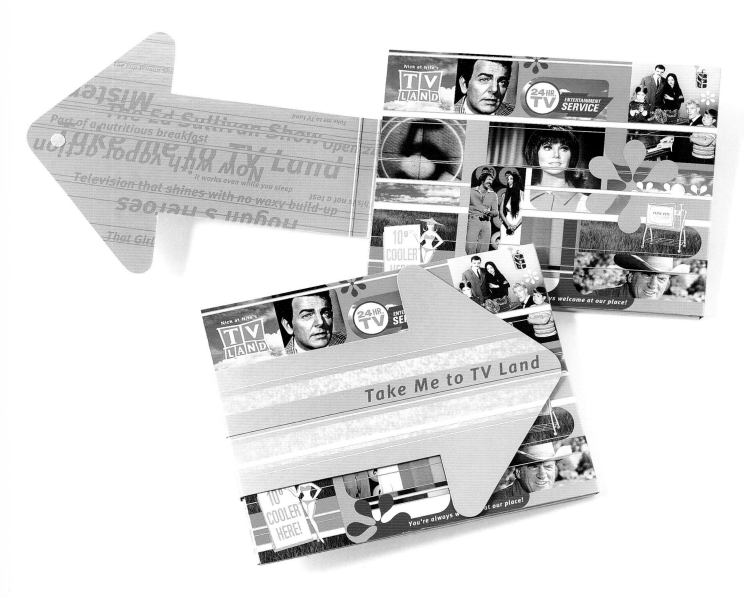

OPPOSITE
DESIGNERS
Tamar Cohen, David Slatoff,
Alex Smith
ART DIRECTORS
Tamar Cohen, David Slatoff
DESIGN COMPANY
Slatoff + Cohen Partners Inc.
COUNTRY OF ORIGIN
USA

WORK DESCRIPTION
Stationery for Slatoff + Cohen
Partners Inc.
DIMENSIONS
Letterhead:
216 x 279 mm
8½ x 11 in
Note card:
121 x 132 mm
4¾ x 5³⁄₁₆ in

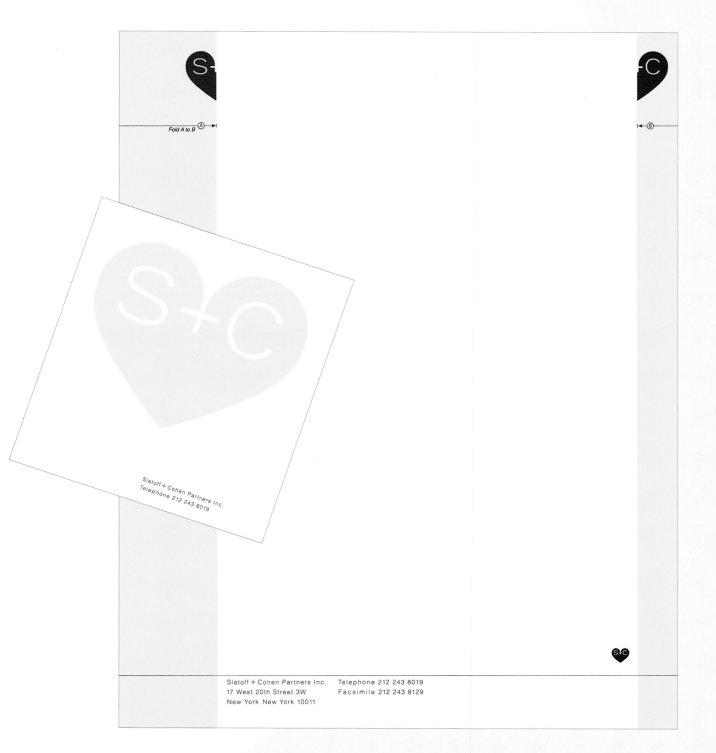

Fold A to B

Slatoff + Cohen Partners Inc.
Telephone 212 243 8019

Slatoff + Cohen Partners Inc. Telephone 212 243 8019
17 West 20th Street 3W Facsimile 212 243 8129
New York New York 10011

DESIGNERS
Paul Neale, Andrew Stevens
ART DIRECTORS
Paul Neale, Andrew Stevens
DESIGN COMPANY
Graphic Thought Facility
ILLUSTRATORS
Paul Neale, Andrew Stevens
COUNTRY OF ORIGIN
UK
WORK DESCRIPTION
Identity for Mighty, film
production company
DIMENSIONS
Various

OPPOSITE
DESIGNERS
Paul Neale, Andrew Stevens
ART DIRECTORS
Paul Neale, Andrew Stevens
DESIGN COMPANY
Graphic Thought Facility
ILLUSTRATORS
Paul Neale, Andrew Stevens
COUNTRY OF ORIGIN
UK
WORK DESCRIPTION
Identity for Pizazz, animation
production company
DIMENSIONS
Various

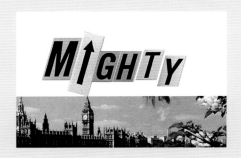

MIGHTY_LIZ JAMES
PRODUCTION MANAGER
37 DEAN STREET, LONDON W1V 5AP
TELEPHONE Nº 0171 437 5966__FAX Nº 0171 437 5967
MOBILE Nº 0802 579299
E-MAIL liz@mighty.co.uk

MIGHTY_ HAVE MOVED TO:
37 DEAN STREET, LONDON W1V 5AP
TELEPHONE Nº 0171 437 5966__FAX Nº 0171 437 5967
E-MAIL info@mighty.co.uk

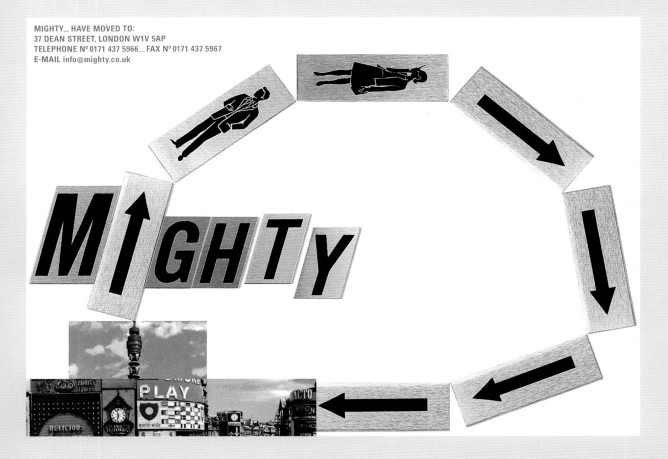

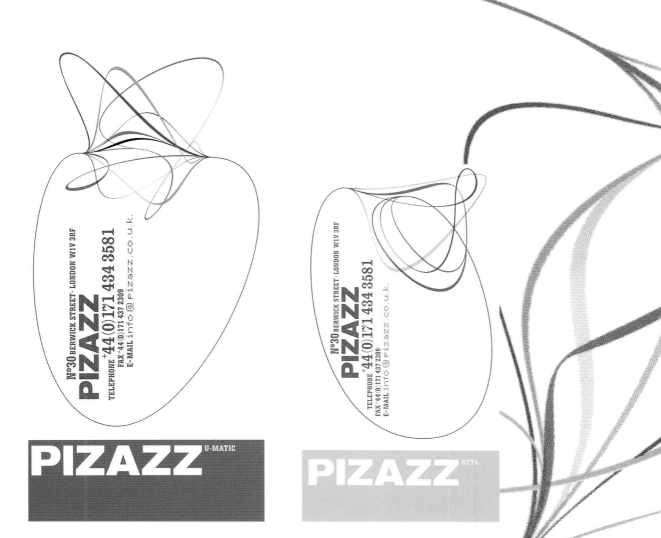

Nº30 BERWICK STREET · LONDON W1V 3RF
TELEPHONE +44 (0) 171 434 3581
FAX +44 (0) 171 437 2309
E-MAIL info @ pizazz.co.u.k.

PIZAZZ U-MATIC

Nº30 BERWICK STREET · LONDON W1V 3RF
TELEPHONE +44 (0) 171 434 3581
FAX +44 (0) 171 437 2309
E-MAIL info @ pizazz.co.u.k.

PIZAZZ BETA

Nº30 BERWICK STREET · LONDON W1V 3RF
TELEPHONE +44 (0) 171 434 3581
FAX +44 (0) 171 437 2309
E-MAIL info @ pizazz.co.u.k.

PIZAZZ PICTURES LTD
DIRECTORS *Mario Cavalli · Pamela Dennis · Sue Goffe*
REGISTERED OFFICE: 58-60 BERNERS STREET · LONDON W1P 4JS
REGISTERED IN ENGLAND Nº 2337236
V.A.T. REGISTRATION Nº 539 1164 44

 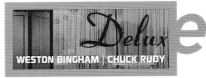

231 W. 13TH STREET #4 | NEW YORK NY 10011 **212.645.2502** deluxemail@aol.com

231 W. 13TH STREET #4 | NEW YORK NY 10011

DESIGNER
Weston Bingham
ART DIRECTOR
Weston Bingham
DESIGN COMPANY
Deluxe Design for Work +
Leisure
COUNTRY OF ORIGIN
USA
WORK DESCRIPTION
Self-promotional postcards
using samples of recent design
projects
DIMENSIONS
152 x 108 mm
6 x 4¾ in

OPPOSITE
DESIGNER
Weston Bingham
ART DIRECTOR
Weston Bingham
DESIGN COMPANY
Deluxe Design for Work +
Leisure
COUNTRY OF ORIGIN
USA
WORK DESCRIPTION
Stationery for a design
studio using a logo from
a beauty salon
DIMENSIONS
Letterhead:
216 x 279 mm
8½ x 11 in
Business card:
89 x 51 mm
3½ x 2 in
Envelope:
279 x 121 mm
11 x 4¾ in

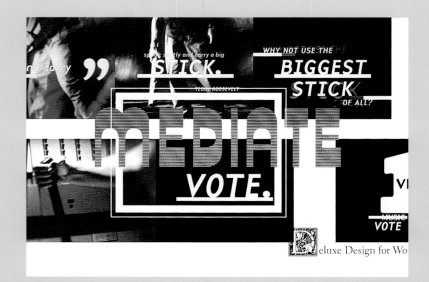

IMAGO THEATRE

P.O. BOX 15182 PORTLAND OREGON 97293-5182

BOX OFFICE: (503) 231-9581
ADMINISTRATION: (503) 231-3959
FACSIMILE: (503) 239-5248
E-MAIL: IMAGO@HEVANET.COM

IMAGO THEATRE
P.O. BOX 15182 PORTLAND OREGON 97293
CAROL TRIFFLE CO ARTISTIC DIRECTOR
V. (503) 231-3959
F. (503) 239-5248
E. IMAGO@HEVANET.COM

DESIGNERS
Anne Abele, Rob Bonds
DESIGN COMPANY
Visual Resource Society
COUNTRY OF ORIGIN
USA
WORK DESCRIPTION
Stationery for Imago theater
DIMENSIONS
Letterhead:
216 x 279 mm
8½ x 11 in
Envelope:
241 x 105 mm
9½ x 4⅛ in
Business card:
89 x 51 mm
3½ x 2 in

IMAGO THEATRE
P.O. BOX 15182 PORTLAND OREGON 97293-5182

NON-P
ORGAN≥
U.S. PC
P A
PORTLA
PERMIT

*cyber*SIGHT

info@cybersight.com

| 514 SW 6th Street, 5th floor Portland, Oregon 97204 | 2444 Wilshire Boulevard, Suite 503 Santa Monica, California 90403 |
| tel. 503.228.4008 fax 503.228.3629 | www.cybersight.com | tel. 310.449.8660 fax 310.449.8662 |

DESIGNERS
Anne Abele, Rob Bonds
DESIGN COMPANY
Visual Resource Society
COUNTRY OF ORIGIN
USA
WORK DESCRIPTION
Stationery for Cybersight, web site design company
DIMENSIONS
Letterhead:
216 x 279 mm
8½ x 11 in
Envelope:
241 x 105 mm
9½ x 4⅛ in
Business card:
89 x 51 mm
3½ x 2 in

*cyber*SIGHT

Andrew R. Shakman
President

andrew@cybersight.com

2444 Wilshire Boulevard, Suite 503 Santa Monica, CA 90403
tel. 310.449.8660 fax 310.449.8662

514 SW 6th Avenue, 5th floor Portland, Oregon 97204

*cyber*SIGHT

| 514 SW 6th Street, 5th floor Portland, Oregon 97204 |
| 2444 Wilshire Boulevard, Suite 503 Santa Monica, California 90403 |

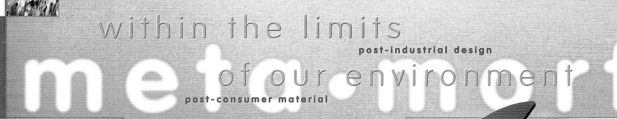
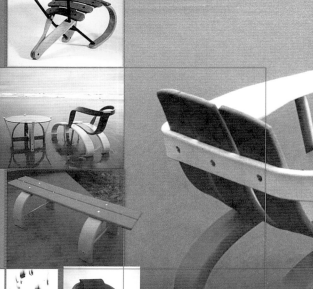

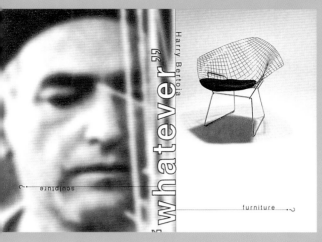

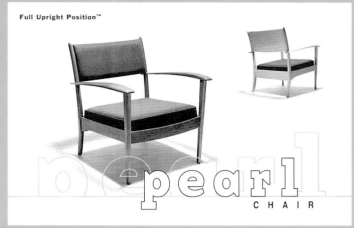

Harry Bertoia

sculpture

"whatever"

furniture

Full Upright Position™

b e **pearl**
CHAIR

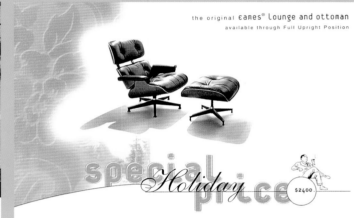

Full Upright Position
1101 NW Glisan Portland, OR 97209
(503) 228-6190 HOURS Tues-Fri 10-6, Sat 10-5, Sun 12-5

nsi Collection
ome, durable aluminum construction for interior or exterior use.
ble chairs. Ideal for your patio or garden room.

the original **eames**® Lounge and ottoman
available through Full Upright Position

special price

Holiday

$2400

EAMES® MOLDED PLYWOOD LOUNGE CHAIR

50th Anniversary

50th Anniver

w, or never! NUMBERED, LIMITED EDITION
IN UNIQUE ROSEWOOD VENEER

AVAILABLE ONLY WHILE SUPPLIES LAST, THROUGH **Full Upright Position**™

Something unusual and fun, yet classic
enough to be included in the collection of
the San Francisco Museum of Modern Art
Something impressive yet affordable
Something substantial that you can still
cover in a single sheet of wrapping paper

the **Puzzle** Armchair
A FUN GIFT FOR ALL AGES

Something they can unwrap, have fun
assembling and enjoy for years to come

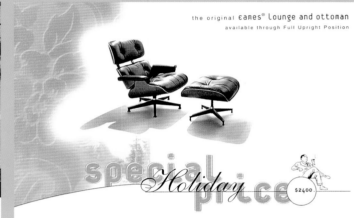

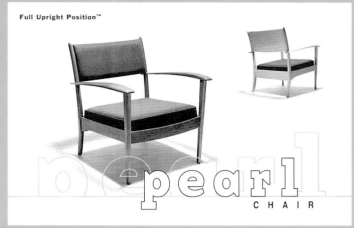

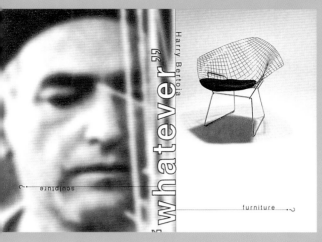

29

OPPOSITE
DESIGNERS
Anne Abele, Rob Bonds
DESIGN COMPANY
Visual Resource Society
PHOTOGRAPHER
Colin Reedy
COUNTRY OF ORIGIN
USA

WORK DESCRIPTION
Poster for meta.morf, recycled
plastic furniture designers
DIMENSIONS
381 x 559 mm
15 x 22 in

DESIGNERS
Anne Abele, Rob Bonds
DESIGN COMPANY
Visual Resource Society
PHOTOGRAPHERS
Bob Waldman, Rob Bonds,
Anne Abele
COUNTRY OF ORIGIN
USA

WORK DESCRIPTION
Six promotional postcards for
Full Upright Position, furniture
company
DIMENSIONS
152 x 102 mm
6 x 4 in

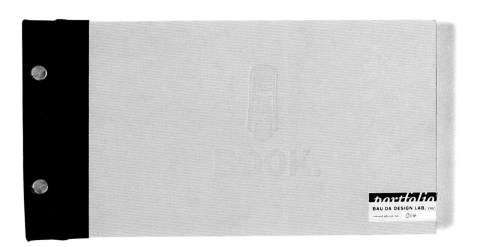

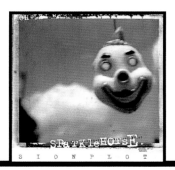

S I O N P L O T

album title: **V.D.S.T.P.**
company: **CAPITOL RECORDS**
item no. 61-03-82

SPARKLEHORSE

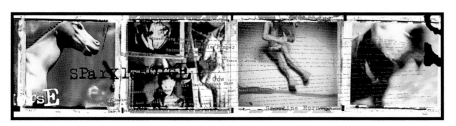

DESIGNERS
P. R. Brown, Peter Stark
ART DIRECTOR
P. R. Brown
DESIGN COMPANY
Bau-Da Design Lab, Inc.
ILLUSTRATOR
P. R. Brown
PHOTOGRAPHER
Mark Linkus (Sparkle Horse)
COUNTRY OF ORIGIN
USA
WORK DESCRIPTION
Front cover (opposite, top) and
pages from a self-promotional
portfolio – a limited edition
hard-bound book sent to
potential clients
DIMENSIONS
279 x 152 mm
11 x 6 in

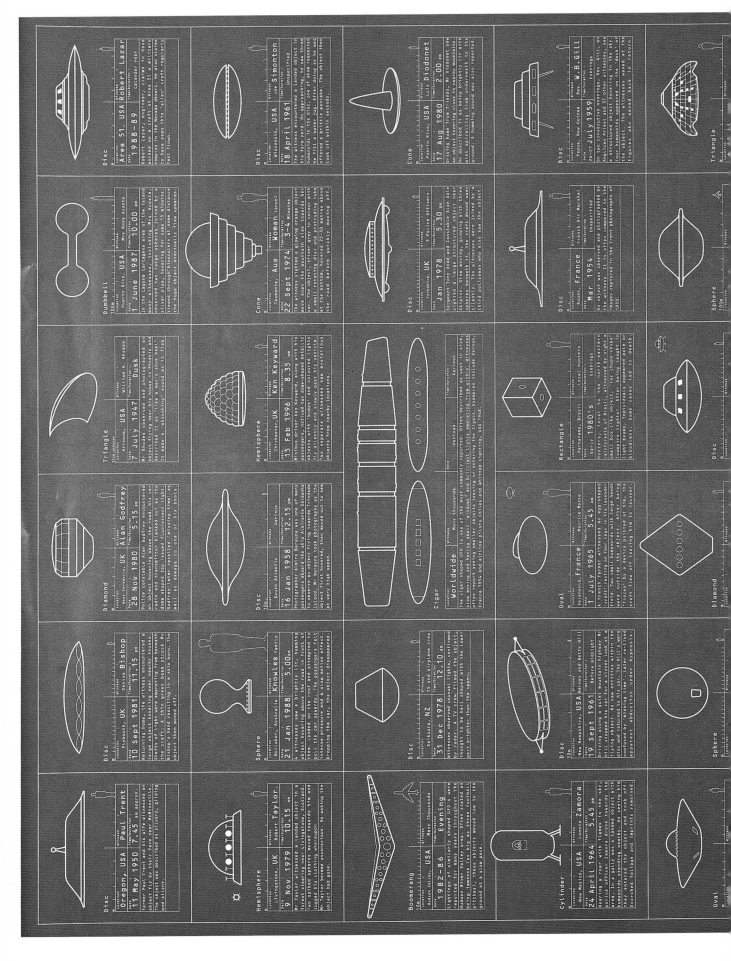

Unidentified Flying Objects ◇ The Physical Aspects

Disc
10m
Location	Witness
Russia	3 Militia officers
Date	Time/Duration
21 Sept 1990	5.30 pm

Witnesses observed an object hovering, emitting a yellow, cone shaped beam of light from one side. Windows around the rim glowed as the object moved near. It seemed to land on hills in the distance where a burned landing trace was left.

Disc
Location	Witness
Idaho, USA	Farmer and two sons
Date	Time/Duration
13 Aug 1947	1.00 pm

Whilst at their fishing camp, the witnesses saw a sky blue object moving 25m in the air, following the ground contours. Pods on each upper side were shooting flames and a 'swishing' sound was heard. Trees swayed as the object passed.

Disc
Location	Witness
California, USA	200 local residents
Date	Time/Duration
4 Feb 1968	7.20-7.25 pm

Residents of Redlands, California saw a huge, low-flying object pass overhead. Bright orange flames issued from below alternating with red and green lights to give a rotating effect. After hovering, the disc shot upwards at great speed.

Disc
Location	Witness
Sydney, Australia	4 Family Members
Date	Time/Duration
19 April 1992	7.30 pm

A family observed a motionless object in the sky over Kyeemagh near Sydney. It had red lights around the rim with a blinking amber light on top. The object then moved off in a series of erratic jumps.

Triangle
Location	Witness
Belgium	Many thousands
Date	Time/Duration
1989-90	Varied

Police officers and Belgian Air Force pilots were amongst many eyewitnesses to a series of sightings. Triangles seen at both high and low altitude had shape changing abilities and were recorded on camera including an F16 radar screen.

Cone
Location	Witness
France	Mrs Garcin & Mrs Rani
Date	Time/Duration
14 April 1957	3.00 pm

At a road intersection, two women out walking saw a top shaped object almost touching the ground. It jumped in an arc and hovered near. The ground once more. Metallic coloured designs vibrated within the objects vicinity.

Shape labels throughout chart: Cone, Sphere, Dumbbell, Disc, Sphere, Cross, Hemisphere, Triangle, Hemisphere, Bell, Oval, Cone, Rectangle, Cone, Disc, Cone, Hemisphere, Sphere, Cone, Disc, Hemisphere, Cylinder, Triangle, Sphere, Disc, Disc, Boomerang, Disc, Sphere, Cone, Cylinder, Sphere, Cylinder, Disc, Disc, Hemisphere, Cigar, Hemisphere, Hemisphere, Cone, Disc, Disc, Hemisphere.

One of the paradoxes of UFO phenomena are the objects apparent ability to appear both physical and non-physical, often within the same encounter. Reports exist of seemingly structured objects defying the known laws of physics by shape changing, splitting in two, 'melting' to nothingness or forming out of gas or mist. Given our day to day experience of the physical world it is no wonder that such reports are treated with unusual claims. If there is some tangible, physical aspect to an encounter or some trace residue left to examine. Many such reports do exist within UFO files covering a range of effects from ground impressions of landed objects to radiation poisoning of witnesses and have themselves become 'classic cases'. In compiling this chart some of these more enduring cases were selected, most of their physical nature, beginning with the most dramatic aspect of any UFO encounter, the objects apparent shape. Other criteria considered were reports featuring multiple witnesses, radar confirmation and witness drawings or photographs on which to base the illustrations. Theories which have developed in order to explain what these objects could be include extraterrestrial or interdimensional craft, unknown atmospheric phenomenon, mirages, secret military aircraft, temporal lobe disturbance in the brain, etc., etc. Clearly the variation in reported unidentified flying objects are matched only by the number of theories proposed as to what they might be. Despite this diversity in the physical aspects of UFOs, it is interesting that comparisons can be made between objects both within the same category as well as between different broad categories; Disc, Cylinder, Sphere, Hemisphere, Triangle, Boomerang, Cone etc. Whilst every effort has been made to accurately interpret witness drawings, photographs, testimonies or subsequent investigative findings each of these elements are open to a certain degree of ambiguity. Although the chart is not representative of every major sighting ever reported, the selected cases are all from 1947 onwards where improved investigative techniques, greater camera ownership as well as a wider general interest in the subject has made information more readily available on this fascinating world-wide phenomenon.

Though the great song return no more

There's keen delight in what we have

PAGES 32–3

DESIGNERS
Patrick Jackson, Mark Spain

ART DIRECTOR
Patrick Jackson

DESIGN COMPANY
Curve Design Associates

ILLUSTRATOR
Patrick Jackson

COUNTRY OF ORIGIN
UK

WORK DESCRIPTION
Poster documenting some of
the most enduring cases of UFO
phenomena, for Flights of Fancy
publishing company

DIMENSIONS
594 x 841 mm
23⅜ x 33⅛ in

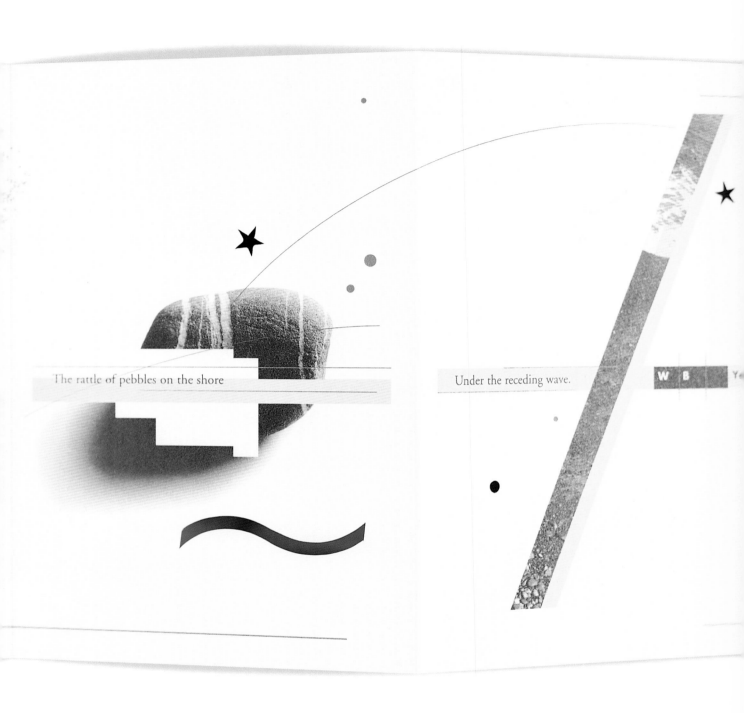

The rattle of pebbles on the shore

Under the receding wave.

W B Ye

DESIGNERS
Chris Myers, Greg Simmons,
Nancy Mayer
ART DIRECTOR
Chris Myers
DESIGN COMPANY
Mayer & Myers Design
PHOTOGRAPHER
Chris Myers
COUNTRY OF ORIGIN
USA

WORK DESCRIPTION
Fold-out self-promotional New
Year card featuring the poem
*The Nineteenth Century and
After*, by William Butler Yeats
DIMENSIONS
432 x 159 mm
17 x 6¼ in

ON THE NEXT FEW PAGES YOU WILL FIND WRITTEN AND SPOKEN EXCERPTS FROM STUDENTS ABOUT THEIR WORK, THEIR PROCESSES, AND HERRON…

Visual Communication

Student Services

Woodworking

Images from Herron's web site [www.herron.iupui.edu].**page (86)**

JOHN **Chastain** ✳ V I S U A L C O M M U N I C A T I O N

As the designer of the Herron School of Art web site, I was given a daunting task,
that task being to weave together numerous images and bits of information about students, faculty, and fields of study,
each embodying a unique set of ideas and philosophies about creativity and aesthetics.
With these diverse elements, I began developing a framework of imagery that would not only serve as a background for
individual works of art, but also enhance the viewer's experience, both of the individual works presented and of the school as a whole.
These framework images define the interface by which the viewer navigates through the web site.
And it is this interface system which serves as metaphorical representation of the school itself.
The images, therefore, need to somehow express that which the many distinct voices of Herron share in common.

But how does one go about synthesizing these different voices into imagery for a web site?
My approach was to use recognizable images of ordinary objects to facilitate personal interpretations by each individual viewer.
Objects contain internal meanings to which we all respond in our daily lives.
For instance, the image of a hammer contains many meanings, a viewer might respond to its more literal meaning of "a tool used to drive
nails," or might respond to a more metaphoric meaning such as "a symbolic image of force or power."
By the juxtaposition of images of ordinary objects, one can combine both their literal and metaphoric meanings into a myriad of personal
meanings or interpretations. The image of a hammer combined with the image of a bird's wings can produce endless interpretations.
One might interpret a more literal meaning "a hammer held aloft into the air by a carpenter"
or one might interpret the image as "a symbolic representation of force and spirit…."

The Cabinet.**page (62)**

CHAD **Gallion** ✳ P A I N T I N G

The Cabinet. The cabinet caught my eye intuitively;
I remember contemplating scale, color, form, balance, what to leave in, and what to take out.
It wasn't until later that it dawned on me what I was dealing with; I was dealing with different types of energy.
For me the cabinet was simultaneously agitated and calm—
it contained a repressed energy—something lurking—like despair hidden under a calm, austere face.
• • • •
There is a deep connection between me and my work, I can't do work that isn't true to me.
The problem of trying to be honest as an artist is not an easy one.
I prefer relying on intuitiveness—when I have a gut feeling and I know I should be painting.

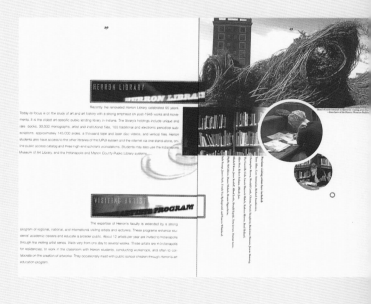

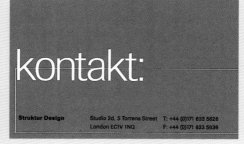

kontakt:

Struktur Design Studio 2d, 5 Torrens Street T: +44 (0)171 833 5626
London EC1V 1NQ F: +44 (0)171 833 5636

Roger Fawcett-Tang M: +44 (0)802 88 54 77
E: struktur@easynet.co.uk

DESIGNER
Roger Fawcett-Tang
ART DIRECTOR
Roger Fawcett-Tang
DESIGN COMPANY
Struktur Design
COUNTRY OF ORIGIN
UK
WORK DESCRIPTION
Business card and change of
address card for Struktur Design
– the two boxes describe the
increased floor area of the
new studio
DIMENSIONS
Change of address card:
200 x 100 mm
7⅞ x 3⅞ in
Business card:
85 x 55 mm
3⅜ x 2⅛ in

OPPOSITE
DESIGNERS
Elisabeth Charman, Brad Trost
DESIGN COMPANY
loft 219
PHOTOGRAPHERS
Elisabeth Charman,
Jenny Ganser, Jon Hines,
Jun Itoi, Brad Trost
COUNTRY OF ORIGIN
USA
WORK DESCRIPTION
Front cover (far left) and
spreads from a prospectus for
the Herron School of Art,
profiling the university's
history, program descriptions
and examples of student work
DIMENSIONS
178 x 254 mm
7 x 10 in

51° 32' 08"N 0° 05' 20"W

51° 31' 54"N 0° 06' 13"W

Struktur Design has moved its London headquarters a few coordinates to larger premises.
Please update your database with the new address and telecommunication details, thank you.

Struktur Design Studio 2d, 5 Torrens Street, London EC1V 1NQ
T: +44 (0)171 833 5626 F: +44 (0)171 833 5636 E: struktur@easynet.co.uk

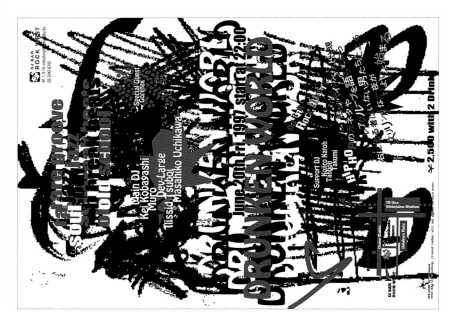

DESIGNER
Reiko Hanafusa
ART DIRECTOR
Reiko Hanafusa
ILLUSTRATOR
Reiko Hanafusa
COUNTRY OF ORIGIN
Japan
WORK DESCRIPTION
Flyer for the event 'Drunken
World' at 'Rock West' bar in
Shinjuku, Tokyo
DIMENSIONS
210 x 297 mm
8¼ x 11¾ in

BELOW
DESIGNERS
Randall Lane, Derek Lerner,
David Merten, Peter Rentz
ART DIRECTORS
Randall Lane, Derek Lerner
DESIGN COMPANY
Graphic Havoc avisualagency
ILLUSTRATOR
Derek Lerner
PHOTOGRAPHER
David Naugle
COUNTRY OF ORIGIN
USA
WORK DESCRIPTION
Promotional schoolbook cover
distributed by Coca-Cola in
urban high schools
DIMENSIONS
368 x 584 mm
14½ x 23 in

DESIGNER
Fabio Berruti
ART DIRECTOR
Fabio Berruti
DESIGN COMPANY
Infinite Studio
PHOTOGRAPHER
Fabio Berruti
COUNTRY OF ORIGIN
Italy
WORK DESCRIPTION
Front and back cover of a
limited edition CD Fragile
Soul by Vasco Rossi for BMG
Ricordi (Rome)
DIMENSIONS
125 x 130 mm
4⅞ x 5⅛ in

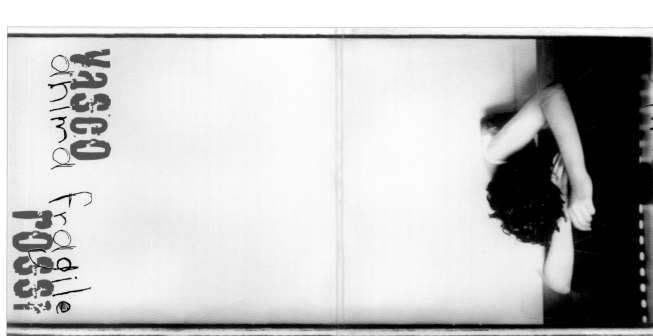

DRINK

Coke

PREPACK★★★★PREPACK★★★PREPACK★★

11/10/93

★PREPACK★★★★PREPACK★★★★PREPACK★★

B-55407-3908

PRIVATE PARKING ONLY

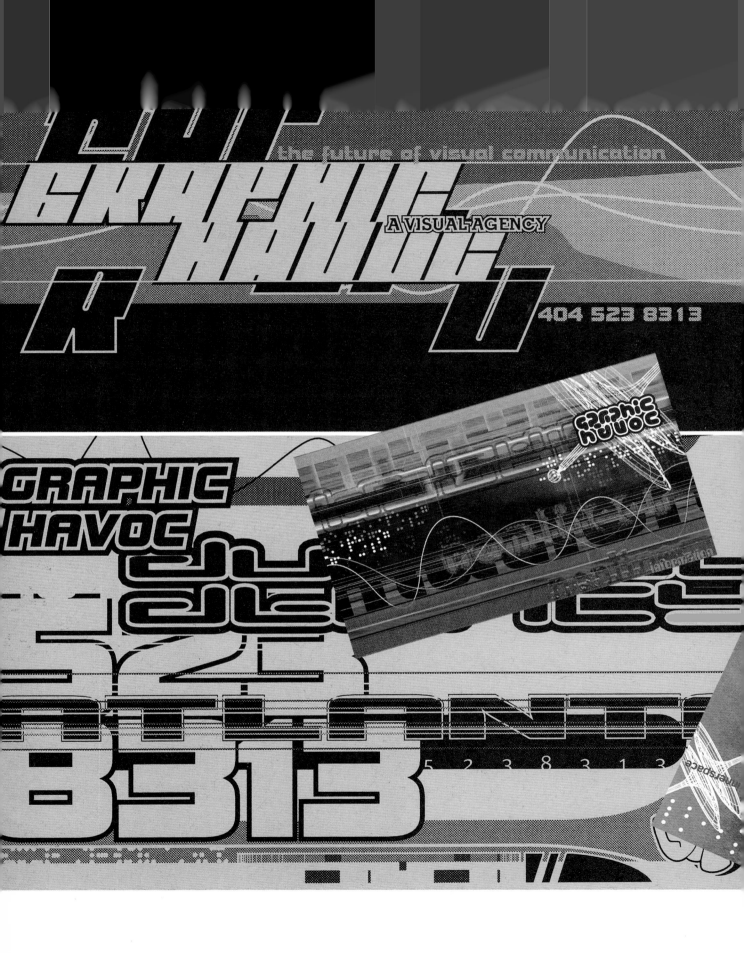

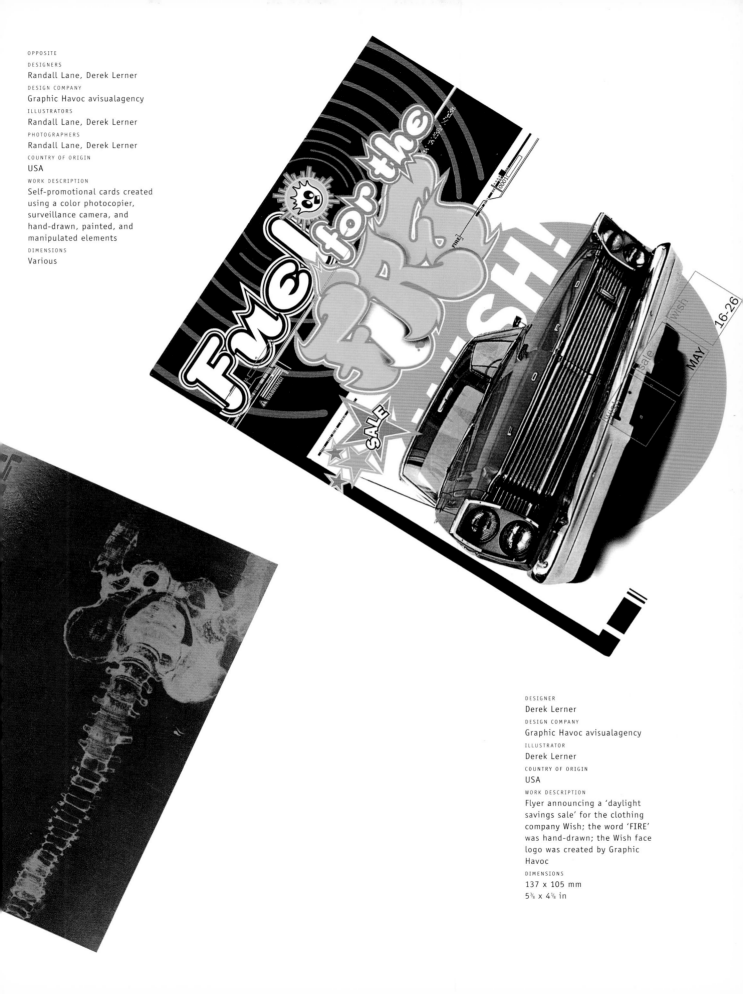

OPPOSITE
DESIGNERS
Randall Lane, Derek Lerner
DESIGN COMPANY
Graphic Havoc avisualagency
ILLUSTRATORS
Randall Lane, Derek Lerner
PHOTOGRAPHERS
Randall Lane, Derek Lerner
COUNTRY OF ORIGIN
USA
WORK DESCRIPTION
Self-promotional cards created
using a color photocopier,
surveillance camera, and
hand-drawn, painted, and
manipulated elements
DIMENSIONS
Various

DESIGNER
Derek Lerner
DESIGN COMPANY
Graphic Havoc avisualagency
ILLUSTRATOR
Derek Lerner
COUNTRY OF ORIGIN
USA
WORK DESCRIPTION
Flyer announcing a 'daylight
savings sale' for the clothing
company Wish; the word 'FIRE'
was hand-drawn; the Wish face
logo was created by Graphic
Havoc
DIMENSIONS
137 x 105 mm
5⅜ x 4⅛ in

SYLVANPRINT contains
100% recycled post consumer
waste, combining excellent
environmental credentials and
outstanding printability.
SYLVANPRINT has a good
whiteness, high opacity and a
smooth clean surface making
it the environmental choice
for all general print as well as
catalogues and magazines.

The SYLVAN range of papers
and boards offer a choice of
shade, environmental and
performance features. The
SYLVAN brand has been
established for over ten years
and all the products are
NAPM approved recycled.

100% Yellow 50% Magenta		SYLVANCOAT BRIGHT
100% Yellow 50% Black		SYLVANBLADE IVORY
100% Yellow 50% Cyan		SYLVANPRINT

42

DESIGNER
Karen Wilks
ART DIRECTOR
Karen Wilks
DESIGN COMPANY
Karen Wilks Associates
PHOTOGRAPHER
Richard Green
COUNTRY OF ORIGIN
UK
WORK DESCRIPTION
Promotional product sheets for
Paperback Ltd., recycled paper
company
DIMENSIONS
210 x 297 mm
8¼ x 11¾ in

OPPOSITE
DESIGNER
Philippe Savoir
ART DIRECTOR
Philippe Savoir
DESIGN COMPANY
Filifox
COUNTRY OF ORIGIN
France
WORK DESCRIPTION
Front and reverse sides of a
self-promotional card
DIMENSIONS
121 x 137 mm
4¾ x 5⅜ in

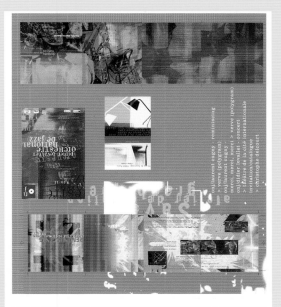

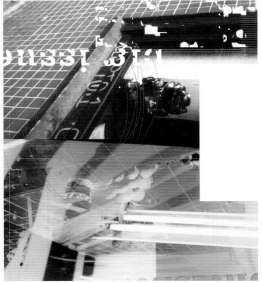

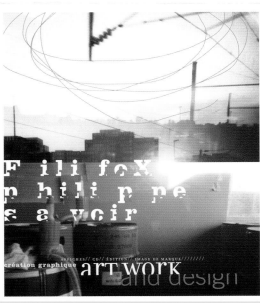

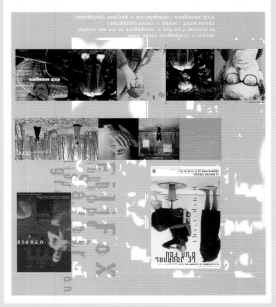

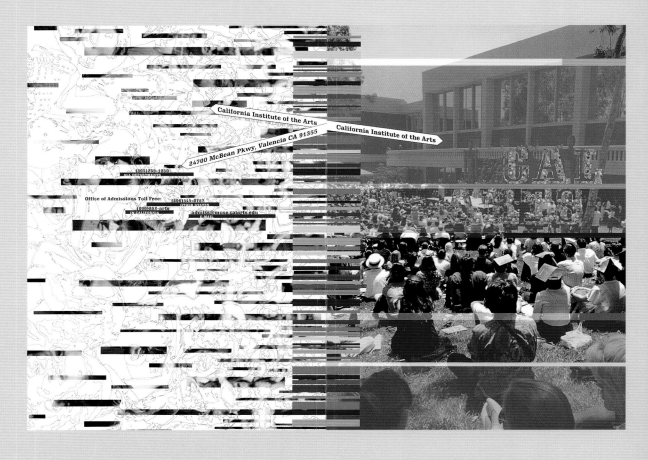

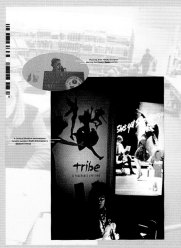

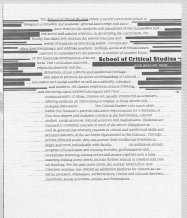

DESIGNERS
Somi Kim/ReVerb,
Barbara Glauber/Heavy Meta
ART DIRECTORS
Somi Kim/ReVerb,
Barbara Glauber/Heavy Meta
DESIGN COMPANIES
ReVerb, Los Angeles
Heavy Meta, New York
ILLUSTRATOR
Alan Kikuchi (back cover
line art)
PHOTOGRAPHERS
Steven A. Gunther,
Rachel Slowinski
COUNTRY OF ORIGIN
USA
WORK DESCRIPTION
Front and back cover (above)
and spread from an Admissions
Bulletin for the California
Institute of the Arts
DIMENSIONS
203 x 286 mm
8 x 11¼ in

OPPOSITE
DESIGNERS
James W. Moore,
Richard Leighton,
Jamandru Reynolds
ART DIRECTOR
James W. Moore
DESIGN COMPANY
ReVerb, Los Angeles
COUNTRY OF ORIGIN
USA
WORK DESCRIPTION
Promotional poster for an
interactive telecommunications
device produced by iMagic
Infomedia Technology Ltd.,
Hong Kong
DIMENSIONS
419 x 572 mm
16½ x 22½ in

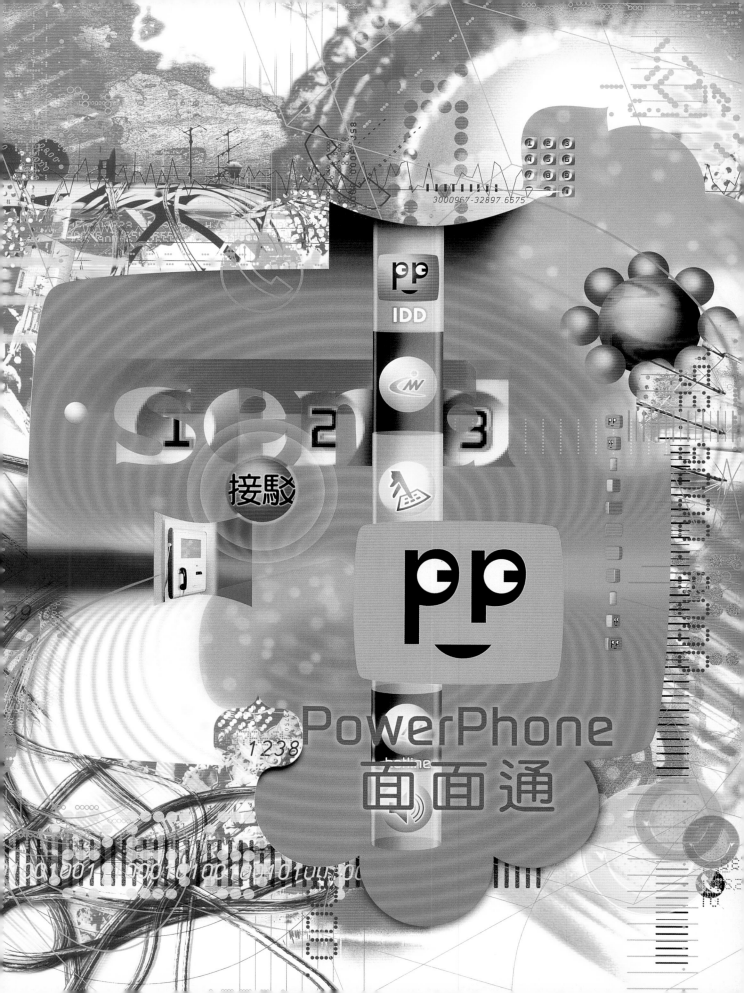

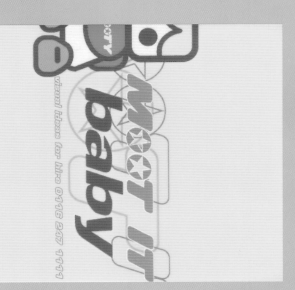

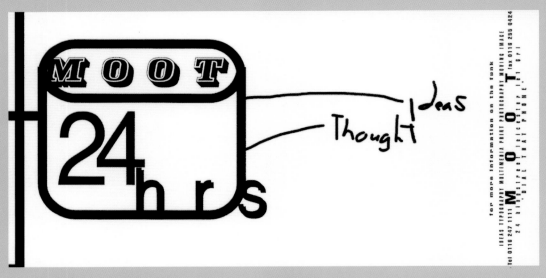

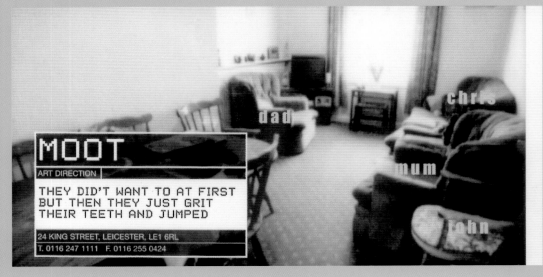

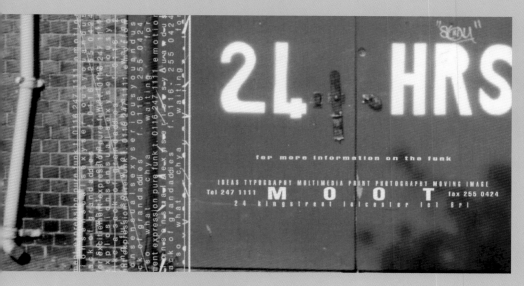

DESIGNERS
Nitesh Mody, John Kariolis
ART DIRECTORS
Nitesh Mody, John Kariolis
DESIGN COMPANY
Moot
ILLUSTRATORS
Nitesh Mody, John Kariolis
PHOTOGRAPHERS
Nitesh Mody, John Kariolis
COUNTRY OF ORIGIN
UK
WORK DESCRIPTION
Self-promotional cards
DIMENSIONS
200 x 100 mm
7⅞ x 3⅞ in

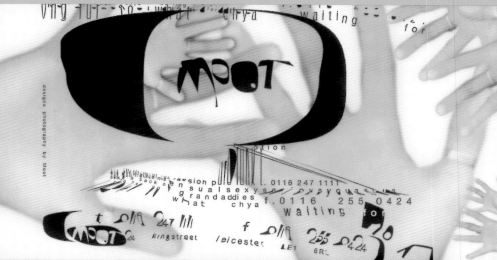

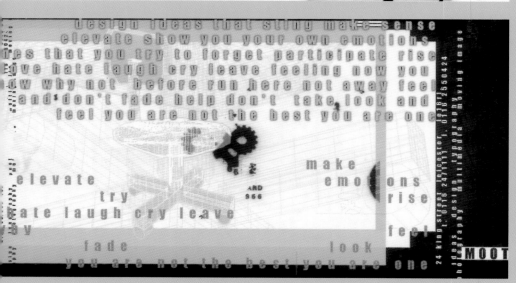

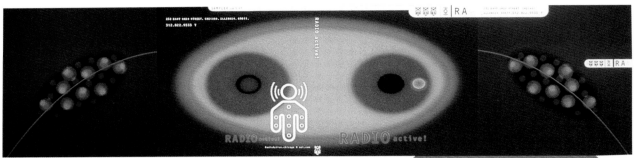

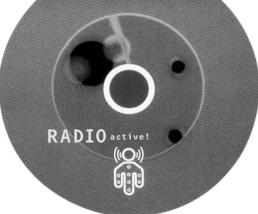

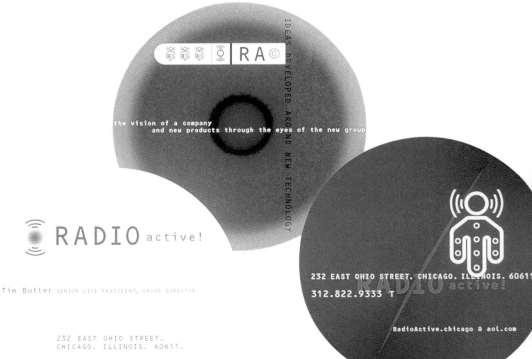

DESIGNER
Carlos Segura
ART DIRECTOR
Carlos Segura
DESIGN COMPANY
Segura Inc.
PHOTOGRAPHER
Photonica
COUNTRY OF ORIGIN
USA
WORK DESCRIPTION
Stationery and identity for
Radio Active – a Chicago-based
radio production company
DIMENSIONS
Various

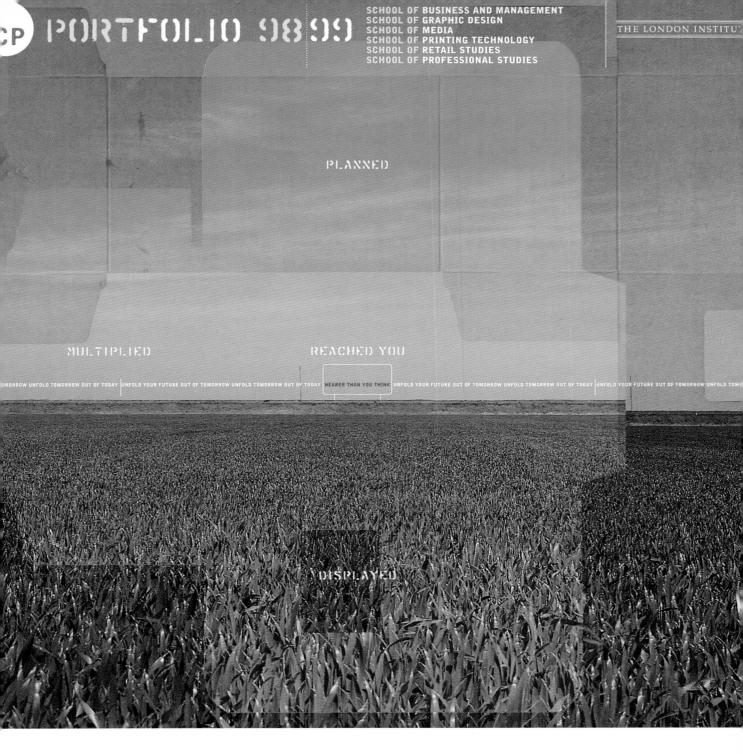

PORTFOLIO 98|99

LCP

SCHOOL OF BUSINESS AND MANAGEMENT
SCHOOL OF GRAPHIC DESIGN
SCHOOL OF MEDIA
SCHOOL OF PRINTING TECHNOLOGY
SCHOOL OF RETAIL STUDIES
SCHOOL OF PROFESSIONAL STUDIES

THE LONDON INSTITUT

PLANNED

MULTIPLIED REACHED YOU

TOMORROW UNFOLD TOMORROW OUT OF TODAY | UNFOLD YOUR FUTURE OUT OF TOMORROW UNFOLD TOMORROW OUT OF TODAY | NEARER THAN YOU THINK | UNFOLD YOUR FUTURE OUT OF TOMORROW UNFOLD TOMORROW OUT OF TODAY | UNFOLD YOUR FUTURE OUT OF TOMORROW UNFOLD TOM

DISPLAYED

DESIGNERS
Nick Bell, Sacha Davison,
Tom Elsner
ART DIRECTOR
Nick Bell
DESIGN COMPANY
Bell
PHOTOGRAPHER
Martyn Rose
COUNTRY OF ORIGIN
UK

WORK DESCRIPTION
Front of wraparound cover for
a London College of Printing
prospectus
DIMENSIONS
238 x 225 mm
9⅜ x 8⅞ in

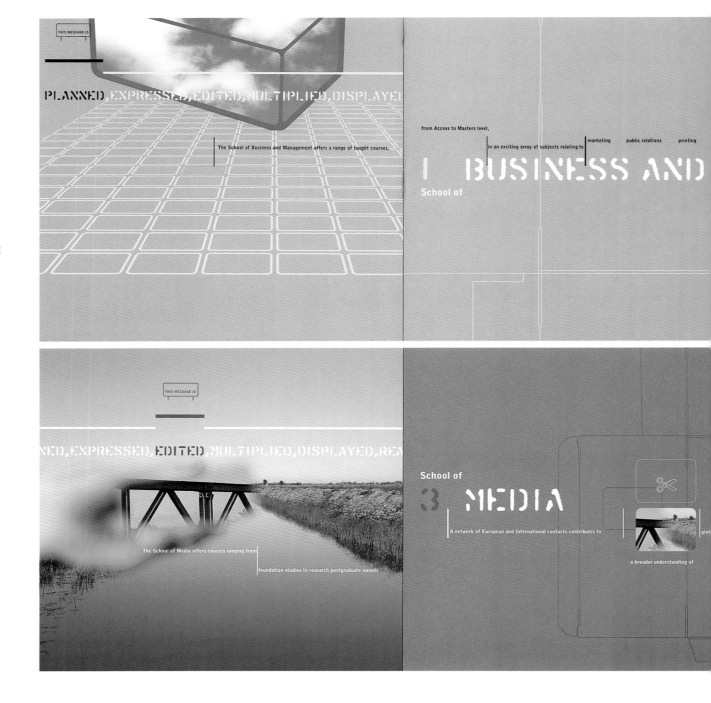

THIS MESSAGE IS

PLANNED, EXPRESSED, EDITED, MULTIPLIED, DISPLAYED

The School of Business and Management offers a range of taught courses,

from Access to Masters level,

in an exciting array of subjects relating to marketing public relations printing

1 BUSINESS AND

School of

THIS MESSAGE IS

NED, EXPRESSED, EDITED, MULTIPLIED, DISPLAYED, REA

The School of Media offers courses ranging from

foundation studies to research postgraduate awards

School of

3 MEDIA

A network of European and International contacts contributes to glob

a broader understanding of

DESIGNERS
Nick Bell, Sacha Davison,
Tom Elsner
ART DIRECTOR
Nick Bell
DESIGN COMPANY
Bell
PHOTOGRAPHER
Martyn Rose
COUNTRY OF ORIGIN
UK

WORK DESCRIPTION
Chapter opening spreads from
a London College of Printing
prospectus: each school is
identified with a stage of
the communication process
DIMENSIONS
238 x 225 mm
9³⁄₈ x 8⁷⁄₈ in

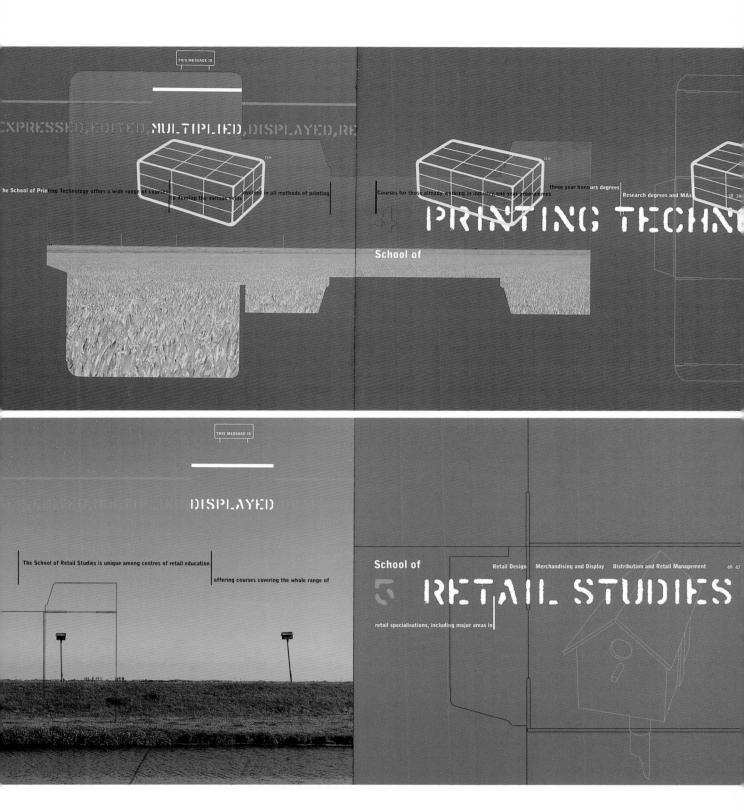

EXPRESSED, EDITED, MULTIPLIED, DISPLAYED, RE

2134

he School of Printing Technology offers a wide range of courses involved in all methods of printing to develop the various skills

Courses for those already working in industry, one year programmes three year honours degrees

Research degrees and MAs 38 39

2135

PRINTING TECHN

School of

DISPLAYED

The School of Retail Studies is unique among centres of retail education

offering courses covering the whole range of

retail specialisations, including major areas in

School of

Retail Design Merchandising and Display Distribution and Retail Management 46 47

5 RETAIL STUDIES

play
a
art
a genuine digital experience by post tool design

cet dee

PAGES 52–5
DESIGNERS
Gigi Biederman, David Karam
ART DIRECTORS
Gigi Biederman, David Karam
DESIGN COMPANY
Post Tool design
ILLUSTRATORS
Gigi Biederman, David Karam
COUNTRY OF ORIGIN
USA
WORK DESCRIPTION
**Cover (opposite) and spreads
from a self-promotional
booklet, including a CD-Rom**
DIMENSIONS
**146 x 146 mm
5¾ x 5¾ in**

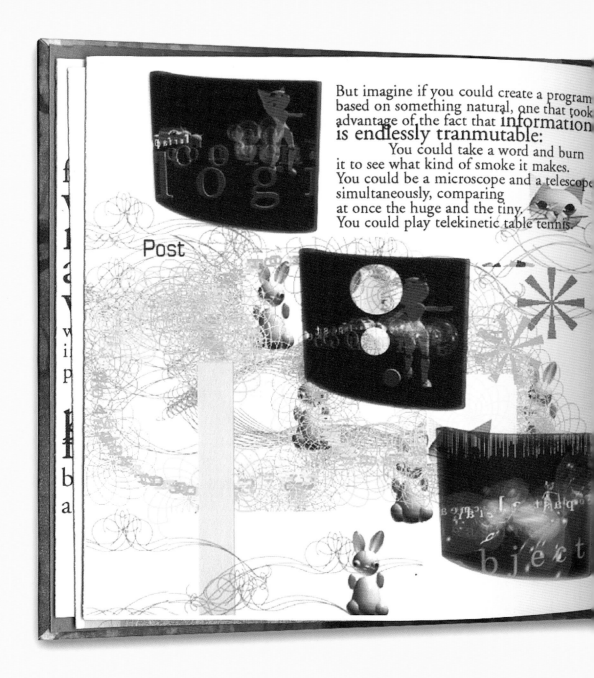

But imagine if you could create a program based on something natural, one that took advantage of the fact that **information** is endlessly tranmutable:
You could take a word and burn it to see what kind of smoke it makes. You could be a microscope and a telescope simultaneously, comparing at once the huge and the tiny. You could play telekinetic table tennis.

Post

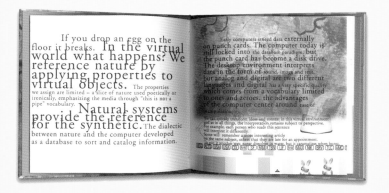

If you drop an egg on the floor it breaks. In the virtual world what happens? We reference nature by applying properties to virtual objects. The properties we assign are limited – a slice of nature used poetically or ironically, emphasizing the media through "this is not a pipe" vocabulary. Natural systems provide the reference for the synthetic. The dialectic between nature and the computer developed as a database to sort and catalog information.

Early computers stored data externally on punch cards. The computer today is still locked into the database paradigm, but the punch card has become a disk drive. The desktop environment interprets data in the form of sound, image and text, but analog and digital are two different languages and digital has a very specific quality which comes from a vocabulary limited to ones and zeroes, the advantages of the computer center around ease of manipulation.

Some will remember a more interesting article on the same subject, others that they are late for an appointment. For example, each person who reads this sentence will interpret it differently.

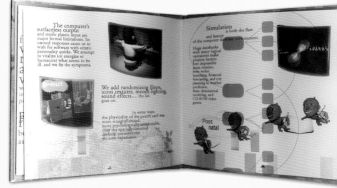

The computer's surfaceless output and sterile plastic input are major formal limitations. Its canned responses cause us to wish for software with erratic personality quirks. We attempt to vitalize (or energize or humanize) what seems to be ill, and we fix the symptoms.

We add randomizing filters, icons textures, moods lighting, sound effects.... the list goes on.

In some ways, the physicality of the punch card was more straightforward, more psychologically comfortable than the spatially-oriented desktop environment we now experience.

Simulation is both the flaw and beauty of the computer desktop environment.

Huge databanks with many logical operations make projects heretofore impossible, from rocket launching, financial forecasting, and city planning to weather prediction, flow dimensional rendering, and CD-ROM video games.

Post natal

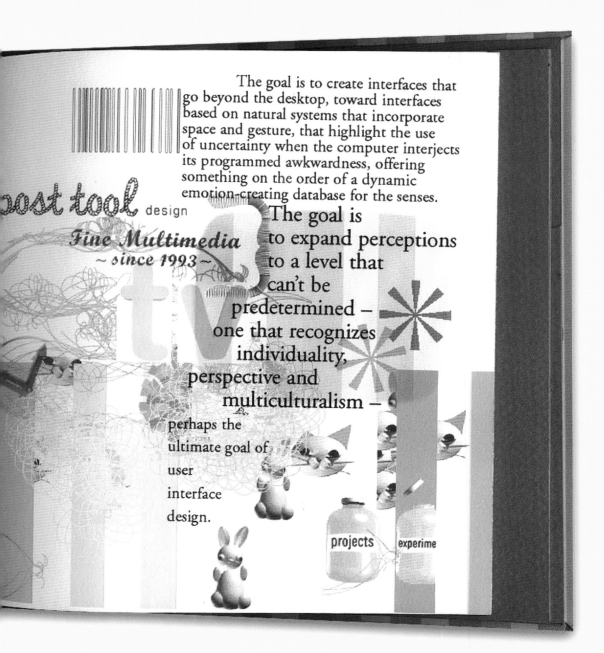

The goal is to create interfaces that go beyond the desktop, toward interfaces based on natural systems that incorporate space and gesture, that highlight the use of uncertainty when the computer interjects its programmed awkwardness, offering something on the order of a dynamic emotion-creating database for the senses. The goal is to expand perceptions to a level that can't be predetermined – one that recognizes individuality, perspective and multiculturalism – perhaps the ultimate goal of user interface design.

post tool design

Fine Multimedia
~ since 1993 ~

projects experime

DESIGNERS
Laura Lacy-Sholly, James Sholly
DESIGN COMPANY
Antenna Commercial Artisans
PHOTOGRAPHERS
Andrew Blauvelt, Ed Funk
COUNTRY OF ORIGIN
USA
WORK DESCRIPTION
Promotional brochure for
Visual Professional, a clothing
company that creates text,
type, and image designs for
their historically-based
garments
DIMENSIONS
159 x 229 mm
6¼ x 9 in

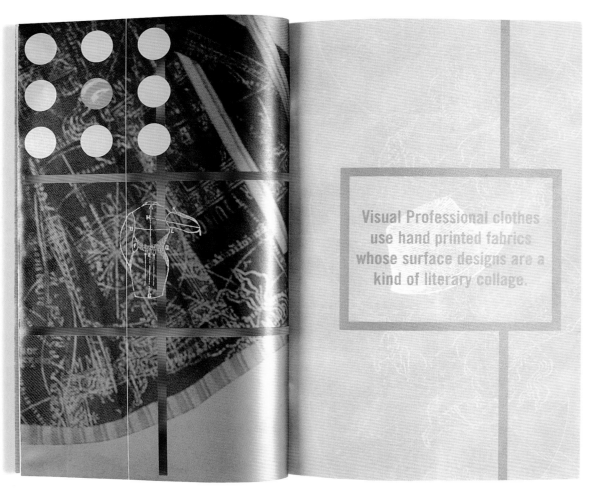

VISUAL PROFESSIONAL
17 Dederick Street, P.O. Box 2376, Kingston, New York 12401
<u>Tel 914.338.0408</u> Fax 914.338.3618

Represented by Miriana Ojeda Showroom
Los Angeles
213.624.5823

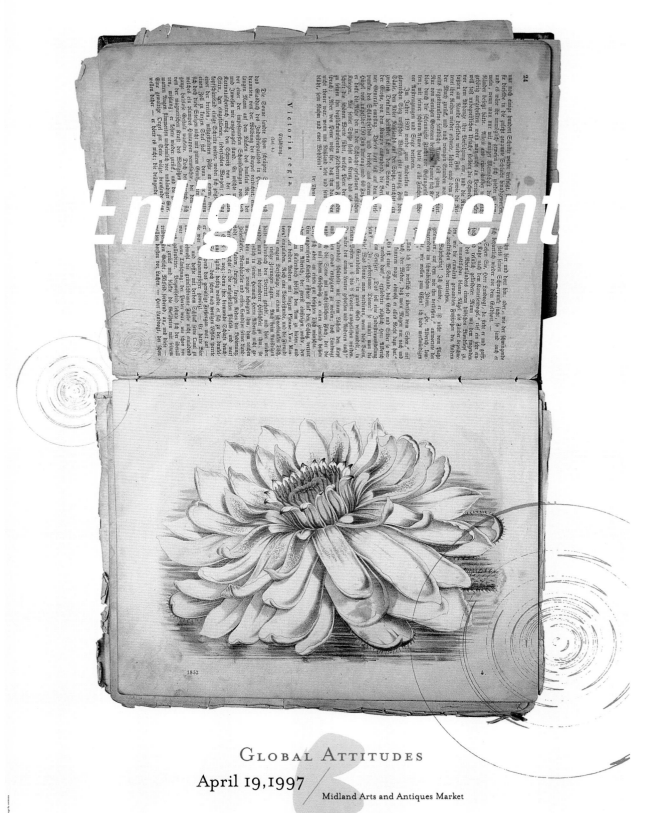

Enlightenment

GLOBAL ATTITUDES

April 19, 1997

Midland Arts and Antiques Market

One perfect evening in the fight against AIDS

TO BENEFIT THE DAMIEN CENTER 632.0123 CALL FOR ADDITIONAL INFORMATION

OPPOSITE
DESIGNERS
Laura Lacy-Sholly, James Sholly
DESIGN COMPANY
Antenna Commercial Artisans
PHOTOGRAPHER
Casey Cronin
COUNTRY OF ORIGIN
USA
WORK DESCRIPTION
Promotional poster for 'Global
Attitudes' – an Indianapolis
AIDS benefit event
DIMENSIONS
610 x 914 mm
24 x 36 in

DESIGNERS
Laura Lacy-Sholly, James Sholly
DESIGN COMPANY
Antenna Commercial Artisans
PHOTOGRAPHER
Casey Cronin
COUNTRY OF ORIGIN
USA
WORK DESCRIPTION
Fold-out invitation for 'Global
Attitudes' – an Indianapolis
AIDS benefit event
DIMENSIONS
127 x 178 mm
5 x 7 in

PAGES 60–1
DESIGNERS
Laura Lacy-Sholly,
James Sholly
DESIGN COMPANY
Antenna Commercial Artisans
COUNTRY OF ORIGIN
USA
WORK DESCRIPTION
Poster documenting the
creative process of Antenna
graphic design studio
DIMENSIONS
1016 x 660 mm
40 x 26 in

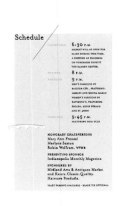

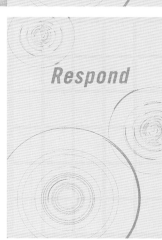

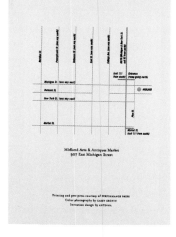

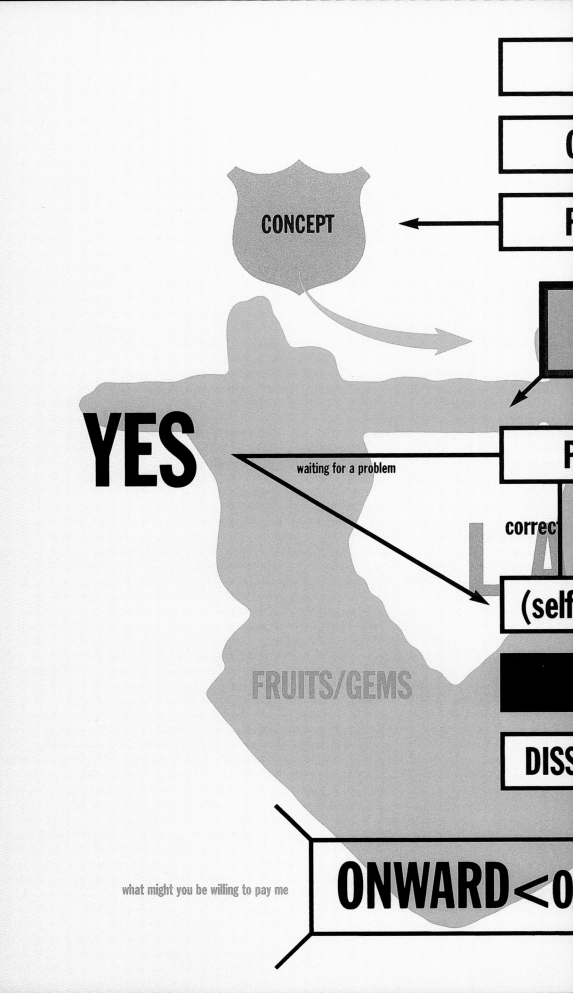

CONCEPT

YES

waiting for a problem

correct

(self

FRUITS/GEMS

DISS

what might you be willing to pay me

ONWARD <o

CONCEIT

goes around comes around

NG FLOUR/BAKING CAKES

NO?

flawless

R

LIZE

OR ELSE OR

REGRET

D<ONWARD

PAGES 62–7
DESIGNERS
John Bielenberg, Chuck Denison
ART DIRECTOR
John Bielenberg
DESIGN COMPANY
Bielenberg Design
PHOTOGRAPHER
Doug Menvez
COUNTRY OF ORIGIN
USA
WORK DESCRIPTION
Front cover (right) and spreads
from a brochure for Strategos
strategy consultants
DIMENSIONS
432 x 559 mm
17 x 22 in

A Revolution is coming in your industry.

It may not happen this week, this month, or this year.

But it will happen.

Which leaves two questions:

"The final test of a leader is that he leaves behind him in other men the conviction and the will to carry on." — WALTER LIPPMANN

1.
Will you be the revolutionary?

2.
Do you have the guts?

"It must be considered that there is nothing more difficult to plan, more doubtful of success, nor more dangerous to manage than the creation of a new order of things." — NICCOLÒ MACHIAVELLI, THE PRINCE (1532)

If you miss it

If you lead it

you will fail.

you can win.

DESIGNER
John Bielenberg
ART DIRECTOR
John Bielenberg
DESIGN COMPANY
Bielenberg Design
ILLUSTRATOR
John Bielenberg
PHOTOGRAPHER
Paul Franz-Moore
COUNTRY OF ORIGIN
USA
WORK DESCRIPTION
Fold-out flyer for Appleton Papers to introduce 'Utopia' – a new line of paper
DIMENSIONS
177 x 121 mm
7 x 4¾

OPPOSITE AND PAGES 70–1
DESIGNER
John Bielenberg
ART DIRECTOR
John Bielenberg
DESIGN COMPANY
Bielenberg Design
PHOTOGRAPHER
Ray Niemi
COUNTRY OF ORIGIN
USA
WORK DESCRIPTION
Spreads from a promotional brochure for Appleton Papers introducing 'Utopia' – a new line of paper; this piece highlights a female convict's vision of utopia: 'Utopia does not exist for me any more.'
DIMENSIONS
305 x 356 mm
12 x 14 in

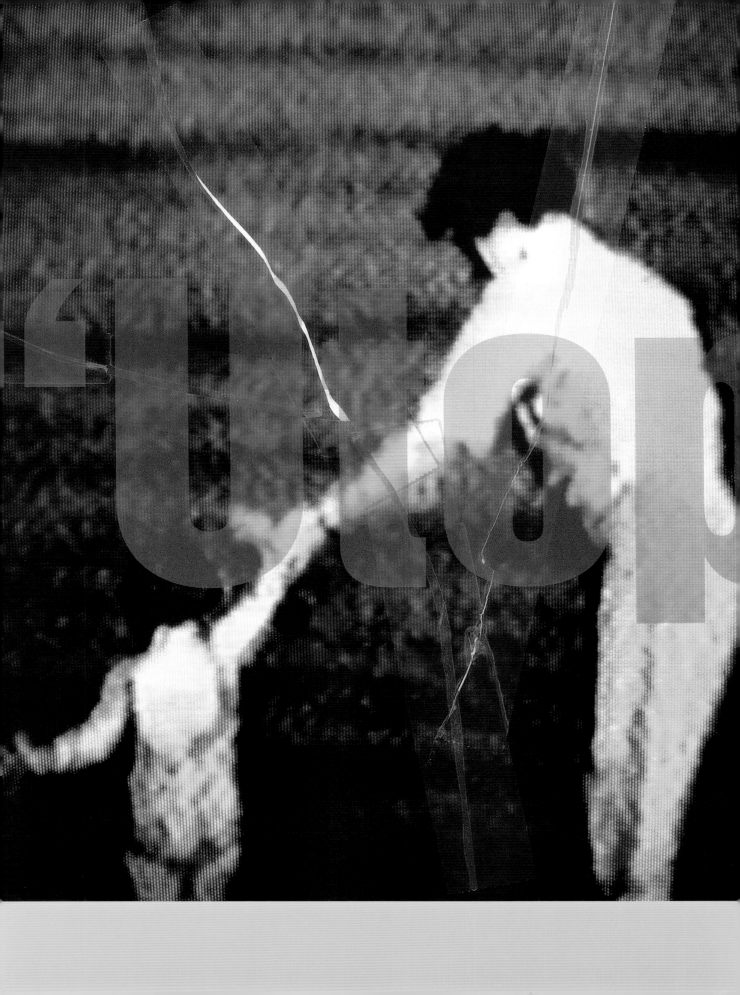

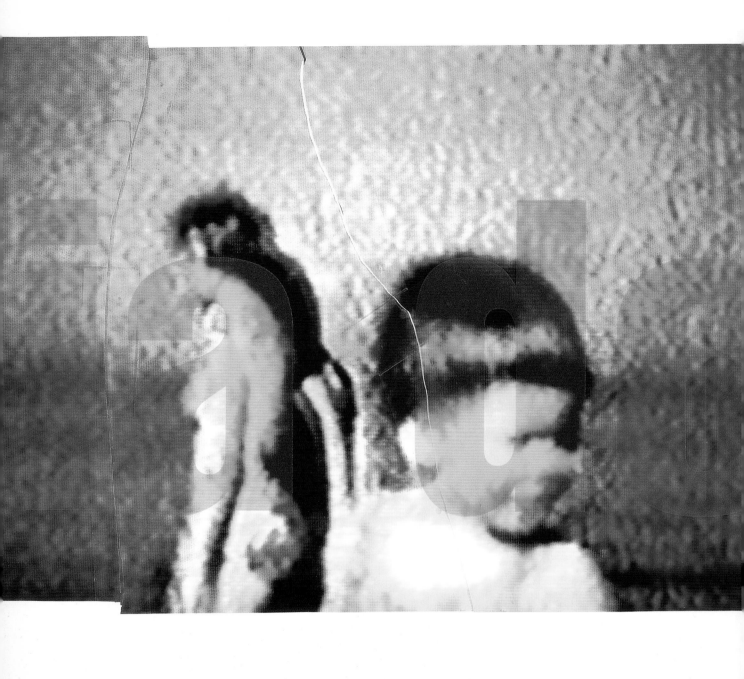

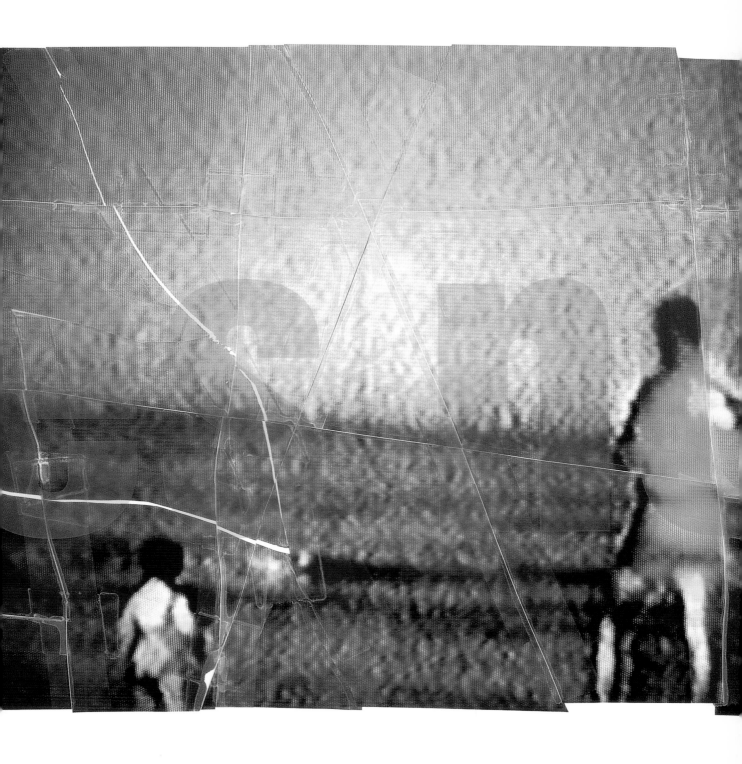

immerse
sound(e)scapes

biosphere
bowery electric
the designers republic
locust
christopher priest

OPPOSITE AND ABOVE
DESIGNERS
Designers Republic
ART DIRECTORS
Designers Republic
DESIGN COMPANY
Designers Republic
COUNTRY OF ORIGIN
UK
WORK DESCRIPTION
**Self-promotional advertisement
in the electronic music
magazine *Immerse***
DIMENSIONS
**210 x 297 mm
8¾ x 11¾ in**

DESIGNERS
Adam Mills, Roger Fawcett-Tang
ART DIRECTOR
Roger Fawcett-Tang
DESIGN COMPANY
Struktur Design
PHOTOGRAPHER
Toby McFarlan Pond
COUNTRY OF ORIGIN
UK
WORK DESCRIPTION
**Front cover of *Immerse*
magazine**
DIMENSIONS
**210 x 297 mm
8¾ x 11¾ in**

BELOW AND OPPOSITE

DESIGNER

Philip O' Dwyer

ART DIRECTORS

Mark Hough, Philip O' Dwyer

DESIGN COMPANY

State

COUNTRY OF ORIGIN

UK

DIMENSIONS

210 x 280 mm

8¼ x 11 in

BELOW

ILLUSTRATOR

Philip O' Dwyer

WORK DESCRIPTION

Spread on musician Finley
Quaye from *Raise* magazine

OPPOSITE ABOVE

ILLUSTRATOR

Philip O' Dwyer

WORK DESCRIPTION

Spread on the 1997 UK
general election from *Raise*
magazine

OPPOSITE BELOW

WORK DESCRIPTION

Spread on Internet addiction
from *Raise* magazine

RIGHT

DESIGNERS

Mark Hough, Philip O' Dwyer

ART DIRECTORS

Mark Hough, Philip O' Dwyer

DESIGN COMPANY

State

PHOTOGRAPHER

Angelo Valentino

COUNTRY OF ORIGIN

UK

WORK DESCRIPTION

Cover of *Raise* magazine

DIMENSIONS

210 x 280 mm

8¼ x 11 in

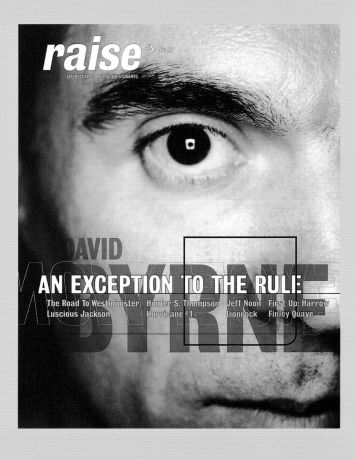

raise #5 06:47

LIFENOTSTYLE FREE TO UK STUDENTS

DAVID BYRNE

AN EXCEPTION TO THE RULE:

The Road To Westminster Hunter S. Thompson Jeff Noon First Up: Harrow
Luscious Jackson Hurricane #1 Lionrock Finley Quaye

SAMPLE#3.1: **FINLEY QUAYE**

words **gld** pictures **pilib o'duibhir**

He attributes much of the way he is and the way he sounds to his travels – London, New York and Europe have all been 'home' at various times. *'Having experienced a lot of things I know that a lot is possible and a lot of things are acceptable,'* he reflects. *'It's had a lot to do with affirmation of some of my beliefs.'* Now he lives in Edinburgh (*'because it's relaxed and because it's one of the sunniest places in Britain in the summer'*) and he just got back from shooting his new video in Namibia: *'We were getting up at 4:30 every morning to drive out and catch the sunrise. It was amazing. Beautiful. I could live there.'* Finley comes across as thoughtful and direct. He's into *'people who are real, people who have energy'*, citing this as the reason why he recently got Iggy Pop involved doing a track with him and Tricky. His collaboration with close friend A Guy Called Gerald, in which he sang on the haunting drum'n'bass track Finley's Rainbow was, he claims, *'a spiritual move'*. His aim now is to *'get together'* with his brother, LA-based guitarist Kaleb Quaye, who has worked with Elton John and Hall & Oates.

Talented, good-looking and with enough pop star in him to get noticed (but not enough to put people off) he is aiming high. Not just for the stages and clubs of the world, but for the everyday listeners: *'people in cars, on the way to work, hippies chilling out, people cooking with a mono radio on...'* He is optimistic about the future, describing the music in 1997 as *'more fiery, more condensed and filled with more new energy than ever before.'* And when he says that, and when you hear his music, you believe it.

6|7

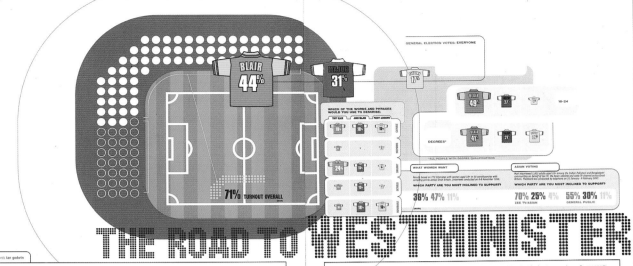

THE ROAD TO WESTMINSTER

BLAIR 44% 31% 17%

71% TURNOUT OVERALL

GENERAL ELECTION VOTES: EVERYONE

WHICH OF THE WORDS AND PHRASES WOULD YOU USE TO DESCRIBE:

18-24

DEGREES*

*ALL PEOPLE WITH DEGREES QUALIFICATIONS

WHAT WOMEN WANT

WHICH PARTY ARE YOU MOST INCLINED TO SUPPORT?

36% 47% 11%

ASIAN VOTING

WHICH PARTY ARE YOU MOST INCLINED TO SUPPORT?

70% 25% 4% 55% 30% 11%
ZEE TV/ASIAN GENERAL PUBLIC

words ian godwin

No wonder staying in is the new going out. Surround sound and takeaway curries were made for nights like these. Election 97 was the most amazing victory to be televised since England beat Holland 4-1 during Euro 96. With hindsight, Blair's rhetoric seemed spot on: Labour was coming home.

Like England, Labour anticipated a win. But the opposition had a better record in the fixture down the years. In the event, of course, Labour played them off the park. And there was no Patrick Kluivert to score a consolation goal for the Tories. Many of their stars were stretched from the field. Some, like David Mellor, were given the red card.

Ironically enough, Enfield Southgate provided the Teddy Sheringham moment. Stephen Twigg's ousting of Michael Portillo was the electoral equivalent of a fourth, delirious goal – when incredulity turned to stunned rapture. Only next morning could you believe the result. Because it said so in the newspaper. LABOUR LANDSLIDE.

In retrospect, the scale of the victory can be put down to two things – the electorate's powerful distaste for the Tories and the personal appeal of Tony Blair. Labour achieved its 179 seat majority (reduced to 178 with the re-election of Betty Boothroyd as Speaker) on the basis of 44.5% of the popular vote. Paddy Ashdown's Liberal Democrats secured 46 seats (up from 27 in the last Parliament) despite their share of the vote falling one point.

There are any number of reasons why. Various discontents welled up over 18 years. Certainly the Conservatives underestimated the issue of 'sleaze'. It was far from being a figment in the imagination of Guardian readers. It symbolised the arrogance of power and the tired condescension which had come to characterise the Conservatives for many swathes of people. To think they could get away with this or that indiscretion. The public took offence more at the gall of their sophistry than the foolishness of their actions.

Moreover, the Conservatives no longer seemed to speak to the Britain which many experienced. Or if they did, voters were not going to let them claim responsibility for it. The anti-Tory landslide left the party without a single seat in Scotland and Wales and without MPs in many of the great conurbations. The pundit Peter Kellner simply confirmed what many had thought for a long while when he observed: 'The bleak truth for the Conservatives is that they have been reduced to a party of the English suburbs and shires.'

You could almost say Labour was elected by default. Hell, even Neil Kinnock might have stood a real chance in 1997.... But then again no. As Blair declared at the victory party:

'We were elected as New Labour and we will govern as New Labour.' Although for all the hitting the ground running, there is still little hard evidence of what this means. Members of the new government brandish the 'five pledge' card as they did throughout the campaign, but there is surely neither illumination nor inspiration in these cautious objectives. That the strategists succeeded in making New Labour an aspirational product is almost entirely due to Tony Blair.

Michael Heseltine always warned us Labour had the marketing sussed. In the end, the ideas are relative. It is the candidate that counts. And in Blair Labour has the better 'body', as the Americans would say. It would not have been a surprise if Labour's last election broadcast had featured a load of multi-ethnic Britkids playing football and mouthing 'I am Tony Blair', with the moody still of the man himself and the caption 'I am Tony Blair' followed on screen by a single red rose as the Prime Minister-elect places a slow motion shot past Frode Grodas (Chelsea's goalkeeper). It was a presidential election.

The American commentator Joe Klein, covering the election for the New Yorker, suggested that New Labour is about proving social responsibility and designer labels are not incompatible. It's a good joke at the expense of the Blairs' LabFab lifestyle – and the media's sudden obsession with the Ford Galaxy, the Ted Baker shirts and Cherie's shoes –

but at the same time it shows New Labour's contemporary relevance. The government's mandate is to reckon with the reality of post-Thatcherite Britain.

At present, Labour is governing as it ran the campaign – with presentation values and Peter Mandelson to the fore. After the chaos of John Major's last days, co-ordination is welcome. But having ditched command and control as a model for the economy, Labour should not revive it as the principle of its day-to-day political life. Delaying the introduction of the Freedom of Information bill is an ominous sign. Blair himself has said this reform would bring about a *change that is absolutely fundamental to how we see politics developing in this country.'*

For the moment these are concerns, not criticisms. There is a long way to go, as you might say at the start of another football season. Blair has asked to be judged by the results he achieves. The Welfare to Work programme, affecting up to 250,000 unemployed young people, is one such measure on which Labour's record will be assessed. However, despite the self-imposed restraints which New Labour has sought to present as virtues, expectations in the country are high.

'It's a new dawn, is it not?' – Tony Blair said. 'I'll let you be in my dawn if I can be in yours.' We should say that.

14 15

WEBWORLDS:
INTERNET ADDICTION

words sally williams

'It's three in the morning and all through the house. Not a creature was stirring Except for my mouse I sit and I stare at the monitor with glee Hoping to find something in there for free Night after night, day after day Oh God! I hope my connection will stay!' Harvard Eriksen, WebAholics Support Group

My story begins with a young man whom I shall call Andrew. He suffered from Internet Addiction, a terrible disease afflicting millions of people worldwide. After successfully overcoming his addiction, Andrew is now ready to share his story...

'Within the last year or so I have exchanged thousands upon thousands of email messages. In the last four months I have exchanged 2610 email messages just with Gaia. Every working day she sat at her computer in the room next to mine. By our 200th email we were in love. By the 300th we had arranged a jazz night out at The Vortex Club. Each moment before my computer screen I expected the "You have new mail" message to pop up. I set my email program, Eudora, to automatically check for new email every minute (its minimum setting), and yearned for the slightest communication with her, however banal.'

These online support groups seem to be very popular, and I noticed I was the 366,267th visitor to the Netaholics Anonymous Web site since October last year. Andrew again: 'I've made several friends all over the world who share the same kind of addiction to email and the Internet. I love being able to talk about my problems without feeling too embarrassed or misunderstood. It's helped me to overcome EDD, and now I hardly ever send myself email.'

But, as Lucy Egger pointed out to me, the fact that many of these 'help' groups are on the Internet only tends to exacerbate the problem. 'Giving support and advice over the Internet,' explains Lucy, 'is not equivalent to receiving personal therapy from a professional counsellor. For example, one of my own clients who came to me for therapy had already tried Netaholics Anonymous, where they give advice on their Web site to, "turn off your computer now, and go outside for fresh air." Although this is not bad advice, my client would open the window so, whilst taking in fresh air, she would still be able to hear the beep of new email arriving. This highlights to me the danger of not receiving professional counselling when trying to overcome Internet Addiction.'

Internet Addiction can be so damaging that Marc Grant, himself an addict, has courageously published his own story, 'THE TRAGEDY OF AN ON-LINE ADDICTION [4] on the Web, as a warning to others. 'The bills begin to come in,' writes Marc. 'You've missed a lot of work. Your old friends no longer call. Everyone close to you knows there's a change and that something is wrong. Sometimes your life does get to you. You're starting to feel the dirtiness of modem addiction, particularly when your spouse makes you feel like a child by berating you for those astronomical phone and credit card bills – if he or she hasn't divorced you by then. But most of the time you don't really care, you have your computer "friends" now. Ahhhh, when you're connected, you feel OK.'

This kind of story can be told a thousand times. Monde Kontrolle emailed the Webaholics Support Group with this sad tale: 'You folks don't KNOW Netscapism... I'm receiving payments for a disability I had three years ago, that I'm over now, but I'm still getting the money! This allows me to NEVER have to worry about work or school; I'm also a single woman with no children.

THE "SORRY, YOU DON'T HAVE ANY NEW MAIL" MESSAGE BEGAN TO THROW ME INTO PANIC.

ONE FRIDAY I EVEN EMAILED MYSELF WITH THE MESSAGE, "GAIA'S ILL TODAY, SO THERE'S NO EMAIL :-("

name: andrew

drug of choice: eudora pro 3.0

[1] http://www.webcreations.co.uk/question/selfscre.html [2] http://www.webaholics.com/ [3] http://www.safari.net/~pam/netanon

YES, I HAVE *NO LIFE*!

THIS HAS LED TO EIGHT TO TEN HOUR NETSCAPING BINGES AFTER WHICH MY REAR END BECOMES COMPLETELY UNABLE TO FEEL ANYTHING AFTER SITTING IN FRONT OF MY MAC FOR SO LONG. CAN YOU BELIEVE I DON'T HAVE A URL YET? BUT I'M WORKIN' ON IT! BY THE WAY, INTERNET ISN'T MY ONLY ADDICTION. YOU GOT TO HAVE SOMETHING TO KEEP YOU AWAKE ENOUGH TO CLICK THE MOUSE.'

name: monde

drug of choice: netscape navigator™ 3.0

[4] http://pwp.starnetinc.com/marcgrnt/4.html [5] http://web-star.com/www.html

'Little did I know at the time that I was one of many people who suffer from E-mail Deficiency Depression (EDD), which forces you to e-mail yourself. Around the 1000th email we even acknowledged our addiction, and I decided to face the truth by taking the Net Junkie Test [1] "Your score is 9", came the awful reply, "This makes you an Absolute Total Net Head."... I didn't know what to do.'

Lucy Egger PhD, a leading Internet Addiction researcher from the The Psychology Unit of the Swiss Federal Institute of Information Technology admits that, 'Our studies have shown that at least 10% of Internet users, equating to millions of people worldwide, are addicted to, or dependent upon, the Internet. I am personally disturbed by these results, and think that immediate action is needed to combat the adverse sociological effects of using the Internet.'

Luckily for Andrew, and others like him, there are online support groups you can turn to for help – The Email Addiction Discussion Group, Webaholics [2], and Netaholics Anonymous [3] to name just three. In many support groups each addict is encouraged to admit to their addiction. This is seen as an important step in overcoming the problem, and many people start off by posting statements onto a website, stating their name, email address and a confession such as, "I am a Webaholic". Once therapy begins, each addict can chat to others with similar problems via personal email or public internet chat forums. As Kirsten Allen confessed on the Webaholics site, 'I'm addicted to Chat Group Therapy. Talk to me, I'm known as Kitten.'

'There are many cases of Internet Addiction,' concludes Lucy 'that have economic and social consequences similar to more recognised forms of addiction, such as drug addiction and compulsive gambling. It's not just about students who miss lectures to surf instead. Internet Addiction can deprive you of sleep, ruin your eyesight and posture, create strains on your personal relationships, and lead to a compulsive need to be online, whether the user can afford it or not. Another concern of mine is that many traditional addiction support groups are springing up on the Internet, which may inadvertently swap one form of addiction for another. There are many issues at stake, and I don't think people really think about these issues when they connect to the Internet.'

Despite the danger of becoming addicted, many people see the Internet as an extremely positive force. 'Well, if what I have is a disease, then, give me more of it is all I can say,' says Howard of The World Wide Webaholics [5]. 'Disease? Addiction? Maybe so to some, but I'm glad I have it. Gosh, if my preoccupation with the Web is a disease, it sure seems like this disease has a tendency to bring people together, to encourage sharing, to promote goodwill, increase knowledge, encourage accomplishment, to open lines of communication and understanding between disparate groups of people, and give back much more than it

takes. I'm glad that the World Wide Web exists. I'm glad that I am helping in some small part, to expand the World Wide Web. I'm overjoyed that, for the first time in recorded history the "common" folks are able to publish their thoughts, emotions, art, rants, views, material, etc. in an easy effective manner; much to the chagrin of some, more entrenched purveyors of information.'

[If you think you may be addicted to the Internet, contact www.webaholics.com.]

40 41

PEACH?

SUB. A3 A/W 8403 (Col. metallic) 21/7/95 2:03 pm

SUB. A3 A/W (Peach)

F 0181 693 1861

HY

M1 T Y P O GRA

PHOTOGRAPHY DESIGN

T 0181 693 1861

SUBSTANCE
Graphic Design

SIGN

Swiss + Grit 00.0114
Promotional mailshot 00.0181

Partners Chris Ashworth Neil Fletcher
 Amanda Sissons BA (Hons)
 London Sheffield

Purveyors of Progressive Swiss Typography

M1 TYPO GR APHY Pantone No.s 472 U 840

T 0181 693 1861 T 0114 268 5835

SUBSTANCE

DESIGN TYPOGRAPHY

HY
IYI

B. A3 A/W (Peach) 16/7/95 11:59 pm

TYPO GR A Y

DESIGN TYPOGRA

TYPOGRAPHY

HY

00.0114

00.0181

00.0114 268 58 35
00.0181 693 18 61

HY PHOTOGRAPHY T Y PO GRA PH

TYPOGRAP
POGRAPHY

GREAT BRITAIN

58 35
18 61
Chris Ashworth
Amanda Sissons BA (Hons)
London

TYPO PHO

F 0181 693 18

TYPOGRAPHY DESIGN PHOTOGRAPHY

SUBSTANCE
MADE IN ENGLAND

D

9.06.95

SUBSTANCE

268
693

68
693

Composite

Composite

DESIGNERS
Neil Fletcher, Chris Ashworth
ART DIRECTOR
Kevin Westenberg (cover)
DESIGN COMPANY
Substance
PHOTOGRAPHER
Kevin Westenberg
COUNTRY OF ORIGIN
UK
WORK DESCRIPTION
Front and back cover
(top right) and spread
from a self-promotional
brochure
DIMENSIONS
156 x 195 mm
6⅛ x 7⅞ in

OPPOSITE
DESIGNERS
Neil Fletcher, Chris Ashworth
ART DIRECTOR
Neil Fletcher
DESIGN COMPANY
Substance
COUNTRY OF ORIGIN
UK
WORK DESCRIPTION
Self-promotional poster
DIMENSIONS
418 x 593 mm
16½ x 23⅜ in

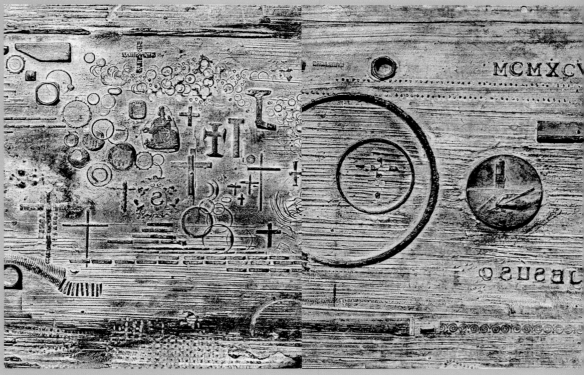

PAGES 78–9
DESIGNER
Stuart Spalding
ART DIRECTORS
Lee Swillingham,
Stuart Spalding
PHOTOGRAPHER
Sean Ellis
WORK DESCRIPTION
Spreads on British
rock band The Verve
for *The Face* magazine
DIMENSIONS
232 x 300 mm
9⅛ x 11¾ in

PAGES 80–1
DESIGNER
Stuart Spalding
ART DIRECTORS
Lee Swillingham,
Stuart Spalding
PHOTOGRAPHER
Aaron Sedway
WORK DESCRIPTION
Spreads on snowboarding
in Alaska for *The Face*
magazine
DIMENSIONS
232 x 300 mm
9⅛ x 11¾ in

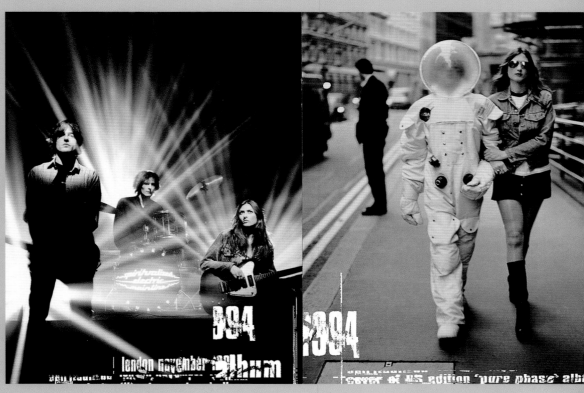

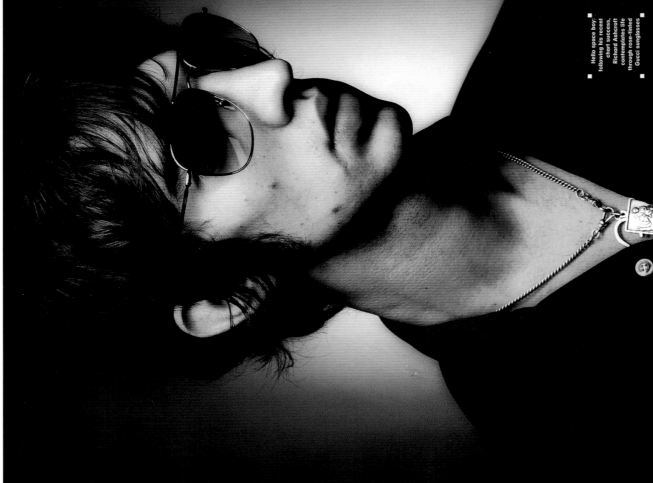

Hello space boy: following his recent chart success, Richard Ashcroft contemplates life through rose-tinted Gucci sunglasses

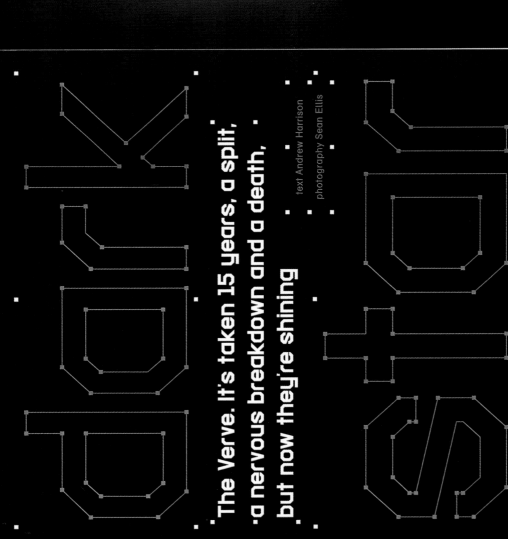

dark
pop
stars

The Verve. It's taken 15 years, a split, a nervous breakdown and a death, but now they're shining

text Andrew Harrison

photography Sean Ellis

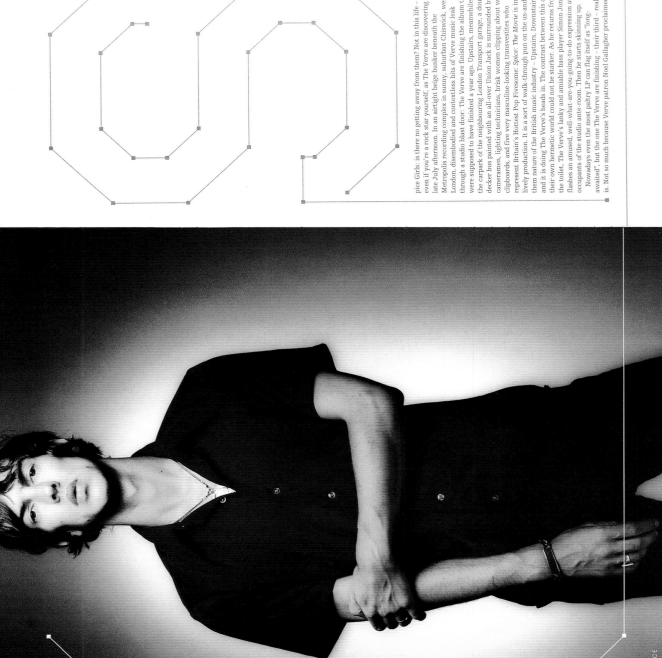

predecessor "A Northern Soul" as runner-up only to his own "Morning Glory" and Paul Weller's "Stanley Road" as the best album of 1995, and dedicated a song – "Cast No Shadow" – to The Verve's singer Richard Ashcroft. Nor because The Verve were actually supposed to have split up in August of that year, just as the gorgeous, string-driven "History" was about to become their first big hit.

No, the real reason is "Bitter Sweet Symphony" and everything that peculiar, direct, heart-filling song promised. Having emerged in the middle of the same 1992 indie boom that produced Suede, The Verve had gone on about the power of music to transform and renew your private world since long before such things were fashionable. Their own music, though, had always consisted of shapeless groove-based wig-outs, a Shamanistic psychedelia that was just too weird to play on the big stage. The Verve were dismissed as Northern nutters from a town [Wigan] with no rock'n'roll pedigree. Their singer – this character with extravagant, not-of-this-earth good looks and the build of a twig with metabolic problems – talked so much mysticism that he became known as "Mad" Richard. He was probably on drugs. It was said that The Verve would be dangerous if they ever wrote a song. Then they did.

No one expected The Verve to connect now, of all times, yet with hindsight you could have seen it building. James Lavelle reckoned that the Verve record would be the only British rock record worth hearing of the year. Mike D was interested (even the copyright notice on one issue of Grand Royal magazine read "This our magazine, or to paraphrase Mad Richard of The Verve – This is magazine"). Noel Gallagher wouldn't shut up about them. The young and on-it Scots novelist Alan Warner placed references to The Verve in his books, for no apparent reason other than that the band seemed to be about to matter in some unspecified way. There is no reason why these people's opinions should matter more than those of any other punter, except that

▲

pice Girls: is there no getting away from them? Not in this life – not even if you're a rock star yourself, as The Verve are discovering this late July afternoon. In an airtight beige bunker beneath the Metropolis recording complex in sunny, suburban Chiswick, west London, disembodied and contextless bits of Verve music leak through a studio blast door: The Verve are finishing the album they were supposed to have finished a year ago. Upstairs, meanwhile, in the carpark of the neighbouring London Transport garage, a double decker bus painted with an all-over Union Jack is surrounded by cameramen, lighting technicians, brisk women clipping about with clipboards, and five very masculine-looking transvestites who represent Britain's Hottest Pop Fivesome: Spice: The Movie is in lively production. It is a sort of walk-through pun on the us-and-them nature of the British music industry – Upstairs, Downstairs – and it is doing The Verve's heads in. The contrast between this and their own hermetic world could not be starker. As he returns from the toilet, The Verve's lanky and amiable bass player Simon Jones flashes an amused, well-what-are-you-going-to-do expression at the occupants of the studio ante-room. Then he starts skinning up.

Nowadays even the most paltry LP can flag itself as "long-awaited", but the one The Verve are finishing – their third – really is. Not so much because Verve patron Noel Gallagher proclaimed its

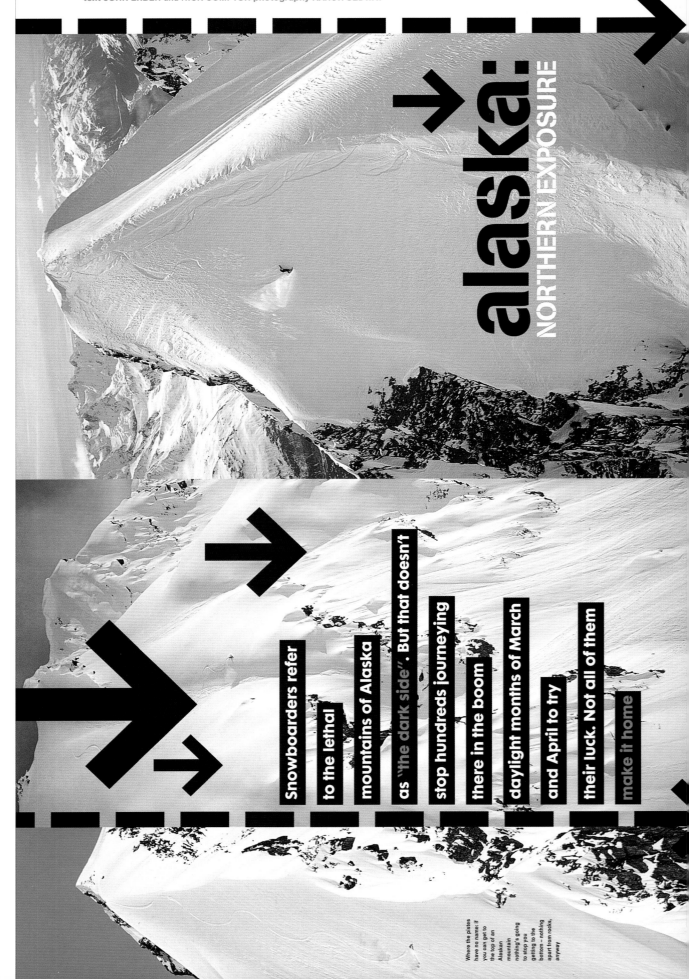

alaska:
NORTHERN EXPOSURE

Snowboarders refer to the lethal mountains of Alaska as "the dark side". But that doesn't stop hundreds journeying there in the boom daylight months of March and April to try their luck. Not all of them make it home

Where the pistes have no name: if you can get to the top of an Alaskan mountain nothing's going to stop you getting to the bottom – nothing apart from rocks, anyway

Crevasse (kre-vas), noun, a deep crack or fissure, esp in the ice of a mountain glacier. Alaskan winds often make the most deadly crevasses invisible by blowing snow bridges across them. Snowboarders don't usually get to see them — let alone leap across them

FUNNILY ENOUGH, FALLING DOWN AN ALASKAN CREVASSE ISN'T BIG ON LAUGHS. AMERICAN SNOWBOARDER MATT GOODWILL LIVED TO TELL THE TALE

It was a lower run, and me and a couple of others were cruising along. The three of us were cutting over, traversing across this nice little windlip. I was like 15 or 20 feet higher than everybody else. Next thing you know, I'm just falling. All I could see was blue and I just started kicking my board, like sideways, back and forth, and I'm definitely hitting both sides of this crevasse. It felt like I fell forever, it was like, "Oh, shit!" kicking, kicking. When I landed, I'm on this narrow spot where the crevasse pinched together. I didn't get pinched because the snow that came down beneath me kinda wedged in the crack, so I could move and my board wasn't trapped. On either side of me, the thing just dropped away forever. If I'd fallen either side from where I went in, I would have gone deep and probably gotten wedged.

Once I was down there I was like, "Whoahhh!" kind of looked around and assessed the situation, more or less. Then I hollered for like two minutes; I yelled, "Yo motherfuckers!" Then I sat there for five or ten minutes, waiting to see if somebody saw me go in. There was nothing, nothing. It was like, "OK man, here we go." So I got off my board and started cleaning the walls of the crevasse because a lot of snow got blown in there and there was like a lot of loose snow up in these little cracks. Then I started using my snowboard, hitting off big chunks of ice – like two-foot or three-foot chunks – so I wouldn't grab anything loose while I'm climbing.

As I was cleaning stuff off, I found this little crack that started thin and got wider and

Matt Goodwill interview by Jake Hauswirth

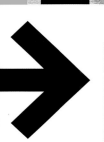

laska is the sharp end of the big country. It is dark, expensive and scary. If there's a hell below we're all gonna go, a wise man once sang. And Alaska is the place for people who can't wait to get there. Some snowboarders go there to see how bad-ass they are, but that's like lying down on the tracks to see how big the train is.

If you're lucky you'll go quickly in an avalanche or a crevasse, your friends will find your transceiver's signal and split up your gear. Large brown bears will eat your carcass so nobody has to pay for the funeral. And everything will be simple.

More likely, the weather will lock you in somewhere and you'll go slowly mad as your supplies run out. Days, maybe months later, you'll wander out 15 kilos lighter, speaking in tongues to companions nobody else can see. The press will spread cannibalism rumours about you, you'll get billed for the Coast Guard helicopter search and go broke. You'll live briefly among wild sled dogs near Chickaloon, then end up on Fourth Street in Anchorage, selling cars, crack or Jesus. Alaska is a serious proposition. But some people like that about it.

The final outpost of the New World has over half of the glaciers on the planet (covering 74,600 square kilometres) and probably more skiable areas than the rest of America combined. And the small Alaskan town of Valdez has what many people consider the best ski-terrain in the world: 1,500-metre vertical runs on treeless slopes and countless unskied, unnamed mountains. That's the kind of serious proposition that over the last six years has made Valdez into a board-bum paradise. From March to May each year they pour in from Europe and the rest of America to try their hand at the just-about-possible.

The thrill of Alaska is the rawness of it, the raw possibilities of it. It is still pioneer country, gold-rush country. It's the kind of environment where you can forego your own little chunk of history, and maybe make a small fortune. And it was a strange kind of quick-cash rush that saw the population of Valdez swell from 4,000 to 12,000 during the summer of 1989.

The *Exxon-Valdez* oil spill brought scientists, clean-up workers and the media in to the town, and the locals went about making money from them. The clean-up operation was something of a fiasco. But working long hours in the extended summer daylight, many Valdez locals made enough cash to launch their own businesses. It is no small irony that the oily profits from an environmental horror story should be the catalyst for an invasion by eco-friendly snow hippies. But history is like that. People can twist and turn it in unexpected ways.

Until the Valdez spill, the town's mountainous back-yard was only skied by hardcore locals. Oil-spill booty and frontiersman spirit would soon open it up. Frontiersmen like Chet Simmons, an old-school California surfer, who came to Alaska after flying choppers in Vietnam. He wouldn't have lasted anywhere else; maybe Australia would have suited him, but he was clearly too crazy to return home. He loves Alaska and it's probably the best place for him. Lots of Vietnam vets headed for the north-west coast of America, for the emptiness of it. And Alaska is the logical end of the road if you have that need.

During 1989, Simmons flew the clean-up workers over Prince William Sound, the site of the disaster. Another Valdez resident, Michael Cozad, used his profits of doom to buy an abandoned roadhouse on Thompson Pass Highway, the only road out of town. Tsaina Lodge sits 36 miles outside Valdez in a magnificent alpine valley where peaks rise over a mile high on all sides. It's further inland than Valdez gets clearer, cooler weather and massive snowfalls. Cozad thought Tsaina would make an excellent ski lodge and he spent months fixing up the place. Then he hooked up with Chet Simmons to fly local skiers into the Chugach Range around Thompson Pass.

Simmons and Cozad saw the potential in the place: there was indeed gold in them there hills, and Cozad's mission now was to bring Valdez to the attention of the international ski and (burgeoning) snowboard community. He pleaded with magazine editors and ski-film moguls to send people out. But no one was really interested in a remote Alaskan lodge near a town tarred as the site of an ecological nightmare.

It's easy to understand the reluctance. For all its grandeur, the area around Valdez is far ▲

For many this is the best ski-terrain in the world: 15-metre annual snowfalls, 1,500-metre verticle runs on treeless slopes and countless unskied, unnamed mountains

Snow joke: helicopters flown by Vietnam vets drop you into the heart of hostile territory. Remember: Charlie don't surf

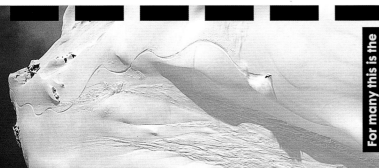

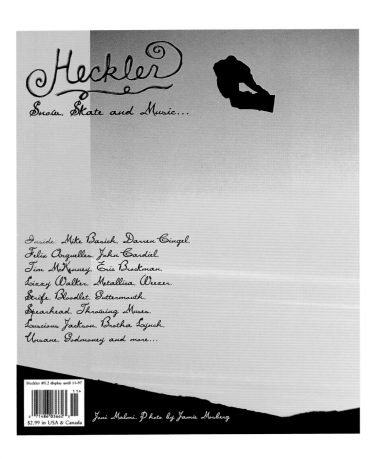

Heckler

Snow, Skate and Music...

Inside: Mike Basich, Darren Cingel,
Felix Arguelles, John Cardiel,
Tim McKenney, Eric Brockman,
Lizzy Walker, Metallica, Weezer,
Strife, Bloodlet, Guttermouth,
Spearhead, Throwing Muses,
Luscious Jackson, Brotha Lynch,
Unsane, Godmoney and more...

Heckler #5.2 display until 11-97

$2.99 in USA & Canada

Joni Malmi. Photo by Jamie Mosberg.

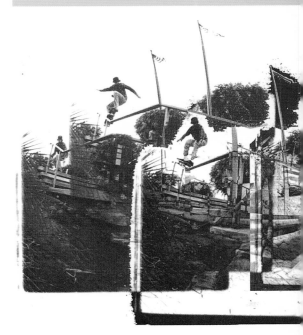

"We're all gonna have machi
guns and shit. We're all gonna
to Burnside and make the wa
hella tall, make a dome
whatever. Big guns, knife
whatever. We're gonna get rea
999 coming up—we're gonna ta
over, we're gonna skate wherev
we can. We will take machine gu
cannons— whatever, as long as
can skateboar

DARR

DESIGNER
John Baccigaluppi
ART DIRECTOR
John Baccigaluppi
DESIGN COMPANY
Heckler Magazine
COUNTRY OF ORIGIN
USA

ABOVE
ILLUSTRATOR
Jennifer Chiang
PHOTOGRAPHER
Jamie Mosberg
WORK DESCRIPTION
Cover for *Heckler* magazine
using a logo sent in by a reader
DIMENSIONS
254 x 305 mm
10 x 12 in

RIGHT
ILLUSTRATOR
Sonny Mayugba
PHOTOGRAPHER
Lance Dalgart
WORK DESCRIPTION
Spread from *Heckler* magazine
DIMENSIONS
254 x 305 mm
10 x 12 in

PAGES 84-5
DESIGNER
Ron Cameron
ART DIRECTOR
Ron Cameron
DESIGN COMPANY
RCD
ILLUSTRATOR
Ron Cameron
PHOTOGRAPHERS
Remy Stratton, Aaron Sedway,
Dave Malenfant
COUNTRY OF ORIGIN
USA

WORK DESCRIPTION
Spread from *Heckler* magazine
DIMENSIONS
254 x 305 mm
10 x 12 in

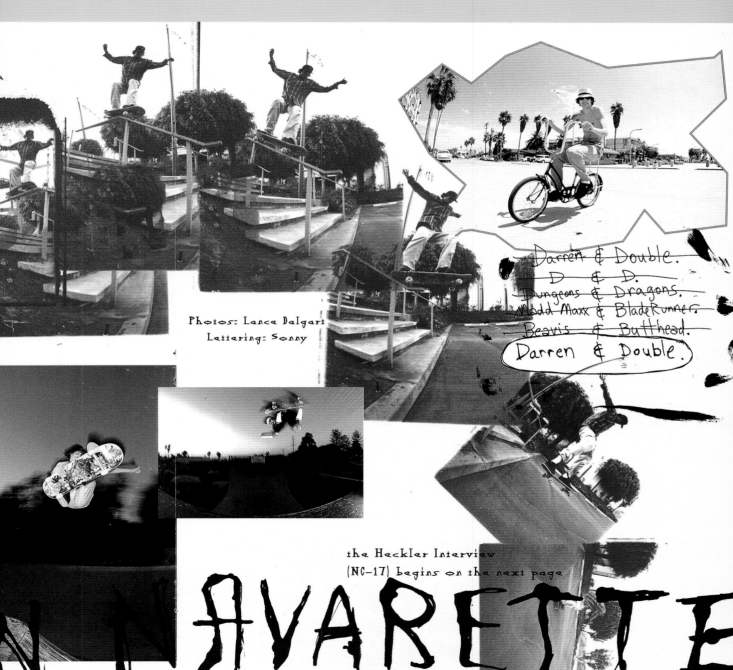

Soul Bowl. Photo: Sedway

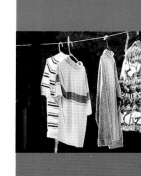

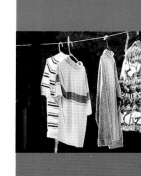

84

he just had a big elephant gun

up last summer? No, that was actually March I think. This whole year's been baffling for me I think, one of my most baffling years. **Just been doin' too much?** Way too much! Like stimulus overload! I can't even document it all...I try, I write and just to keep my sanity I drag my acoustic guitar around with me just to strum it. I try to skate, I work at Volcom, because I'm trying to get a grip on all this garbage goin' on right now. It's all great fun and it's hard to justify what's right and what's wrong. **You have to account for every second of the day.** Yeah, the second I'm awake I'm already not hungry because I have to be somewhere. **So, what have your outside interests been lately?** I've been trying to filter through all these opportunities and various stimulus', whether it's social or work or shootin' photos. I have been getting more into preparing to prepare to write and to shoot more knowing that I love it. I mean, now I can actually afford to buy good gear. I totally love shooting so much. I love playing music, I have been playing guitar for awhile now and that's just a great pass time. Ridin' bikes if I have enough time, I don't know, I try to cope. This is a high pressure area down here! I mean it's strange, you have to hold on to your sanity, physically, I go away and feel so at peace and see so clearly and then the second that I come home, like I will be home for two days and I will already be like turning into a little freak again I just have to tell myself to stay focused. **When you go away do you feel you have to prepare yourself for when you have to come home, like prepare for an attack?** Yeah, I know now that when I come home from trips I know I have a couple days off before goin' back to work. I need a few days for adjustment so that I can get back into the high paced swing of things with a clean mind. You go to these cities with such cool social vibes, full cultural cities with old archetecture and people that are people, and then you come back down here and you realize that you're dealing with Orange County which is a very unique place I think. **Orange County is only here to get business done, nothin else...** Yeah, it's dry as hell and at the same time I think that's why you get all these silicone boobs and made up girls and puffy hair-do's and expressive people that are trying to release all this pressure in some odd way. I even find myself telling younger people that this is not the way it is else where! Not really preaching, just rather enlightening people that all you have to do is take a road trip, go north, go south, go east, it's not all about... beers... bongs, boobs, babes... **As far as outside interests, do you kinda key that in to preparing for times after skateboarding?** Yeah, it seems like I have been preparing for that time to come for a few years now ever since I was working at Acme with you, ya' know? The whole reason I was working there was because... I just didn't like the direction it was going at the time...feeling like I didn't want to represent what I felt, was being represented. So I just kinda went underground and started working. I was still always skating. **You mean after I quit?** No, no I'm just talkin' about the whole political skateboard thing, just how much bullshit was goin' on with the industry and I was just like if this is the direction it's going then I'll just

does and showin his buddies, like "...ahhh, check it out boys..." I was just a pup, I'd never seen raw skateboarding before. And he was chargin' this wooden plywood quarter pipe that was well over my head and he was like pushin', pushin', running first, then jumping on his board and keep pushin' and then "Boom!"...big back side air and then come down and there was these like holes in the cement where palm trees used to be and he would just kinda ollie every one of them just like totally smooth and I was just baffled! That was like, I think when I bought some Sims B-52 wheels. First time I ever bought like brand new stuff. Before that I was into the Sims Snakes and the old Bad Company skateboards...all the big bully's in my neighborhood givin me their old gear. I don't know, I guess Neil Blender was always good, and Gator and so was Chris Miller. **Back to sponsor stuff, after those early spon-**

sors you actually got on G&S? Yeah...that was like for awhile. It's weird, I was never really into hoppin' around I guess. I mean I look back now and I think I was with G&S for almost 6 years and now it's been 6 years with Acme. I remember I got shit for riding for Acme at first 'cuz it was the first non-pro model company. I was just baffled at the fact that people would give me shit for my

In your early sponsored years, who influenced you the most or who are people that really blew your mind and that you looked up to? I remember one time I was out kite flying with my dad's kite company at Venice Beach and I saw Christian Hosoi skating with his Alva Sun board and he had a front Indy truck without any rubbers in it at all. It had a kingpin and nut on it and that was it. It had Ratbones. His front truck was rattling...he was just so solid and focused and like able to skate that

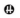

down the center of Century freeway and ends at the LAX airport. But the subway or the tram itself stops right before the airport, because the taxi's lobbied, the shuttle companies and buses lobbied that they couldn't have that because it would compete with their business. They probably payed off the government and that's the kind of bullshit that makes me want to *kill* the government! **Have you entered any contests this year?** No, with all those tours and I am working so hard for Volcom that I just didn't have the time. There are just so many contests goin' on ya know? **Are you gonna try and get in the contest mode next year?** Yeah, I think this year I'm gonna totally be on a re-rage, and work less in the office and get outside a lot more. **Do you still have any old cars or motorcycles goin'?** Yeah. I still have my Triumph sittin in the garage and I then I have a 1970 Toyota Corona Deluxe with the Toyo-glide automatic tranny. It's definately funky. **Has your hyperactivity gotten you in any trouble lately?** Yeah, I had people concerned. actually Sarge and Hill told me about a year ago that, they were concerned for me, wondering what route I was going. I was shocked. I mean I knew in the G&S days with them that like things were just super out of hand, but I just never knew people perceived me as too out of hand or mis-led. I look at kids now and I can tell their route, where they're headed. I gues they were thinking they were seeing something back then with me. Yeah, it's all relative. What is "trouble?" it's all about life's experi-inces, is it living and learning? My business card at Acme did say "the Instigator" for awhile. **What are you gonna do in the next segment of your life?** I have got a little Fender guitar's project...I don' know.... **Do you have any last statements?** Basically, I am concerned for the youth of today. 'Cuz I live in Orange County and I don't see many real constructive things goin' on. I do know that this is only one place and it's not like that everywhere. I do think that the youth should be alert for being misled by the media, the masses and the hype and everything. There is so much stimulus on T.V. and billboards and commercials. There's so much oppressive information just digging into you. You've got to watch out for yourself and use your own head these days because not everyone has good intensions out there. They're creating two classes: the brain class and the clone class who are just the pawns of society, of the chessboard. There's not one constructive T.V. show on anymore, I grew up watching the Cousteau Society and Wild Wild Kingdom and stuff like that. It's such a shame that. such a potentially wonderful tool has gone to such crap! **Any thanks?** I don't know, I'll leave too many people out. If you had a good time with me - thanks! Because I probably had a good time with you! I don't know, I mean I've met so many people through-out the globe, it's just been a crazy ride.

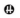

Soul Bowl (Ol-H Bowl?) Photo: Sedway

Headland. Photo: Dave Malenfant

have all these non- pro model boards and people are always saying, "Wow, Acme's cool, but how is it riding without. a board"? I think back and all these past 5 or 6 years I never once had to worry about my board sales or my graphic or my shape. It was like maintence free skateboarding. the best.

Right about the time when you quit GGS and started riding for Acme is when Mike Hill, Carter and all those guys split and did Alien Workshop isn't it? Yep, that's right. **What was goin' on there?** I mean how did they figure out who was and wasn't gonna be included with the Workshop? Well I found out that, I think this is how the story goes unless those guys were just being nice to me when telling me what they told me, but, Sarg and Hill just were sayin' that I had already been up and coming under G&S name for awhile with the advertisments that they took everybody that was kinda new and not. as focused on. Like, Rob Dyrdek, Duane Petre and Bo Turner. Which was cool with me. I mean I still love those guys to death and I was stoked for them! The Workshop rules! Those guys are cool. **Do you still talk to those guys sometimes?** Yeah. at the Tradeshows or like I'll just give em an outta the blue call once in awhile. Mike Hill refuses to go to the Tradeshows [laughs]. Mike Hill is mental! **Did you hear about his farmhouse?** Nah-uh. Last summer he bought a 10 -acre ranch house out on the outside of Dayton. Just this old house out in the middle of nowhere with a little stream 'n stuff...he's settin' up for the Apocalypse! [laughter] That rules! Is he down for visitors? Oh yeah, I went there a year and a half ago a he was completely down and he knows you, so... No, Mike's the nicest! "Good for you Mike!" [laughter] **So then you went to Acme and that's where you presently are and everything's goin' great?** Yeah! Jim's really cool 'cuz he knows I've been workin' with Volcom since I stopped working for Acme pretty much a couple years ago. and I represent Volcom really hard. He is totally cooperative, we work together. though it may not show. [Remy grabs the recorder for this brief interuption:] O.K. I just wanted to say that there is no public transportation in Orange County. There's no subways. there's no trains. There's a shitty bus system. But there's really good roads and there's lots of gridlock and traffic. I think this represents an unbalanced government where people don't vote and they don't take care of business, and the people that. *are* making the big decisions always have a big "payoff" in the back of their minds. Like, What company is gonna support. me the most. on this decision I make, and that's the decision I'm gonna make. Then Ford and GM and all these guys are gonna puy me a big. big lump because I'm not gonna house out on the outside of Orange County because. from what I believe, the Motor Companies, the Gas Companies, all these big huge companies that sell millions of cars in Orange County don't "allow" public transportation thoughts to even grow into a plan. There's

85

WORK DESCRIPTION
Covers for *Blunt* magazine
DIMENSIONS
Left: 216 x 276 mm
8⁷/₁₆ x 10¹³/₁₆ in
Below: 205 x 275 mm
8¹/₁₆ x 10¹³/₁₆ in

DESIGNER
Natas Kaupas
ART DIRECTOR
Natas Kaupas
DESIGN COMPANY
Natas Kaupas
PHOTOGRAPHER
Whitey
COUNTRY OF ORIGIN
USA

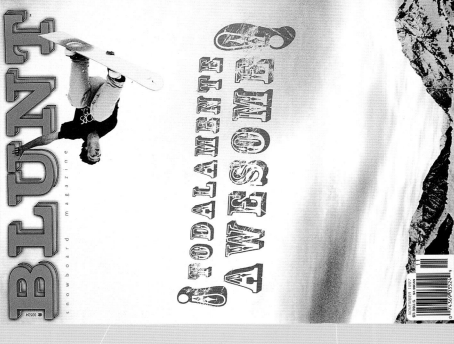

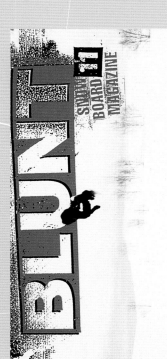

BELOW
WORK DESCRIPTION
Spread from *Blunt* magazine
DIMENSIONS
205 x 275 mm
8¹/₁₆ x 10¹³/₁₆ in

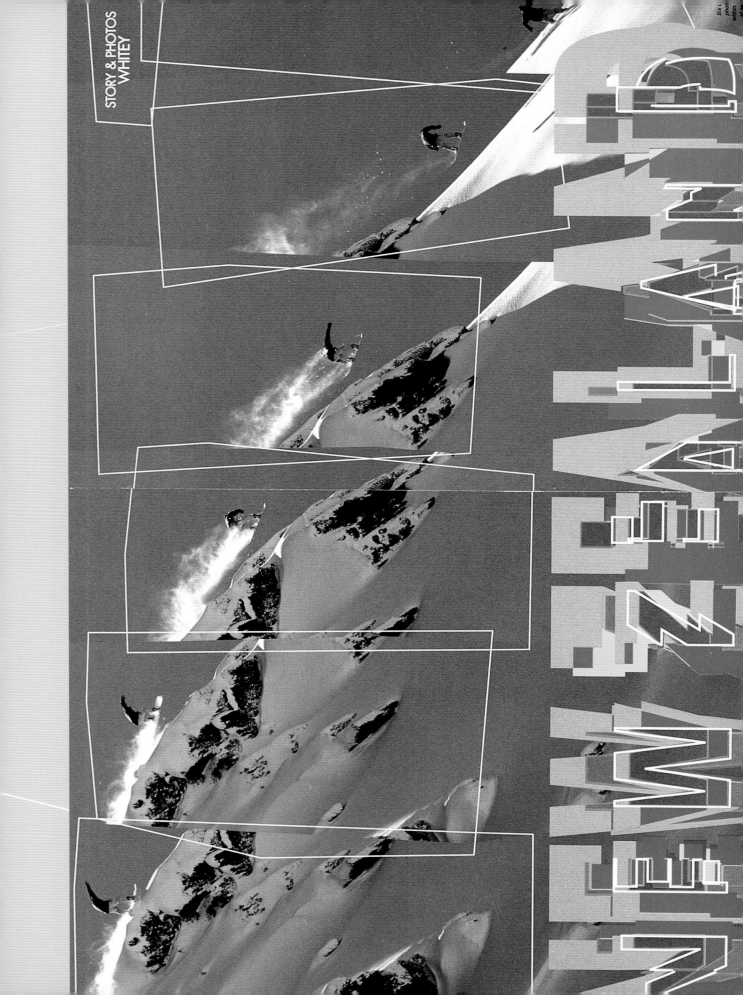

STORY & PHOTOS
WHITEY

NEW ZEALAND

Six
phot
within

ILLUSTRATOR
Ilja Sallacz (left)
PHOTOGRAPHER
Stefan Pape (below)
WORK DESCRIPTION
Cover and spreads from *ARTUR* –
a quarterly magazine on art and
culture

PAGES 88–91
DESIGNER
Ilja Sallacz
ART DIRECTOR
Ilja Sallacz
DESIGN COMPANY
Pilot
COUNTRY OF ORIGIN
Germany
DIMENSIONS
210 x 297 mm
8¼ x 11¾ in

PAGE 90
ILLUSTRATORS
Ilja Sallacz, Richard Sekules
PHOTOGRAPHER
Ilja Sallacz

PAGE 91
PHOTOGRAPHER
Sarah Winter

KARIBIKGEWITTER

EIN ... BEGLEITET VON EINER BÜHNENREIFEN WOLKENINSZENIERUNG.

FOTOGRAFIEREN? LASSEN WIR UNS BEGIESSEN.

RÜCKENLIEGEND.

DEN RUM IN DER HAND.

DIE HAVANNA IM MUND

BLICKT MAN AUF

PROXIMA CENTAURI –

NUR 4,3 LICHTJAHRE ENTFERNT –

DIE AUSSICHT GIBT ES

NUR IN DIESEN BREITENGRADEN.

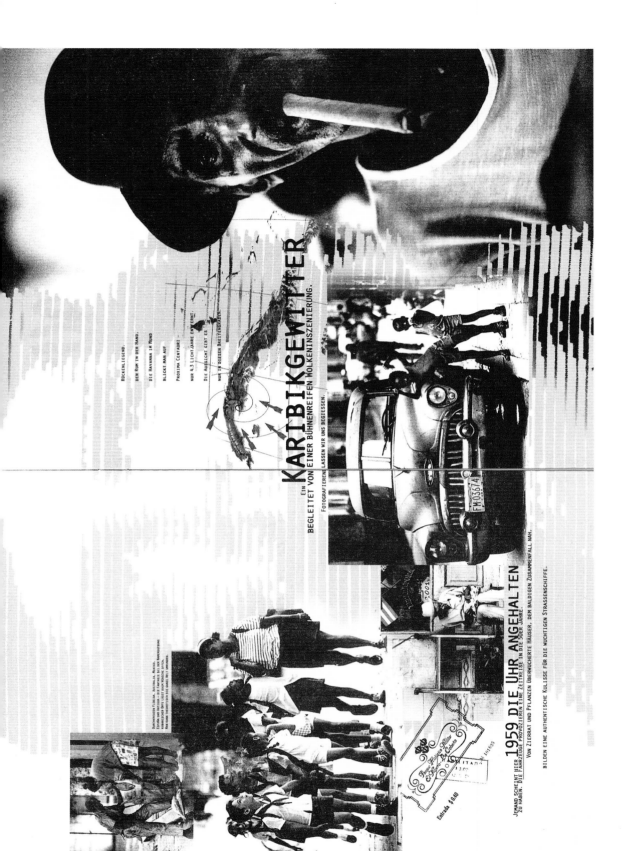

BÜHNENREIFEN FLORIDA – AUSTRALIA, MEXICO.
ESPAÑA UND ANTIGUA – DIE FANTASIE BEI DER BENENNUNG
HÄNGESCHIRR ÖFFT LÄSST KAUM WÜNSCHE OFFEN.
MAN KANN THEORETISCH DIE GANZE WELT UMRUNDEN.

1959 DIE UHR ANGEHALTEN

JEMAND SCHEINT HIER ZU HABEN. DIE FAHRZEUGE PROVOZIEREN EINE ZEITREISE IN DIE 50ER JAHRE.

VON ZIERRAT UND PFLANZEN ÜBERWUCHERTE HÄUSER, DEM BALDIGEN ZUSAMMENFALL NAH.

BILDEN EINE AUTHENTISCHE KULISSE FÜR DIE WUCHTIGEN STRASSENSCHIFFE.

HANDBUCH FÜR DIE LETZTE REISE

Ilja Sallacz Auseinandersetzung mit dem Tod öffnet neue Horizonte

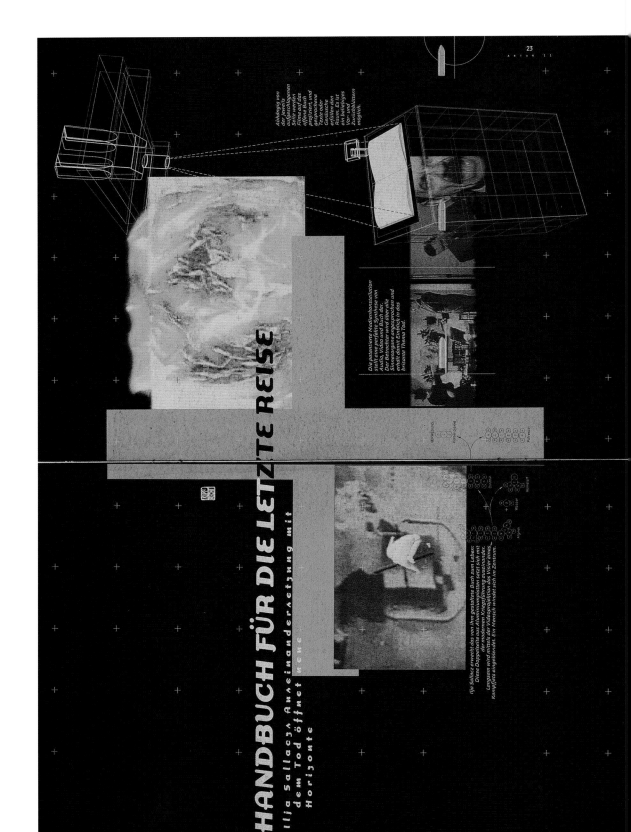

Abhängig von der jeweils aufgeschlagenen Seite werden Filme auf das offene Buch projiziert, und gesprochene Texte oder Geräusche erfüllen den Raum. Es ist ein beliebiges Vor- und Zurückblättern möglich.

Die potenzierte Medienkonstallation stellt eine perfekte Synthese von Audio, Video und Buch dar: Der Betrachter wird über alle Sinnesorgane angesprochen und erhält damit Einblick in das brisante Thema Tod.

Ilja Sallacz erweckt das von ihm gestaltete Buch zum Leben. Diese Doppelseite aus Aluminiumplatten setzt sich mit der modernen Kriegsführung auseinander. Langsam wird mittels der Videoprojektion das Visier eines Kampfjets eingeblendet. Ein Mensch windet sich im Zentrum.

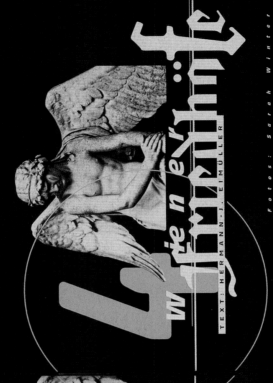

4 Wiener Friedhöfe

TEXT: HERMANN·J.EIMÜLLER

Fotos: Sarah Winter

DER ST. MARXER FRIEDHOF

Angeblich unvergessen, in Wirklichkeit längst abgeschriebene Verblichene. Das stolze Pfauenpaar zwischen halbzerfallenen Grabdenkmälern. Eine Kohlmeise, die den in ihr Reich Eingedrungenen neugierig mustert, um ihn dann, abflatternd, wieder mit den Fragmenten allein zu lassen. Ein Vormittag im St. Marxer Friedhof.

Vor der Fremdenverkehrsbranche ins drittklassige Verdorben: Alois Drobrer, gestorben im 33. Lebensjahr den 22. März 1856. Dominant indes: Herr Johann Franta, bürgerl. Kanalräumer. Landstrasse Nro. 370, gestorben den 21ten August. 46 Jahr alt, betrauert von seiner Gattin und vier Kindern. Friede seiner Asche!

Es ist nichts zu loben, nichts zu verdammen, nichts anzuklagen, aber es ist vieles lächerlich - es ist alles lächerlich, wenn man an den Tod denkt.
Thomas Bernhard

In stummer Würde bewahren flügellahme oder gar kopflose Conterngan-Engel die Mystik dieses friedenreichen Orts. Die Eitelkeit der k.u.k. Hoffriseure, der Kommerzialräte, der Eisenbahnbeamten und ihrer Erben wird unbedeutend angesichts der augenscheinlichen Vergänglichkeit: Viele Namen hat die Zeit abgeschlagen, ausgelöscht; die anderen sind längst vom Grün überwuchert. Den Rest besorgt die benachbarte Stadtautobahn mit ihrem alles übertönenden Lärm.

Und die Engel stampfen ihre Fackeln in den Boden.

IM ZENTRALFRIEDHOF

Die Ehrengräber den Herdentouristen überlassend, zieht es mich heute zu den Normalsterblichen. Deutlich sichtbar: das braune Erbe Österreichs. Eine Gedenktafel mit Eisernem Kreuz und zwei ovalen Fotografien: der Vater Hauptwachtmeister bei der Schutzpolizei, SS-Schütze sein Sohn. Beide im Osten gefallen. Ich gehe weiter.

Vom Mittags-Sonnenlicht umspielt: der Messias. Mit offener Gebärde für die Mühselig-Beladenen. Aber Hände zum Segnen besitzt er keine mehr. Sie sind dem Rebben Jeschua im Verlauf des jüngsten Pogroms abgeschlagen worden.

Nördlich der Zentralfriedhofskirche befinden sich die Reihengräber der Roten Armee. Zwei markige Soldatenfiguren auf steinerner Wacht. Inmitten der Anlage steht ein Obelisk mit dem Sowjetstern an seiner Spitze. Die Genossen Offiziere liegen separat, abseits der Mannschaftsmassen. Selbst post mortem sind manche um einige Grade gleicher.

Unter Alleebäumen weiter. Links ein

Feld mit Armengräbern. Da ein einfaches Kreuz im Rasen (der Name mit Hand aufgepinselt), dort ein Metallschild. Eine Strecke weiter ist vom Kreuz nur noch ein morscher Längsbalken übriggeblieben.

Dann die Widnis der (alten) israelitischen Abteilung.

Sie macht beklommen. Umgestürzte Denkmäler, offene Gatter vor zerstörten Mausoleen, überwachsene Gräber: Friedhofsdschungel. Bei etlichen Stellen ist ein Durchkommen nicht mehr zu denken. Selten begegnet einem hier ein Mensch.
Die Inschriften zeugen vom liebevoll pathetischen Anteilnehmen gutbürgerlicher Wiener am Ableben des edlsten Charakters, der zärtlichsten Gattin, der aufopferndsten Mutter, des sonnigsten Gemüts. Den

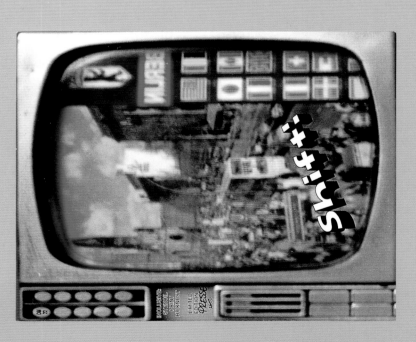

DESIGNERS
Anja Lutz (above left)
Neil Gardiner (above right)
Rik Bas Backer (below)
Martijn Oostra (pages 94–5)
ART DIRECTOR
Anja Lutz
DESIGN COMPANY
Shift!

COUNTRY OF ORIGIN
Germany
WORK DESCRIPTION
Cover (above left) and
spreads from *Shift!* magazine –
about a Berlin co-operative
design project involving ten
international designers and
artists
DIMENSIONS
210 x 260 mm
8⅜ x 10¼ in

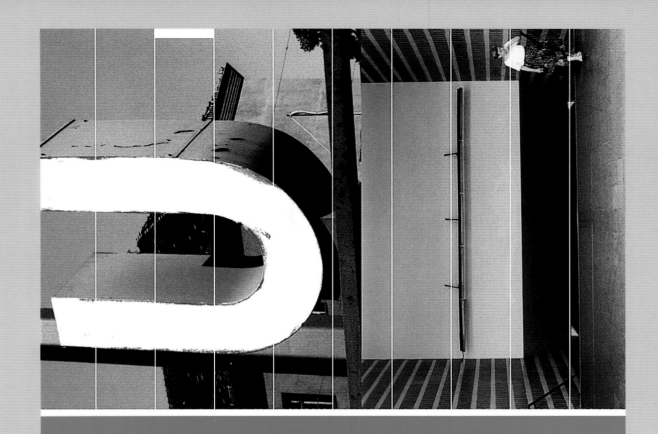

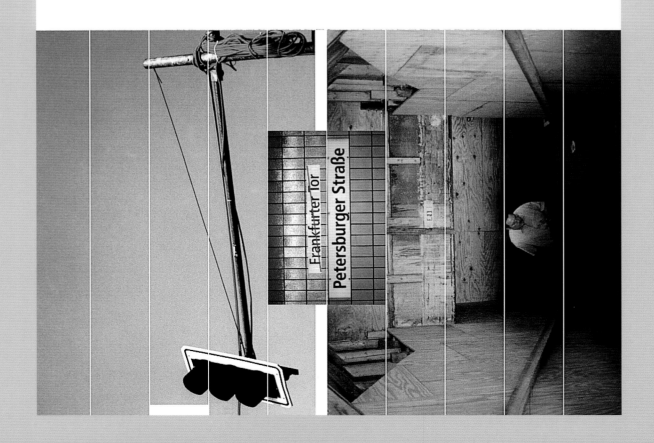

Frankfurter Tor

Petersburger Straße

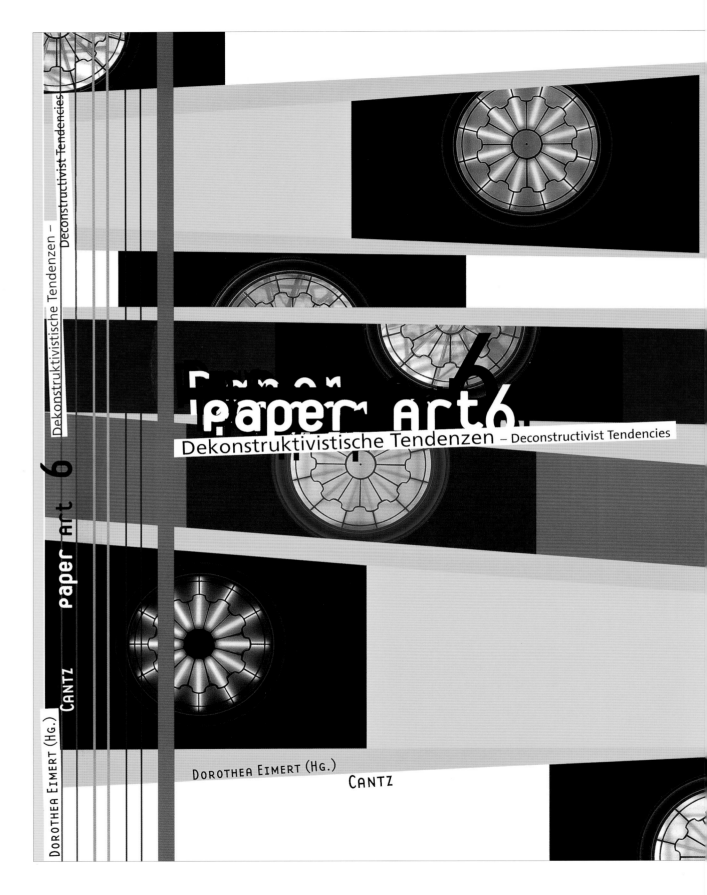

paper art 6.
Dekonstruktivistische Tendenzen – Deconstructivist Tendencies

Dorothea Eimert (Hg.)

Cantz

Emory University, Atlanta, Georgia

Das Center for the Arts der Emory University ist ein deutliches Zeichen für Atlantas kulturellen Elan. Das Center beherbergt vier große Aufführungssäle und ist als nationales und internationales Zentrum für Stipendiumprojekte und Aufführungen in den Bereichen Theater, Musik und Film vorgesehen. Während es vorwiegend für die Ausbildung von Studenten in diesen Disziplinen gedacht ist, wird das Center for the Arts doch zwei Zielgruppen dienen: dem Emory Campus und der größeren Gemeinde.

In diesem neuen Center werden Studenten und Lehrkörper eng kooperieren können. In einem einzigen, sorgfältig gegliederten Gebäude wird so die fruchtbare Zusammenarbeit zwischen den verschiedenen Künsten ermöglicht, und dies zu einer Zeit, in der sich die einzelnen Disziplinen sehr stark gegenseitig beeinflussen und inspirieren – wie es bei Performance, zeitgenössischer Musik und Videokunst bereits der Fall ist.

Das Center stellt eine Verbindung zwischen der Gemeinde und der Universität her, sowohl durch gemeindeorientierte Aufführungen als auch durch seine Lage am Rand des Campus, die eine natürliche Eingangssituation bildet. Das Center schließt auf der einen Seite an ein bereits existierendes mehrstöckiges Garagengebäude an und richtet seine Hauptsäume zu einem natürli-

chem Hügel hin aus. Eine Promenade führt über den Hügel durch die Lobby des Gebäudes hin zu einem offenen Amphitheater und zu einem Skulpturengarten. Diese wiederum erstrecken sich über einen der vielen Gräben des Campus bis zum Kunstmuseum der Universität, das an dem historischen, von Hornbostel gestalteten quadratischen Platz liegt.

Der historische Platz basiert auf einem Schachbrettmuster, das, wenn man es bis zum Center verlängern würde, theoretisch von der Topographie der Gräben deformiert werden würde. Diese anfängliche Deformation entwickelt sich zu fünf Wellen, ähnlich der der musikalischen Harmonik zugrundeliegenden Sinuskurve. Die Sinuswelle ähnelt in Amplitude und Frequenz der Topographie der Gräben. Diese harmonischen Wellen pressen die gebäudeblöcke des Centers zusammen und ziehen sie auseinander, indem sie sie in eine Vielzahl von Konfigurationen einbeziehen.

The Center for the Arts at Emory University is an active expression of Atlanta's cultural momentum. The Center accommodates four major performance spaces, and is designed to be a national and international center for scholarship and performance in the creative fields of theater, music, and film. While its primary purpose will be to teach and train students in these fields, the Center will serve two constituencies: the Emory campus and the larger community.

In the new Center, students and faculty will be able to converge in a single, carefully articulated building that facilitates rich collaboration between different creative disciplines, which is particularly important at a time when the arts draw increasingly upon each other for inspiration, as is the case with performance art, contemporary music, and video art.

The Center's location at the edge of the campus places it in a position to serve as a

connection between the community and the University, both through community-oriented performances, and by physically providing a natural point of entry to the campus. The Center envelops an existing multiple-level garage structure on one side, and projects its main spaces onto a natural knoll. A promenade crosses the knoll and passes through the building lobby to arrive at an open amphitheater and sculpture garden. These in turn pass over one of the campus' many ravines, leading to the University art museum on the historical Hornbostel-designed quadrangle.

The historical quadrangle is based on a grid system which, when extended to the Center's site, is hypothetically deformed by the topography of the ravine. This initial deformation approximates the five lines of a fundamental sine wave in musical harmonics; the wave is similar in amplitude and frequency to the ravine topography. These harmonic waves compress and extend the continuous surfaces of the Center's four main building bars, folding them in a multiplicity of configurations.

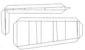

PAPER ART 6 1996/97 PETER EISENMAN 137

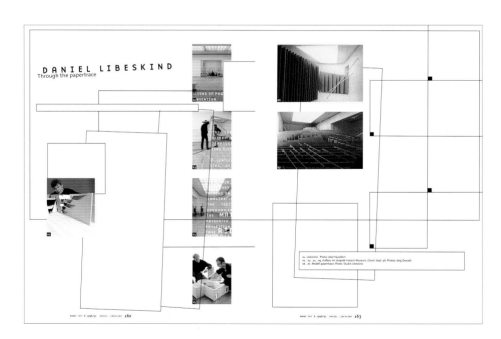

DANIEL LIBESKIND
Through the papertrace

PAPER ART 6 1996/97 DANIEL LIBESKIND 162
PAPER ART 6 1996/97 DANIEL LIBESKIND 163

DESIGNERS
Jens D. Auhage, Markus Aust,
Dmitri Broida, Jörg Oswald

ART DIRECTOR
Jens D. Auhage

DESIGN COMPANY
Televisor

PHOTOGRAPHERS
Jörg Oswald, Dick Frank Studio,
Abe Frajndlich, Studio Libeskind

COUNTRY OF ORIGIN
Germany

WORK DESCRIPTION
Front cover and spreads from a
catalog for an exhibition 'Paper
Art 6 – Deconstructivist
Tendencies'

DIMENSIONS
200 x 270 mm
7⅞ x 10⅝ in

DESIGNER
Resa Blatman
ART DIRECTORS
Resa Blatman, Steven Cooley
DESIGN COMPANY
Bella Design
COUNTRY OF ORIGIN
USA

BELOW
ILLUSTRATOR
Resa Blatman
PHOTOGRAPHER
Tony Stone Images
WORK DESCRIPTION
Book cover for *Love Enter*
DIMENSIONS
140 x 213 mm
5½ x 8⅜ in

OPPOSITE
ILLUSTRATOR
Resa Blatman
PHOTOGRAPHER
Stefan Cooke
WORK DESCRIPTION
Book covers for *The Book of Yaak* (above) and *The Lost Grizzlies* (below)
DIMENSIONS
140 x 229 mm
5½ x 9 in

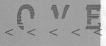

A *New York Times* Notable Book of the Year

Winner of the *Los Angeles Times* Book Prize for First Fiction, Paul Kafka's sparkling novel is a bittersweet romance for the cyberspace age. Intern Dan Schoenfeld, delivering babies in a Louisiana hospital, seizes the moments between dramatic births to tap out ardent e-mail messages (password "LOVE") to the friends he loved and lost five years earlier in Paris. With his plump, outrageous friend Beck he shared a ramshackle garret and the friendship of Margot and Bou, two women who happened to be in love with each other. For a brief, enchanted time, the foursome reveled in the bohemian splendor of the City of Light, until old-fashioned jealousies intervened. Now connected to his friends only through the Internet, Dan conjures up the rapture and heartbreak of their days together, when love entered their lives as innocent as a newborn baby.

PAUL KAFKA grew up in Bethesda, Maryland, graduated from Harvard College, and received his doctorate in English literature from the University of Denver. He has been a member of modern dance companies in the United States and Paris. A distant relative of Franz Kafka, he lives in Boston.

"Original and moving"
— *New York Times Book Review*

"An e-epistolary novel that mingles hearts and smarts"
— *Los Angeles Times Book Review*

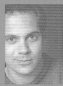

Fiction / $12.00

LOVE.ENTER

"As multilayered as a napoleon, as bittersweet as absinthe"
— *Washington Post Book World*

"Stunning"
— *Newsday*

A NOVEL

PAUL.KAFKA

LOVE.ENTE

PAUL.KAF

WINNER OF THE *LOS ANGELES TIMES* BOOK PRIZE FOR FIRST FICTION

ISBN 0-395-86001-6

9 780395 860014

90000

0697 / 6-81048

Cover design: Resa Blatman
Cover photograph: © Tony Stone Images
Author photograph: © Linda Krikorian

MARINER BOOKS / HOUGHTON MIFFLIN COMPANY

MARINER BOOKS

MARINER B

THE BOOK OF YAAK

RICK BASS

"It would be difficult not to feel a passion for the Yaak Valley equivalent to Rick Bass's after reading this extraordinary, lyrical, and powerful testimonial." — George Plimpton

Nature / $12.00

RICK BASS

THE BOOK OF YAAK

MARINER BOOKS

The Yaak Valley of northwestern Montana is one of the last great wild places in the United States, a land of black bears and grizzlies, wolves and coyotes, bald and golden eagles, wolverine, lynx, marten, fisher, elk, and even a handful of humans. It is a land of magic, but its magic may not be enough to save it from the forces that now threaten it. The Yaak does have one trick up its sleeve, however — a writer to give it voice. In Winter Rick Bass portrayed the wonder of living in the valley. In The Book of Yaak he captures the soul of the valley itself, and he shows how, if places like the Yaak are lost, so too will be the human riches of mystery and imagination.

Bass has never been a writer to hold back, but The Book of Yaak is his most passionate book yet, a dramatic narrative of a man fighting to defend the place he loves.

Rick Bass is the author of eleven books, fiction and nonfiction, including Winter, Oil Notes, In the Loyal Mountains, and The Lost Grizzlies. His short stories have appeared in a wide range of periodicals and anthologies. He lives with his family on a remote ranch in the Yaak Valley.

ISBN 0-395-87746-6

90000

0997 / 6-81198

Cover design: Resa Blatman
Cover photograph: © Stefan Cooke

9 780395 877463

MARINER BOOKS / HOUGHTON MIFFLIN COMPANY

THE LOST GRIZZLIES

[a search for survivors in the wilderness of colorado]

RICK BASS

An adventure quest in "places, interior and exterior, that exist just beyond the bounds of civilization" — Joe Kane, SAN FRANCISCO CHRONICLE

Nature / $13.00

RICK BASS

THE LOST GRIZZLIES

MARINER BOOKS

Do grizzly bears still wander the San Juan Mountains of Colorado, where they have long been considered extinct? Rick Bass, along with veteran grizzly expert Doug Peacock and biologist Dennis Sizemore, search for proof — a claw mark on a tree, a tuft of fur, bear tracks — that the grizzly, though elusive, still exists in this mountain wilderness. With the exhilarating insight for which he is known, Rick Bass describes the dangers and clues on the trail of the grizzly, the mystery and beauty of the animal, and the courage and hope at the heart of the search. The Lost Grizzlies is more than a foray into deep wilderness. It is, ultimately, a search for our lost, true selves.

Rick Bass is the author of ten books, including The Book of Yaak, In the Loyal Mountains, and Winter. His stories have appeared in The Paris Review, Esquire, The Quarterly, and other periodicals and have been widely anthologized. He lives with his family on a remote ranch in northern Montana.

ISBN 0-395-85700-7

90000

0797 / 6-81244

Cover design: Resa Blatman
Cover photograph: Stefan Cooke

9 780395 857007

MARINER BOOKS / HOUGHTON MIFFLIN COMPANY

DESIGNER
Karen Wilks

ART DIRECTOR
Karen Wilks

DESIGN COMPANY
Karen Wilks Associates

COUNTRY OF ORIGIN
UK

WORK DESCRIPTION
Spreads and section openers
from *The Guinness Book of
Records 1998*

DIMENSIONS
220 x 297 mm
8⅝ x 11¾ in

PHOTOGRAPHERS
Creepy crawlies:
Natural History Museum,
Andrew Syred/
Science Photo Library
Earth opener:
Frank Zullo/
Science Photo Library,
NASA/Corbis,
Jonathan Blair/Corbis,
Tom Bean/Corbis,
Robert Dowling/Corbis,
NASA/Rex Features,
Salaber/Liaison/
Frank Spooner Pictures,
Warren Faidley/
Oxford Scientific Films,
Richard Packwood/
Oxford Scientific Films

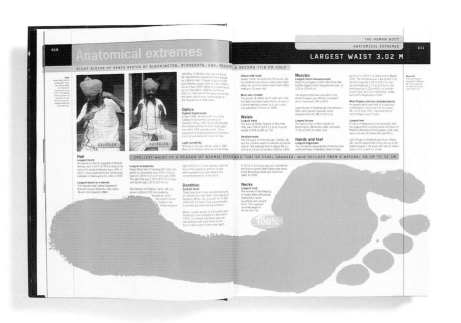

PHOTOGRAPHERS
Anatomical extremes:
Santosh Basak/Gamma/
Frank Spooner Pictures
Society opener: Rex Features,
Dan Lamont/Corbis,
David Wells/Corbis,
Morton Beebe-S.F./Corbis,
Adam Woolfitt/Corbis,
Hulton Getty,
The National Archives/Corbis,
Jim Preston/Rex Features,
Bettmann/UPI/Corbis

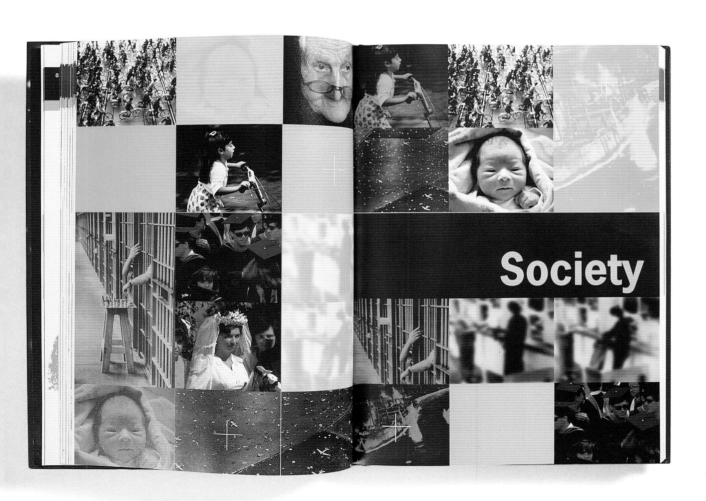

Society

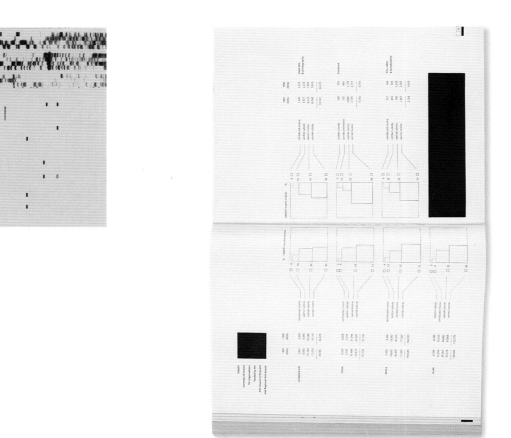

DESIGNERS
Louise Hill, Justy Phillips,
(London College of Printing)
COUNTRY OF ORIGIN
UK
WORK DESCRIPTION
Exam brief: to design an annual
report for the Arts Council
DIMENSIONS
297 x 230 mm
11¾ x 9 in

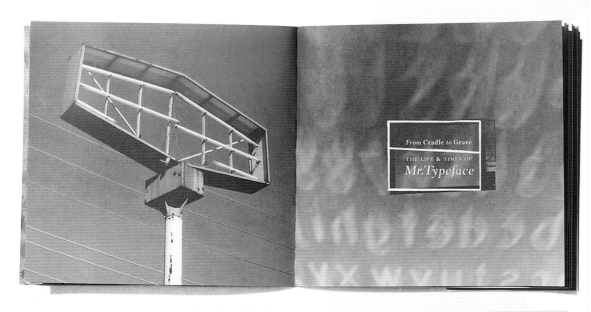

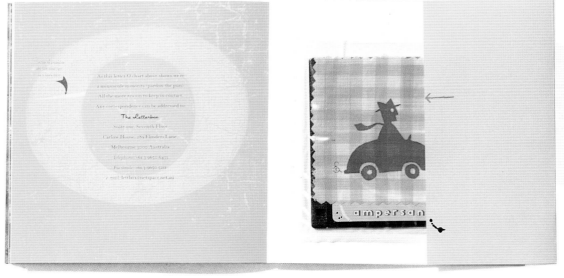

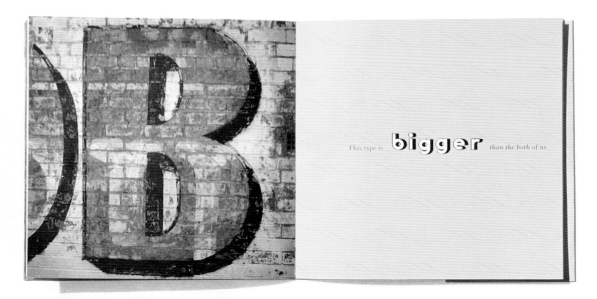

This type is **bigger** than the both of us

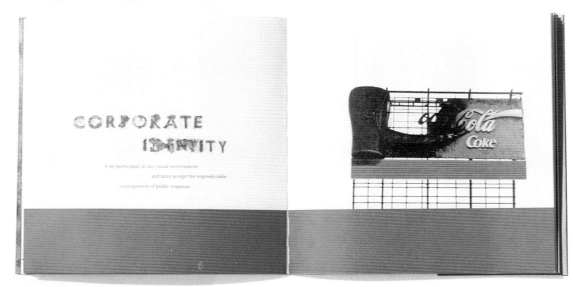

CORPORATE
IDENTITY

is an participant in our visual environment
and must accept the unpredictable
consequences of public response.

DESIGNER
Stephen Banham
ART DIRECTOR
Stephen Banham
DESIGN COMPANY
The Letterbox
ILLUSTRATOR
Sonia Kretschmar
PHOTOGRAPHERS
**David Sterry, Reimund Zunde,
Arunas, Gavin Liddle**
COUNTRY OF ORIGIN
Australia
WORK DESCRIPTION
**Transparent plastic box
(opposite, top) and spreads
from *ampersand* – a book on
Australian type culture**
DIMENSIONS
**145 x 145 mm
5¾ x 5¾ in**

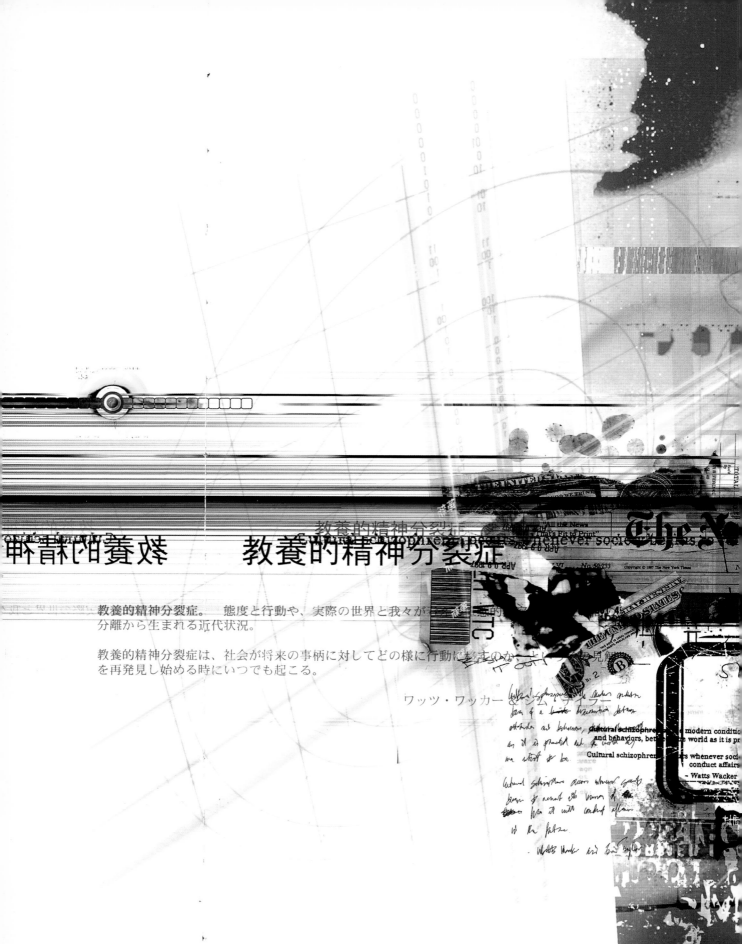

教養的精神分裂症

教養的精神分裂症。 態度と行動や、実際の世界と我々が□□□□
分離から生まれる近代状況。

教養的精神分裂症は、社会が将来の事柄に対してどの様に行動に移すのか□□□□
を再発見し始める時にいつでも起こる。

ワッツ・ワッカー

Cultural schizophren□ □□rs whenever soci□
conduct affairs

— Watts Wacker

SKITSOFRI.NIA

Cultural schizophrenia occurs whenever society begins to reinvent its vision

how it will conduct affairs in the future.

designed for pleasure

*pocket money on a Friday, spent on a Saturday, a week of childhood
or an early introduction to the visually exciting use of
letters, pictures, colours, shapes, textures & movement?*

PAGES 106–7
DESIGNER
Simon Dixon
ART DIRECTOR
Simon Dixon
DESIGN COMPANY
The Attik
COUNTRY OF ORIGIN
UK

PAGE 108
DESIGNER
Neil Carter
ART DIRECTOR
Neil Carter
DESIGN COMPANY
The Attik
PHOTOGRAPHER
Neil Carter

PAGE 109
DESIGNER
The Attik
ART DIRECTOR
The Attik
DESIGN COMPANY
The Attik

WORK DESCRIPTION
Spreads from *Noise 3* – a
promotional book highlighting
personal and client work by
Attik designers
DIMENSIONS
220 x 320 mm
8⅝ x 12⅝ in

DESIGNER
Aporva Baxi
ART DIRECTOR
Aporva Baxi
DESIGN COMPANY
The Attik
COUNTRY OF ORIGIN
UK
WORK DESCRIPTION
Poster for the film *Face* for
United International Pictures
DIMENSIONS
Various

PAGES 111-13
DESIGNER
Bob Aufuldish
DESIGN COMPANY
Aufuldish & Warinner
ICON EMBLEM DESIGNER
Mark Fox, Blackdog
COUNTRY OF ORIGIN
USA

WORK DESCRIPTION
Front cover (right) and spreads
from a catalog for 'Icons: magnets
of meaning' – an exhibition at San
Francisco Museum of Modern Art;
the counterforms of the typeface
Avenir were removed to slow down
the reader, focusing their attention
on the text as object
DIMENSIONS
152 x 229 mm
6 x 9 in

Originally, it was a religious artifact whose subject and style were prescribed by tradition.

These conventional forms could bring abstract beings or ideas into a recognizable shape. Famous people or things can also become icons, as the Statue of Liberty or Abraham Lincoln have done.[1] Part of our twentieth-century loss of faith has been a loss of the kind of icons that are unapproachable, semidivine apparitions, and yet icons are all around us. The paradox this exhibition addresses is that some of the most normal, run-of-the-mill objects we use in the United States have become iconic. A surfboard, a mixer, or a building can become iconic. The simplest object, through both use and design, can take on tremendous importance in our world. It can become a carrier of meanings that allows us to see within its

simple shapes much larger structures. Icons of everyday use are haunted by a long tradition by which mute objects are imbued with meaning, as well as by over a century of modernist design that has sought to make the perfect form.

Icons are the haunted objects of modern design.[2]

We usually think of icons as either religious artifacts or representations that do not merely stand for one thing but condense into a visible form a much larger idea. Thus icons are objects that present the unpresentable. They put into a physical form a force that we cannot otherwise see, whether it is a divinity or the mysterious working of a computer that we control through a little icon on our screen. The icon is a symbol in a material form, an object of adoration, and a fetish, and in all of these ways it creates something we can see that condenses and makes physical the invisible or unnameable forces that control our world. It is an object of art, use, and mystery all at the same time.

It is important to realize that icons are made, not born. They are repositories of meaning or carriers of import in which something remains. What makes something into an icon varies from time to time and from place to place. It used to be religion or myth, but these days it is as often as not advertising or corporate public relations. That does not mean that icons

FREE WAYS

ICONIC

FOUNDATIONS

previous pages:

LUXOR HOTEL, LAS VEGAS, 1995, MARILYN BRIDGES

Bridges photographed the hotel from the air, showing the sphinx that both guards the hotel's entrance and indicates the iconography that the abstract shape of the building lacks. The area to the right is now occupied by a two-thousand-room addition.

ATLANTIS HOTEL MODEL, 1993, ANTOINE PREDOCK

Predock's entry in a competition to design a one-billion-dollar casino in Las Vegas proposed to resurrect the mythical world of Atlantis as an iceberg-vertex rising out of the desert. A different design for the casino is to be constructed.

FISH LAMP, 1984, FRANK GEHRY

This object was commissioned by Formica Corporation to explore the potential of its Colorcore product. The form of the lamp supposedly came about when Gehry threw the pieces of this integrally colored laminate to the ground in frustration and found that the pieces looked like a fish, his emblem of perfection and a memory from his youth.

right top:

STANDARD STATION, AMARILLO, TEXAS, 1963, ED RUSCHA

This image is part of a series in which Ruscha obsessively redrew a gas station—with a perspective reminiscent of that of the Twentieth Century Fox logo—before creating one painting that shows it on fire.

right bottom:

LUXOR HOTEL ATRIUM, 1996, VELDON SIMPSON

For the first four years of the hotel's existence, its main interior space (more than 100,000 square feet of gambling) was taken up by stage sets that housed high-tech rides exploring visions of the past, present, and future. Their stories offered justification for the hotel's strange appearance.

PAGE 114

DESIGNERS
Tamar Cohen, David Slatoff

ART DIRECTORS
Tamar Cohen, David Slatoff

DESIGN COMPANY
Slatoff + Cohen Partners Inc.

PHOTOGRAPHER
Tom Collicott

COUNTRY OF ORIGIN
USA

WORK DESCRIPTION
Book cover for *The Anatomy Lesson* published by St Martin's Press

DIMENSIONS
143 x 215 mm
5⅝ x 8½ in

The Anatomy Lesson

a novel

FIG. 19

Simple Cross of the Chin.

TINCT FERPER

CEREBRUM or BRAIN

Wonders of ... the eye is ...
ell as delicate, ... body. It is ...
eart, mind and so... shines. Sorro...
or pleasure, sunshine ... shadow are reflecte...
a of light; the human passions hold their
... and love dance their happy and joyous
... curtain; and through it accurate del...

DEFPOTEC

LEFODPCT

FDPLTCEO

M E

FIG. 16.

Cross of the Eyes.

Morley is one of those rare
ravelers who manages truly
o enter the heart of a foreign
erritory"—Anne Tyler, *The New
ork Times Book Review* on
ictures from the Water Trade

John David Morley

author of *The Feast of Fools*

Zoetrope

All Story

Arthur C. Clarke Sylvia Foley Philip Gourevitch Curt Leviant
Jim Lewis Phillip Lopate Javier Marías Lucia Nevai Natasha Waxman

When God Dips His Love in My Heart

by Jim Lewis

The wind off the water bent the tall grass by the side of the highway. There was a black pick-up truck behind Dr. Thayer; it pulled into the left lane and passed, then it pulled back in front of him and slowed so suddenly that he had to step abruptly on the brake and almost dropped his telephone receiver into his lap. If the sky was clear then the hills weren't burning. Goddamn, he said out loud, and his secretary, who was waiting on the other end of the line for him to acknowledge the next day's appointments, paused for a second and said, Excuse me? He passed a fruit stand by the side of the road. The windows of the truck were tinted the color of the ocean: green, gray, ultramarine. > page 3

DESIGNERS
Tamar Cohen, David Slatoff
ART DIRECTORS
Tamar Cohen, David Slatoff
DESIGN COMPANY
Slatoff + Cohen Partners Inc.
ILLUSTRATOR
David Plunkert (below)
PHOTOGRAPHERS
Nola Lopez (left),
Geoff Spear (below)
COUNTRY OF ORIGIN
USA
WORK DESCRIPTION
Front cover and spreads
for *Zoetrope*, a short fiction
magazine published by
filmmaker, Francis Ford Coppola
DIMENSIONS
267 x 355 mm
10½ x 14 in

115

WORK DESCRIPTION
Back cover (bottom, left) and
spreads from *Things That
Quicken the Heart* – a collection
of short fiction by California-
based artists and writers,
edited by Soo Jin Kim

DIMENSIONS
114 x 140 mm
4½ x 5½ in

DESIGNER
Michael Worthington

ART DIRECTOR
Michael Worthington

DESIGN COMPANY
Worthington Design,
Los Angeles

PHOTOGRAPHER
Michael Worthington

COUNTRY OF ORIGIN
USA

"Question?"

"When you start adding them up they make quite a collection, don't they?

What did you see that night?

Watch for what?

She asked me why I looked so sad?

How did she escape?

"Are you busy?"

"fine?"

why did you leave me alone?

Why do I feel so at home on such precarious, uncharted terrain?

"WHAT TO DO?"

"WHAT HAPPENED?"

"WHAT DO YOU WANT TO DO?"

How did you imagine your escape?

Murder isn't it?

Do we know each other?

How could you forget something like that?

Do we ever know where history is really made?

What would it tell her?

Do you want it?

Honey, do you mind if we make love later?

Why can't I find one in New York?

Why oh why is the world such a cruel place?

Who were all these unknown admirers who wanted to meet her?

Was it beautiful the first time you heard it?

"Yeah and have you ever thought that maybe I'm not one of them."

"are you two always like this?"

"Did you feel that?"

"HUH?"

MILK TOKEN
LETTERS FROM G
BUNNY
DOLPHIN RING
BUBBLE GUM
EYELASHES
KISS MINT
BALLOON ANIMAL
STARS AT NIGHT

117

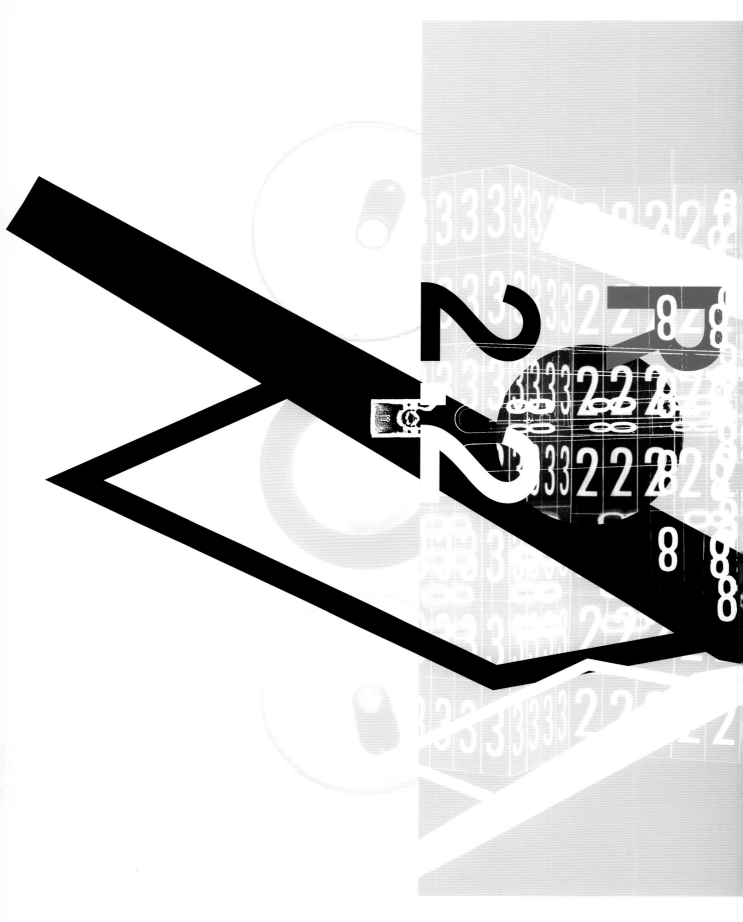

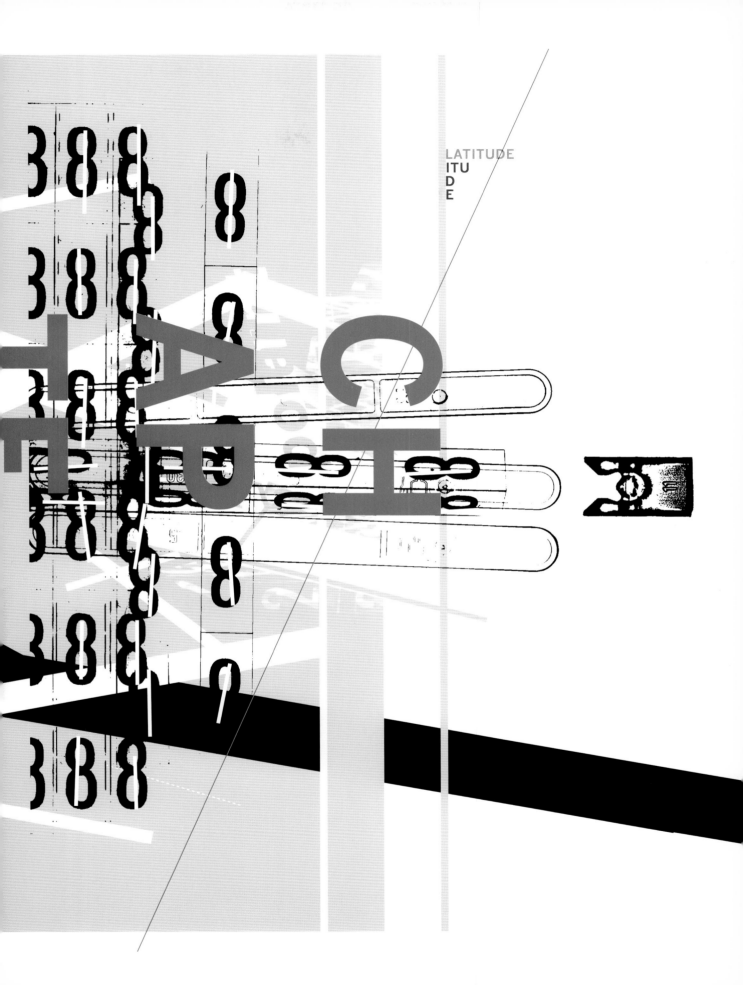

LATITUDE
ITU
D
E

DESIGNER
Mark Caylor
ART DIRECTOR
Mark Caylor
DESIGN COMPANY
Stylorouge
ILLUSTRATOR
Mark Caylor
COUNTRY OF ORIGIN
UK
WORK DESCRIPTION
Covers for the Mundy album
l mn e.p. 1 (left), and single
To you I Bestow (opposite)
DIMENSIONS
Various

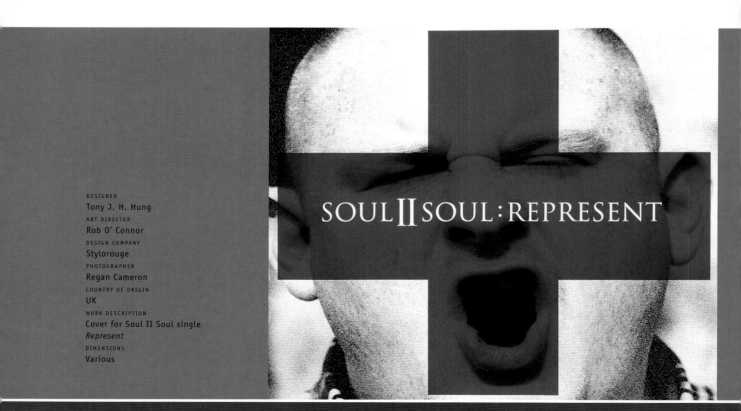

DESIGNER
Tony J. H. Hung
ART DIRECTOR
Rob O' Connor
DESIGN COMPANY
Stylorouge
PHOTOGRAPHER
Regan Cameron
COUNTRY OF ORIGIN
UK
WORK DESCRIPTION
Cover for Soul II Soul single
Represent
DIMENSIONS
Various

SOUL II SOUL : REPRESENT

To You I Bestow

One last night in bed for a time. Two more wishes and both are for thine. So I give you the stars from the bruised evening sky. And a crown of jewels for your head now.

mundy

For the first time in my life
I know how I want to go
Spin through the warm air
To a thousand feet below
The top of the world's the place
Where the canyons fall below
And you can see from there
To the depths of your soul

I'm not there yet
Not weak enough yet
I'll keep paying my bills
If this is as hard as it gets
On top of the world
On top of the world

Walk up to the edge
And the silence fills your head
You'll find right there
If you will lead or just be led

I'm not there yet
Not weak enough yet
Don't flatter me now
If this is as hard as it gets
On top of the world
On top of the world

I'm not there yet
Not weak enough yet
Don't forgive all my sins
If this is as hard as it gets

I'm not there yet
Not weak enough yet
Keep my name in your book
If this is as hard as it gets
On top of the world
On top of the world

TOP OF THE WORLD

You live your life like it's on rails
No choice where you go, you're on rails

We stumble through
And I think I am linked up to you
'Cos I can never think of you without this sorrow

You live your life like it's on rails
No choice where you go, you're on rails

What can you do
In the face of all your dreams
When your destination's never where it seemed, where it se...

We like to think that we choose our fortune
Like spinning a wheel
But with leaves on the track you tell me
How does it feel?

You live your life like it's on rails
No choice where you go, you're on rails

You live your life like it's on rails
No choice where you go, you're on rails

You live your life like it's on rails

← RAILS

DESIGNER
Carl Rush
ART DIRECTOR
Carl Rush
DESIGN COMPANY
Stylorouge
ILLUSTRATOR
Blaise Thompson
COUNTRY OF ORIGIN
UK
WORK DESCRIPTION
CD booklet cover, (right),
booklet spreads (above and
above right), and CD box back
cover (far right) from the Jesus
Jones album *Already*
DIMENSIONS
120 x 118 mm
4¾ x 4⅝ in

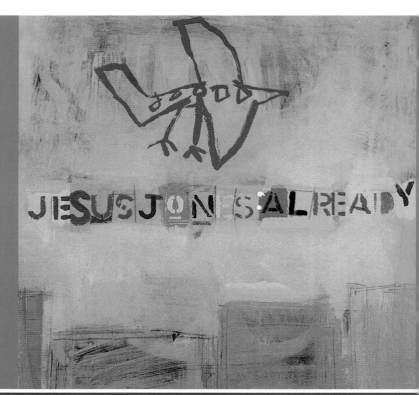

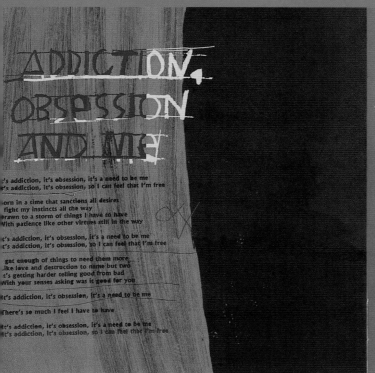

ADDICTION, OBSESSION AND ME

It's addiction, it's obsession, it's a need to be me
It's addiction, it's obsession, so I can feel that I'm free

Born in a time that sanctions all desires
I fight my instincts all the way
Drawn to a storm of things I have to have
With patience like other virtues still in the way

It's addiction, it's obsession, it's a need to be me
It's addiction, it's obsession, so I can feel that I'm free

Get enough of things to need them more
Like love and destruction to name but two
It's getting harder telling good from bad
With your senses asking was it good for you

It's addiction, it's obsession, it's a need to be me

There's so much I feel I have to have

It's addiction, it's obsession, it's a need to be me
It's addiction, it's obsession, so I can feel that I'm free

FEBRUARY

You're never going to say the things you want to say
The things you want to change will usually stay that way
The promises you break outweigh the ones you keep
The sky I'm told is blue is looking very grey

Nothing's going to seem the way it seems to you
It never turns out quite the way you want it to
Paint upon the wall for the hundredth time
But what you try to hide will come shining through
But what you try to hide will come shining through

There's so much you would do if you just had the time
Like try to write a song but it never rhymes (only sometimes)
You'd love to change the system but it works too well for you
If you didn't have the patience you could turn to crime

There's something that you feel that you can't explain
That makes you feel lost when it starts to rain
It bothers you the most when you are on your own
It whispers your intentions will all be in vain

The month you hate the most is always February

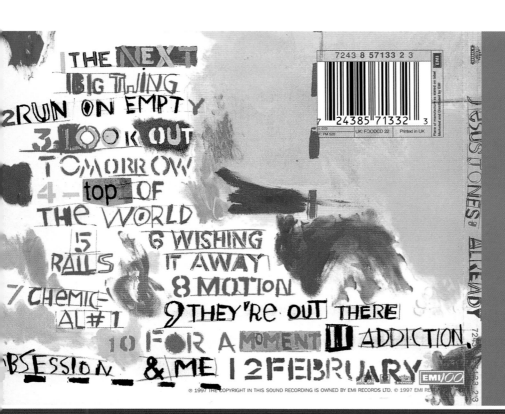

THE NEXT BIG THING
2 RUN ON EMPTY
3 LOOK OUT TOMORROW
4 top OF THE WORLD
5 RAILS
6 WISHING IT AWAY
7 CHEMICAL#1
8 MOTION
9 THEY'RE OUT THERE
10 FOR A MOMENT
11 ADDICTION, OBSESSION & ME
12 FEBRUARY

JESUS JONES • ALREADY

UK: FOODCD 22 Printed in UK

EMI 100

7243 8 57133 2 3

DESIGNER
Alison Fielding
ART DIRECTOR
Alison Fielding
DESIGN COMPANY
Beggars Banquet
PHOTOGRAPHER
Mary Farbrother
COUNTRY OF ORIGIN
UK
DIMENSIONS
Single: 178 mm diameter
7 in diameter
Cover: 181 x 181 mm
7⅛ x 7⅛ in
WORK DESCRIPTION
Vinyl single (right) and cover
(below) for *Somewhere Else* –
the second in a series by China
Drum

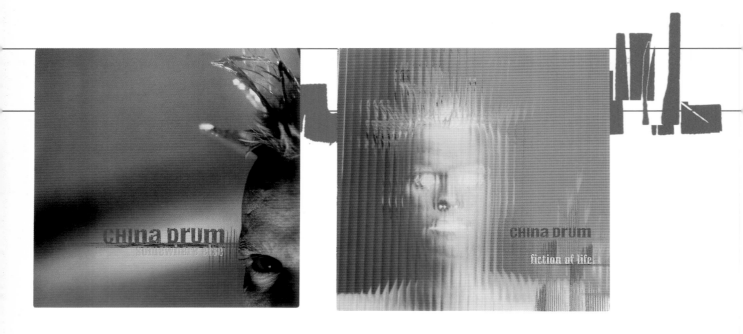

DESIGNER
Alison Fielding
ART DIRECTOR
Alison Fielding
DESIGN COMPANY
Beggars Banquet
PHOTOGRAPHER
Mary Farbrother
COUNTRY OF ORIGIN
UK
DIMENSIONS
Single: 178 mm diameter
7 in diameter
Cover: 181 x 181 mm
7 ⅛ x 7 ⅛ in
WORK DESCRIPTION
Vinyl single and cover
(opposite, below right) for
Fiction of Life – the first in a
series by China Drum

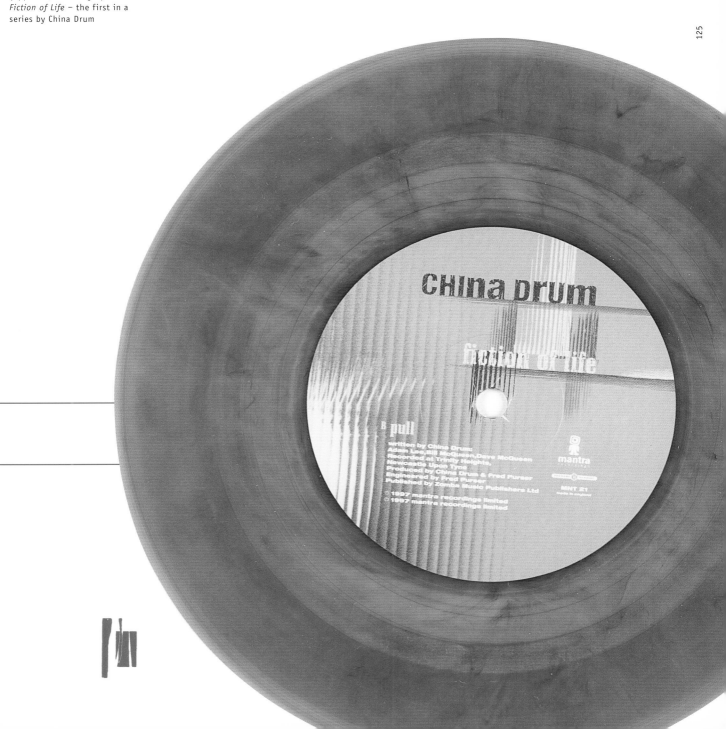

DESIGNER
Alison Fielding
ART DIRECTOR
Alison Fielding
DESIGN COMPANY
Beggars Banquet
PHOTOGRAPHER
Mary Farbrother
COUNTRY OF ORIGIN
UK
WORK DESCRIPTION
CD cover (right) and booklet
spreads from the album *Self Made
Maniac* by China Drum — the
album is the final part of the
series, combining the broken
glass and figure
DIMENSIONS
120 x 120 mm
4¾ x 4¾ in

126

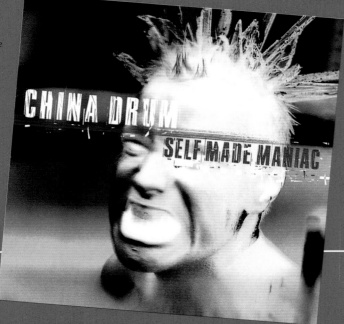

When I'm gone and you are broke, you will find another toy/When I'm broke and you have gone, you will find another toy/The wind was cutting in so well/I covered up my ears/The rain was going through me like a knife/It was taking every inch of warmth I had in me/I was shaking like I'd never in my life/I'm always staring at my watch when I'm there with you/I think I've bitten off more than I can chew/I think its one thing I'll never get to learn/If you ignore advice you'll end up getting burned/I've got no time for me/So I've got no time for you/I've got no time to walk along/And try and sift it through/It wouldn't be so bad If I was a million miles away/I could have come back to live another day/I might have even heard you trying to explain/But with you I'll never get to see another day/You will find another toy/Toy,Toy,Toy/You will find/You will find another toy/When I'm broke and you have gone/You will find another toy/When you're broke and I have gone/I will find another toy/Another toy

60 SECONDS

60 seconds what could happen now?/He could end up going down/60 seconds what could happen then?/He could end up changing again/He was dreaming softly in his bed/He woke to find a gun at his head/He heard them say 'Now don't move a muscle/You'll still be breathing in the morning bustle/60 seconds what could happen then/He just goes to work again/To make up for the things that they damaged/They lifted everything that they could manage/They're not scared of consequence of hammers/They'll have your things no matter what happens/While they're outside loading the truck/You know they'll never give it up/60 seconds now he's had enough/He's sick of people calling his bluff/He's seen them tearing everything apart/Its time to change them into something that doesn't.../Walk talk, eat sleep, blink drink, hit shit, lie die,/shy fly, age rage, care share/His house and fucking rifled it/You've made your bed now fucking die in it/He's been so good for you,like surviving a crash to you/You've been so bad for him, like finding lost cash to him/Like finding all he needs/60 seconds what could happen now/He could end up going down/60 seconds what could happen then/He could change into something that doesn't/Wake to find a gun at his head/After dreaming softly in his bed/He wouldn't be the one moving a muscle/'Cos he's changed into the something that doesn't.../walk talk, eat sleep, blink drink, hit shit,lie die, shy fly, age rage, care share. Scream gleam, piss kiss, lust fuss, hate shake, love shove, smoke choke, hear fear, care share.

hshouldn't have it/It's taken me far too long to hide it you now/You should keep it such a precious thing to away/You found it easy/To break in through these I thought I'd built so well/But not so easy for my head and find you there/Are you running from the same hat are snapping at my heels?/My heels have been ed up so much lately/That its hard for me to stand up/I aken every precaution to stop it all adding up/They n't have it/Its been built up to something nowhere wish that it was creeping up on them/Filled up with ut no matter/No matter how fast I go, I'm never as s slow/I found my feet getting tangled in the traps aid so well/Do you remember when she asked me if I k/If I had anything to say?/We looked at each other in ief/We fell over laughing at her feet/Shes treading an giving path/That will never take her back/Do you that put her in her place?/Do you think she saw the rs on my face?

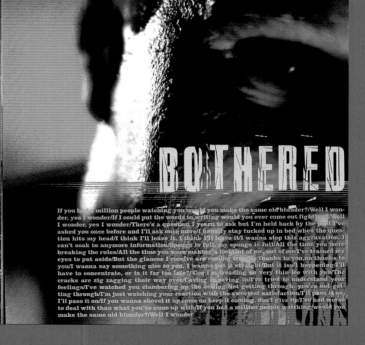

BOTHERED

If you had a million people watching would you make the same old blunder?/Well I wonder, yes I wonder/If I could put the words in writing would you ever come out fighting?/Well I wonder, yes I wonder/There's a question I yearn to ask but I'm held back by the past/I've asked you once before and I'll ask once more/I usually stay tucked up in bed when the question hits my head/I think I'll leave it, I think I'll leave it/I wanna stop this aggravation. I can't soak in anymore information/Sponge is full, my sponge is full/All the time you were breaking the rules/All the time you were making a fool/Out of me, out of me/I've trained my eyes to put aside/But the glances I receive are coming true/No thanks to you,no thanks to you/I wanna say something nice to you. I wanna put it straight/But it isn't happening/I'll have to concentrate, or is it far too late?/Cos I'm treading on very thin ice with you/The cracks are zig zagging their way over/Caving in/I've tried to understand your feelings/I've watched you clambering up the ceiling/Not getting through, you're not getting through/I'm just watching your reaction with the sweetest satisfaction/I'll pass it on, I'll pass it on/If you wanna shovel it up come on keep it coming, don't give up/I've had worse to deal with than what you've come up with/If you had a million people watching/would you make the same old blunder?/Well I wonder.

128

DESIGNER
Simon Gofton
ART DIRECTOR
Simon Gofton
DESIGN COMPANY
Blue Source
PHOTOGRAPHER
Simon Gofton
COUNTRY OF ORIGIN
UK

WORK DESCRIPTION
Fold-out club flyers
DIMENSIONS
70 x 210 mm
2¾ x 8¼ in

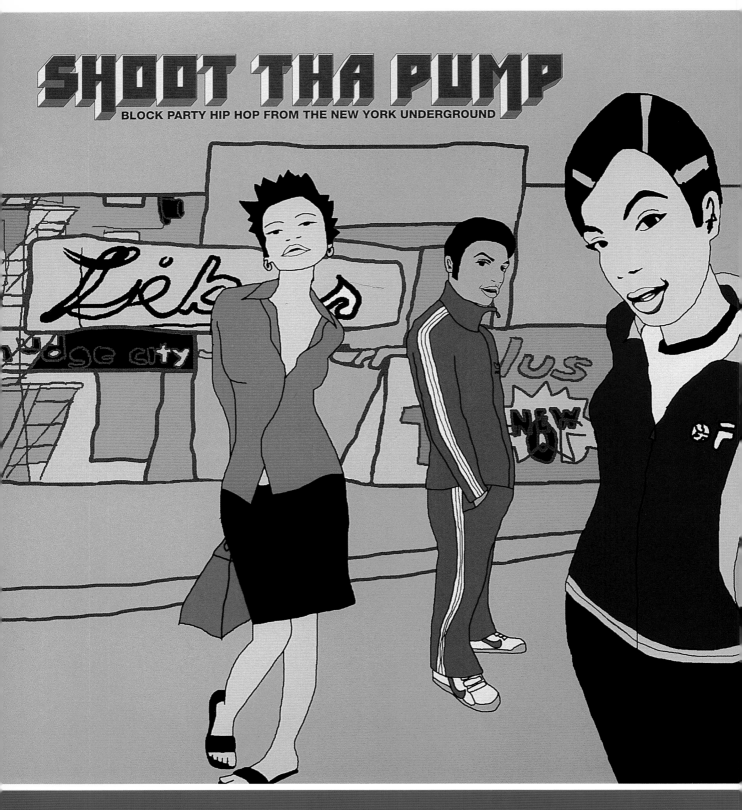

SHOOT THA PUMP

BLOCK PARTY HIP HOP FROM THE NEW YORK UNDERGROUND

DESIGNER
Mark Tappin
ART DIRECTOR
Mark Tappin
DESIGN COMPANY
Blue Source

ILLUSTRATOR
Graham Rounthwaite
COUNTRY OF ORIGIN
UK

WORK DESCRIPTION
Sleeve design for *Shoot Tha Pump* – a hip hop compilation album released on Concrete Records
DIMENSIONS
Various

Concrete

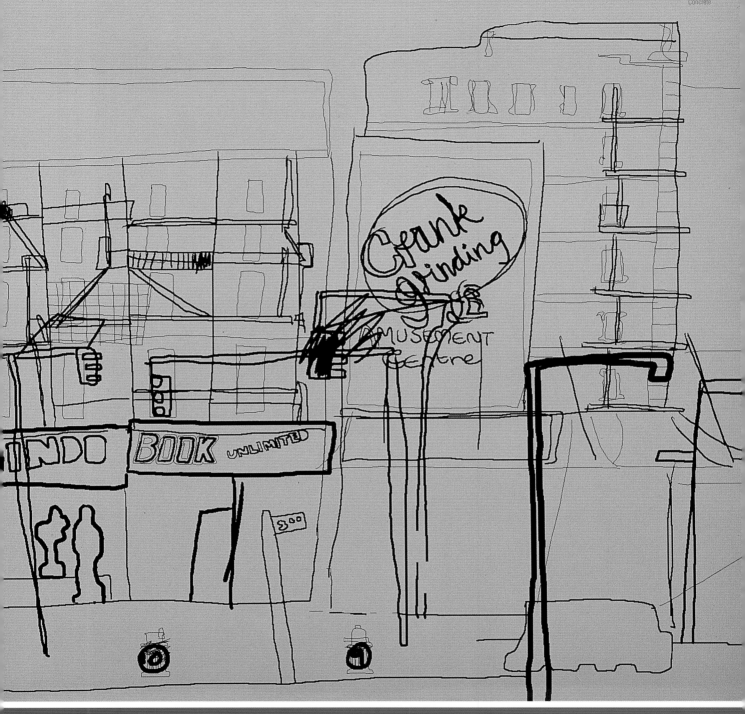

DESIGNER
Mark Tappin
ART DIRECTOR
Mark Tappin
DESIGN COMPANY
Blue Source

ILLUSTRATOR
Graham Rounthwaite
COUNTRY OF ORIGIN
UK

WORK DESCRIPTION
Sleeve design for a single by DJ
Rags from *Shoot Tha Pump*,
released on Concrete Records
DIMENSIONS
Various

© D·Fuse. Web: d.s...

D·FUSE

AMID

Association of Music
Industry Designers
Promotes and supports
designers working in the
music industry.

For more info on these
designers and other
members visit the
website: www.amid.co.uk
Fax +44 (0)171 221 7195

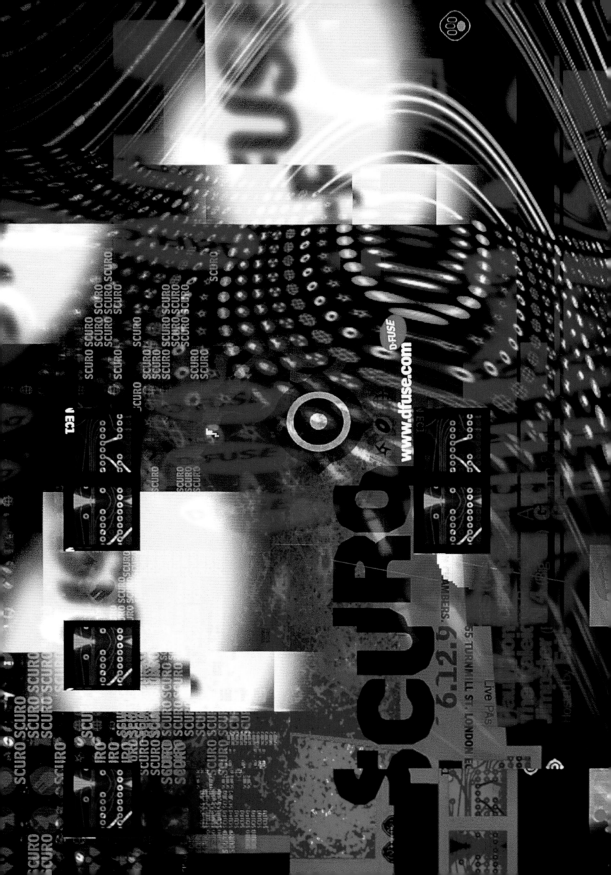

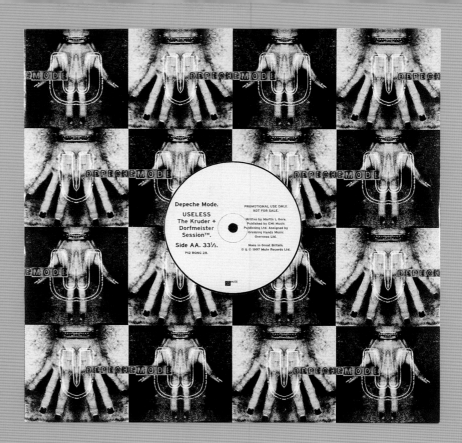

Depeche Mode.
USELESS
The Kruder +
Dorfmeister
Session™.
Side AA. 33⅓.
P12 BONG 28.

PROMOTIONAL USE ONLY.
NOT FOR SALE.

Written by Martin L Gore.
Published by EMI Music
Publishing Ltd. Assigned by
Grabbing Hands Music
Overseas Ltd.

Made in Great Britain.
℗ & © 1997 Mute Records Ltd.

DESIGNER
Richard Smith
ART DIRECTOR
Anton Corbijn
DESIGN COMPANY
Area
PHOTOGRAPHER
Anton Corbijn
COUNTRY OF ORIGIN
UK
WORK DESCRIPTION
Sleeve designs for the single
Useless by Depeche Mode for
Mute Records
DIMENSIONS
310 x 305 mm
12¼ x 12 in

PAGES 132–3
DESIGNER
Michael Faulkner
DESIGN COMPANY
Rawpaw Graphics (D-Fuse Art)
COUNTRY OF ORIGIN
UK
WORK DESCRIPTION
Images used as projections for
club events
DIMENSIONS
35 mm slides
1⅜ x 1⅜ in

Mandy Mayes, Allison Martin,
Martin Isaac
ART DIRECTOR
Mandy Mayes
DESIGN COMPANY
Dry

ILLUSTRATORS
Wil Overton,
Graham Rounthwaite
PHOTOGRAPHERS
Jeremy Mahr, Mandy Mayes
COUNTRY OF ORIGIN
UK

WORK DESCRIPTION
Swing tags for the Switched On
clothing collection
DIMENSIONS
128 x 65 mm
5⅛ x 2½ in

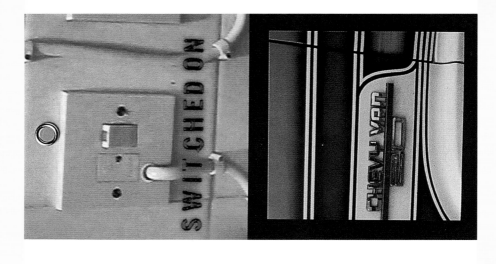

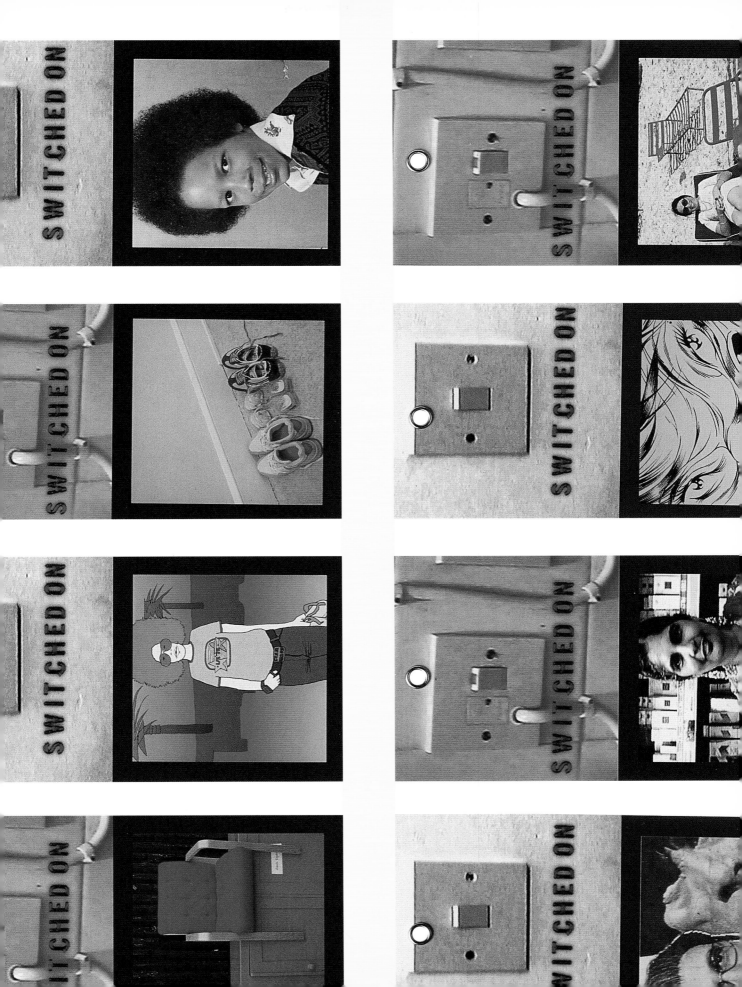

DESIGNERS
Mandy Mayes, Allison Martin,
Martin Isaac
ART DIRECTOR
Mandy Mayes
DESIGN COMPANY
Dry
ILLUSTRATOR
Alan Watt
COUNTRY OF ORIGIN
UK
WORK DESCRIPTION
Price tag as accessory for the
Switched On clothing collection
DIMENSIONS
25 x 260 mm
1 x 10¼ in

OPPOSITE
DESIGNERS
Mandy Mayes, Allison Martin,
Martin Isaac
ART DIRECTOR
Mandy Mayes
DESIGN COMPANY
Dry
ILLUSTRATOR
Mandy Mayes

COUNTRY OF ORIGIN
UK
WORK DESCRIPTION
Front and inside of CD box for
the single *Same Thing in
Reverse* by Boy George for
Virgin Records Ltd.
DIMENSIONS
140 x 122 mm
5½ x 4¾ in

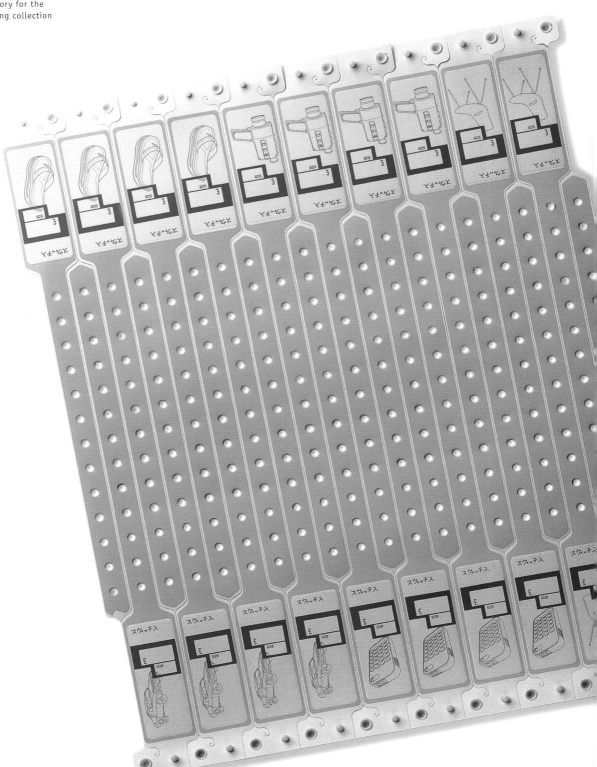

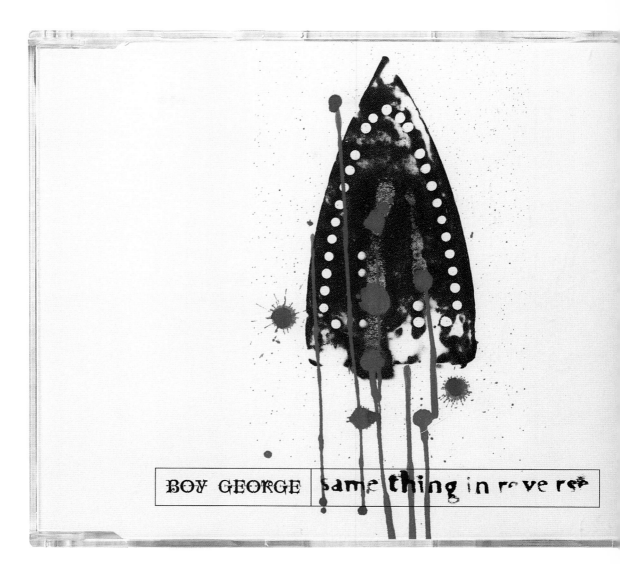

BOY GEORGE | same thing in reverse

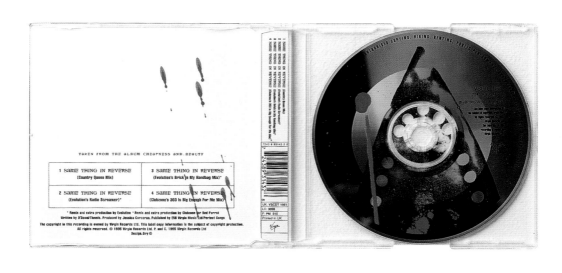

TAKEN FROM THE ALBUM CHEAPNESS AND BEAUTY

1 SAME THING IN REVERSE (Country Queen Mix)	3 SAME THING IN REVERSE (Evolution's Brick In My Handbag Mix)*
2 SAME THING IN REVERSE (Evolution's Radio Screamer)*	4 SAME THING IN REVERSE (Clubzone's 303 Is Big Enough For Me Mix)*

* Remix and extra production by Evolution * Remix and extra production by Clubzone for Red Parrot
Written by O'Dowd/Themis. Produced by Jessica Corcoran. Published by EMI Virgin Music Ltd/Perfect Songs

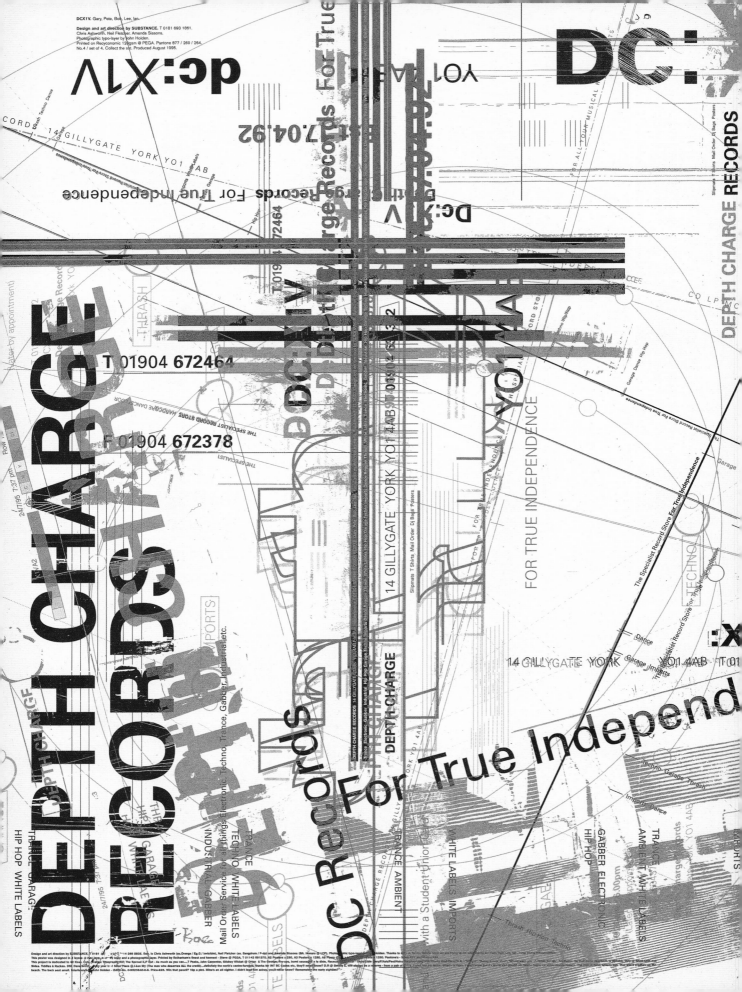

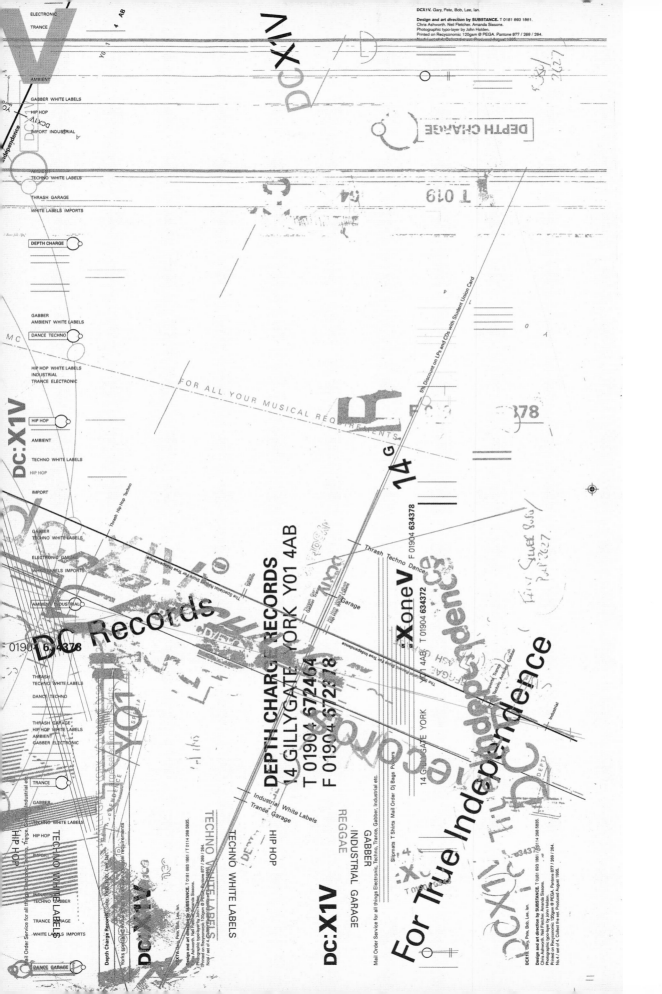

PAGES 140–1

DESIGNERS
Neil Fletcher, Chris Ashworth

ART DIRECTOR
Neil Fletcher

DESIGN COMPANY
Substance

COUNTRY OF ORIGIN
UK

WORK DESCRIPTION
Promotional poster for Depth
Charge Records

DIMENSIONS
451 x 640 mm
17¾ x 25¼ in

DESIGNER
Marc Serre

ART DIRECTORS
Daniel Fortin, George Fok,
Marc Serre

DESIGN COMPANY
Époxy

COUNTRY OF ORIGIN
Quebec, Canada

DIMENSIONS
Box: 145 x 125 mm
5¾ x 4⅞ in
Booklet: 137 x 124 mm
5⅜ x 4⅞ in

BELOW LEFT AND RIGHT

ILLUSTRATOR
Marc Serre

PHOTOGRAPHER
George Fok

WORK DESCRIPTION
Front cover of CD box and
booklet spread from the album
Vire et Valse la Vie by Bori for
Les Productions de l'Onde

BELOW RIGHT AND OPPOSITE

ILLUSTRATORS
Marc Serre, Michel Valois,
Bob Beck

PHOTOGRAPHER
Italo Lupi

WORK DESCRIPTION
Reverse of CD box and two
booklet spreads from the album
Bori by Bori for Les Productions
de l'Onde

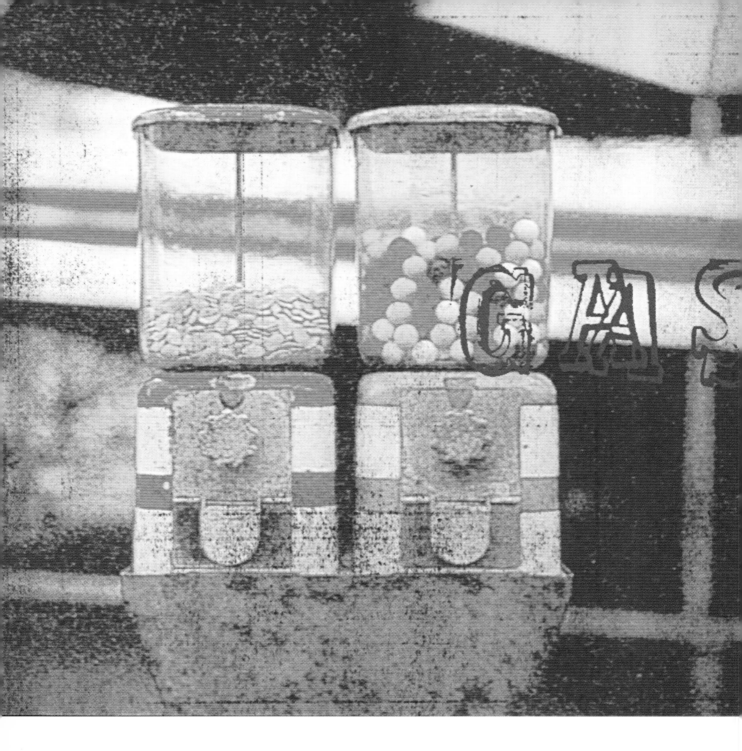

DESIGNER
Marc Serre
ART DIRECTORS
Daniel Fortin, George Fok,
Marc Serre
DESIGN COMPANY
Époxy
ILLUSTRATORS
Marc Serre, Michel Valois,
Bob Beck
PHOTOGRAPHER
Italo Lupi

COUNTRY OF ORIGIN
Quebec, Canada
WORK DESCRIPTION
CD booklet spread from the
album *Bori* by Bori for
Les Productions de l'Onde
DIMENSIONS
137 x 124 mm
5⅜ x 4⅞ in

Le voilà là dans ma loge
À me maquiller
Prêt à prendre place sur la scène
Où tous les soirs
On appelle Gaspar

Je défile dans ses habits
Les mots écrits pour lui
Défiant les idées folles
En trichant

Les rires croulent
Cousus à l'ombre
Tout me ment tout me rend sombre
On m'appelle Gaspar
Vous croyez en voir un autre
Sous les feux de la rampe
Au reflet sur les paupières
À l'armure tombée à l'eau
Par vous bordé
Porté par vous si haut
Des ailes
Des ailes jusqu'à la fin du spectacle

Après le numéro on tire le rideau
Sur celui qui se porte sur mon dos
À mille pas des bravos il se fait face
À peine le temps d'un mot devant la glace
Et de sa main l'esprit ailleurs s'efface
Étonnant dans ses habits
Des yeux trop grands pour lui
Soulevant les cabrioles
Au bout d'un parapluie

Paroles
Edgar BORI,
Gustave et Gaspar

Musique et arrangements
Edgar BORI

Musiciens
Mario Légaré
basse
Michael Pucci
guitare

Le voilà là dans ma loge
À se maquiller
Prêt à prendre place sur la scène
Où tous les soirs
On appelle Gaspar... Gaspar

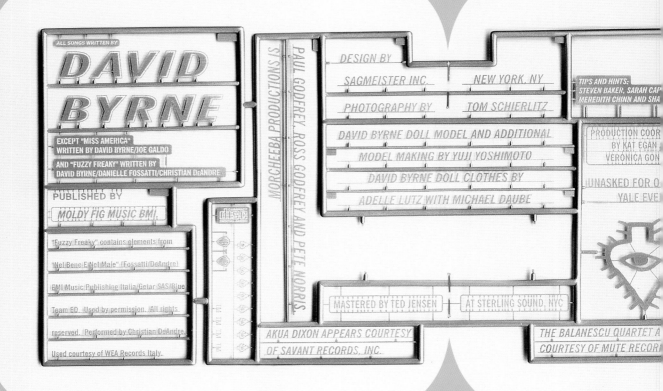

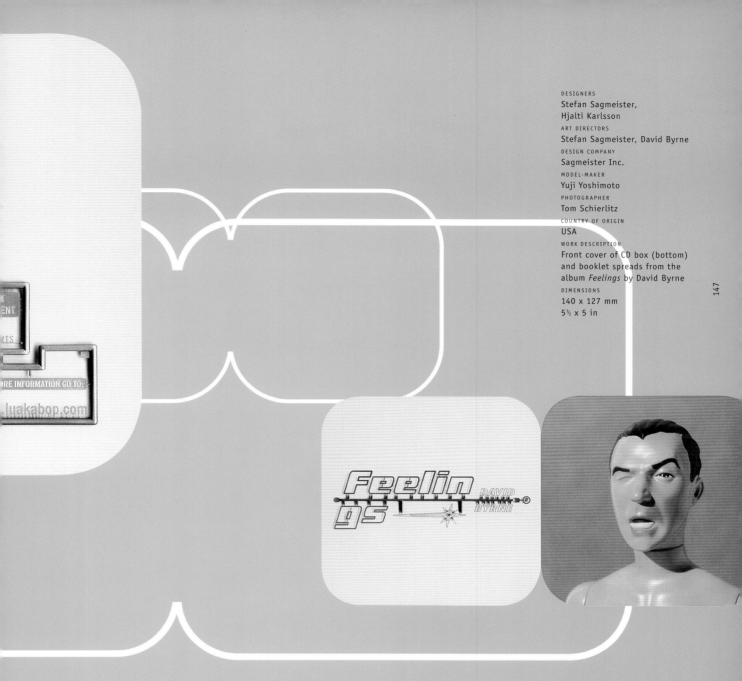

DESIGNERS
Stefan Sagmeister,
Hjalti Karlsson
ART DIRECTORS
Stefan Sagmeister, David Byrne
DESIGN COMPANY
Sagmeister Inc.
MODEL-MAKER
Yuji Yoshimoto
PHOTOGRAPHER
Tom Schierlitz
COUNTRY OF ORIGIN
USA
WORK DESCRIPTION
Front cover of CD box (bottom)
and booklet spreads from the
album *Feelings* **by David Byrne**
DIMENSIONS
140 x 127 mm
5½ x 5 in

147

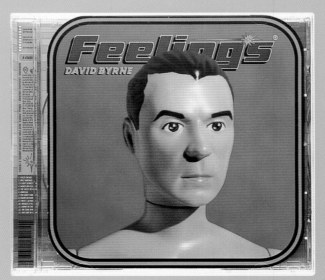

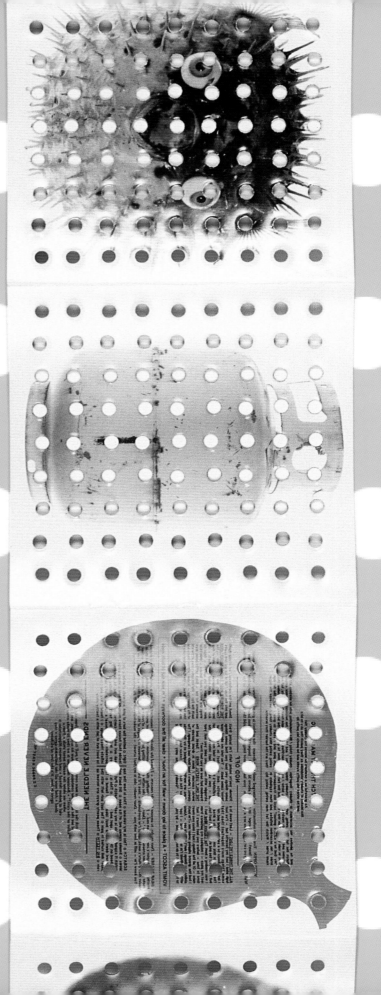

DESIGNERS
Hjalti Karlsson,
Stefan Sagmeister
ART DIRECTOR
Stefan Sagmeister
DESIGN COMPANY
Sagmeister Inc.
PHOTOGRAPHER
Tom Schierlitz
COUNTRY OF ORIGIN
USA
WORK DESCRIPTION
Front cover of CD box
(opposite) and booklet
spread from the album
Fantastic Spikes Through Balloon
by Skeleton Key
DIMENSIONS
140 x 127 mm
5½ x 5 in

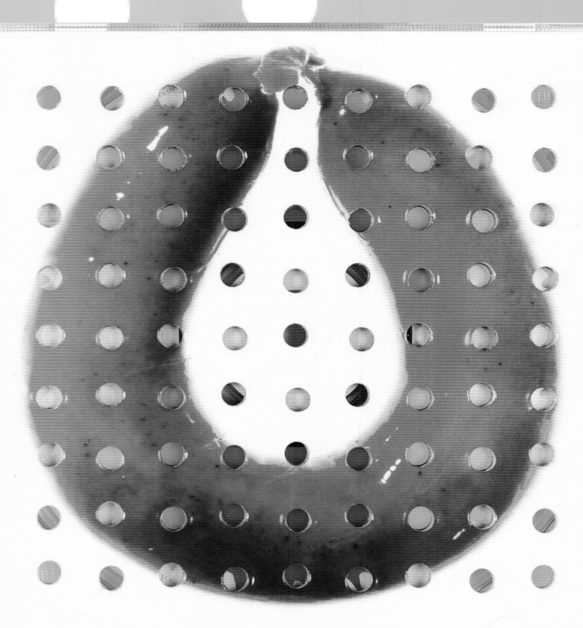

ARTIST	TRACK NO. PHOTO NO.	TRACK TITLE	WRITTEN AND PRODUCED
PUMPIN LEE & CHEN SEN	1	THOSE GOOD OLD DISCO TIMES	MICHAEL KOHLER/NILS JENSEN
GROOVE CONSTRUCTION	2	DOWN TO THE GROUND	PAUL NEGRO JR./JUSTIN TARENTINO
DJ DEETRON	3	PEACEFUL WAR	SAMUEL GEISER
DJ DEE TREE-9	4	Z-COME	PHILIPP FREI
DJ SONIC-T	5	INVADING PLANET	JEAN-MARC LÜTHY/ANDY KLEEBERG
DJ POSEIDON	6	TRANSONIC	EMILIO BONGARZONE/ANDY KLEEBERG
DJ OBSESSION	7	TOGETHER	MARCO BONUCCI/STEFAN ISCHI
SQUAREWAVE	8	WE KNOW	THOMAS SCHWARZ
OVERTONE	9	IMAGES OF ABSTRACT REALITIES-REPRISE	DANI WIHLER
KALEIDOPHONE	10	CALUX	MICHAEL GIANFREDA
DJ CHEERS	11	KEEP SITTING	STEFAN RIESEN
MARCO REPETTO	12	DORNVAL	MARCO REPETTO

DER BAU, ABBAU UND ÜBERBAU VON DIESEM HOUSE:
DIE ZEICHNUNG UND BERECHNUNG DER STATIK, DAS ABSTECKEN DER BAUZONE,
DIE BAUPROFILE SCHWINGEN LEICHT (TR. 1-5). LÄSSIG UND STOLZ HEBT DER
KRANFÜHRER LEICHT DAS SCHWERE UND DIE GERÜSTBAUER MACHEN EINE GUTE
FIGUR. SOMMERMORGEN AUF DER BAUSTELLE.
GLEICHZEITIG SCHWITZT UND ÄCHZT DER GIESSER IM STAHLWERK UND STRÄFLINGE
KLOPFEN BLÖCKE IM STEINBRUCH. DAS SCHWERE BLEIBT SCHWER UND QUER (TR. 6-8).
FRIEDE DEN HÜTTEN, KRIEG DEN PALÄSTEN: AUF DER BAUSTELLE (TR. 9-12)
DENKEN DIE ARBEITER AN IHRE GENOSSEN. SIE LEGEN DIE ARBEIT NIEDER UND
BLEIBEN DER BAUSTELLE FERN. GRAS WÄCHST ÜBER AUFSCHÜTTUNGEN UND AUF
HALBFERTIGEN MAUERN SONNEN SICH EIDECHSEN.

CONSTRUCTION, DECONSTRUCTION
THE DRAWINGS AND FIGURES OF
BUILDING AREA, THE CONSTRUCT
IN A PLEASANT AND PROUD WAY
AND THE BRICKLELAYERS BUILD
THE BUILDING SITE.
AT THE SAME TIME THE FOUNDRY
ROCKS TO PIECES, WHAT'S HEAV
FREEDOM TO HUTS AND WAR TO P
WORKERS THINK OF THEIR MATES
FROM THE BUILDING SITE. GRAS
SUNBATHE ON THE YET TO BE FI

LINER NOTES: SALAM-I
BERNE ELECTRONIC CONSULTANTS

FEATURING: LEE & CHEN SEN
PUMPIN' CONSTRUCTION
GROOVE CON
DJ DEE TREE-9
DJ DEE TREE
DJ SONIC
DJ POSEIDON
DJ SQUAREWAVE
OKALCHE
KAJ
MARCO REPETTO

BERNE ELECTRONIC
compactdisc

BEet
DESIGN

SEE TRAY INLAY

BERNE ELECTRONIC

COMPILED BY MARCO REPETTO, MARCO BONUCCI
PHILIPP FREI AND EMILIO BONGARZONE 1997

THANKS TO:
ALL ARTISTS INVOLVED IN THIS PROJECT, DANI WIHLER FOR MASTERING,
SANDRO FISCHLI, MARCO "HOTHANDS" MALINVERNO, BDLOPETZ FOR ARTWORK,
URSULA AND ALEC @ DISCTRADE.

SPECIAL THANKS TO:
ABTEILUNG KULTURELLES - STADT BERN, PETER SCHRANZ
ABTEILUNG KULTUR - KANTON BERN, PHILIPPE WALKER

OF THIS HOUSE:
IMINATION OF THE
Y SWING (TR. 1-5)
OLDS THE HEAVY PARTS
URE. SUMMER MORNING ON

OANS AND CONVICTS BREAK
UNUSUAL (TR. 6-8).
ING SITE (TR. 9-12) THE
IR WORK AND KEEP AWAY
IDGES AND LIZARDS

MARCO BONUCCI

PAGES 150–1
DESIGNER
Lopetz
DESIGN COMPANY
büro destruct
COUNTRY OF ORIGIN
Switzerland
WORK DESCRIPTION
Fold-out CD booklet
from the techno-compilation
album *Berne Electronic*
DIMENSIONS
120 x 120 mm
4¾ x 4¾ in

DESIGNER
Lopetz
DESIGN COMPANY
büro destruct
COUNTRY OF ORIGIN
Switzerland
WORK DESCRIPTION
Club flyers
DIMENSIONS
120 x 120 mm
4¾ x 4¾ in

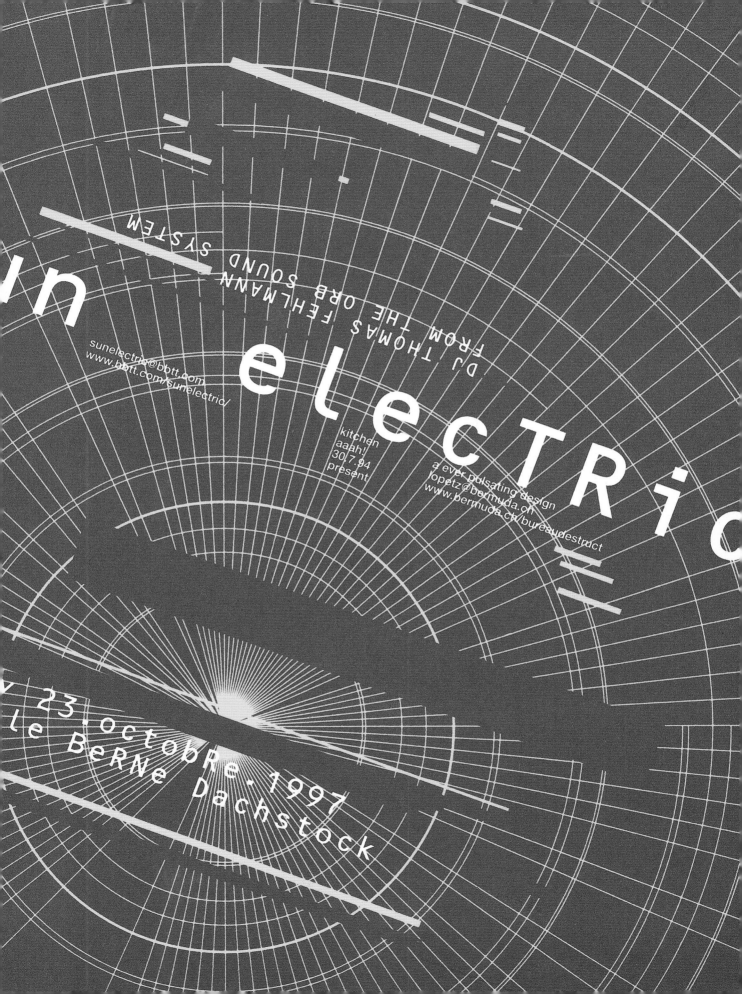

DESIGNER
H1reber
DESIGN COMPANY
büro destruct
ILLUSTRATOR
Lopetz
COUNTRY OF ORIGIN
Switzerland
WORK DESCRIPTION
Promotional poster
DIMENSIONS
287 x 593 mm
11¼ x 23⅜ in

exce
eder
neu uk

a walk on the future side

sa. 22. november
wasserwerk

wasserwerkgasse #5 bern
vorverkauf: chop records, waisenhausplatz 2
Historisches Museum, Helvetiaplatz 5

dj fatdilat (f.d.a.)
drum'n'hass, big beat
dj raphaël delan
le delan house spectrum

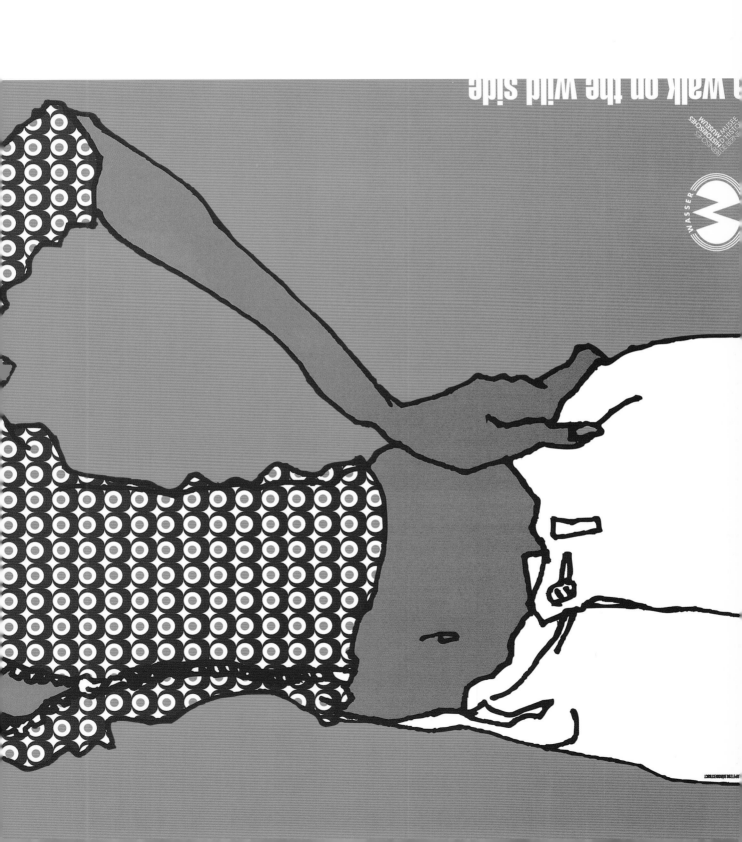

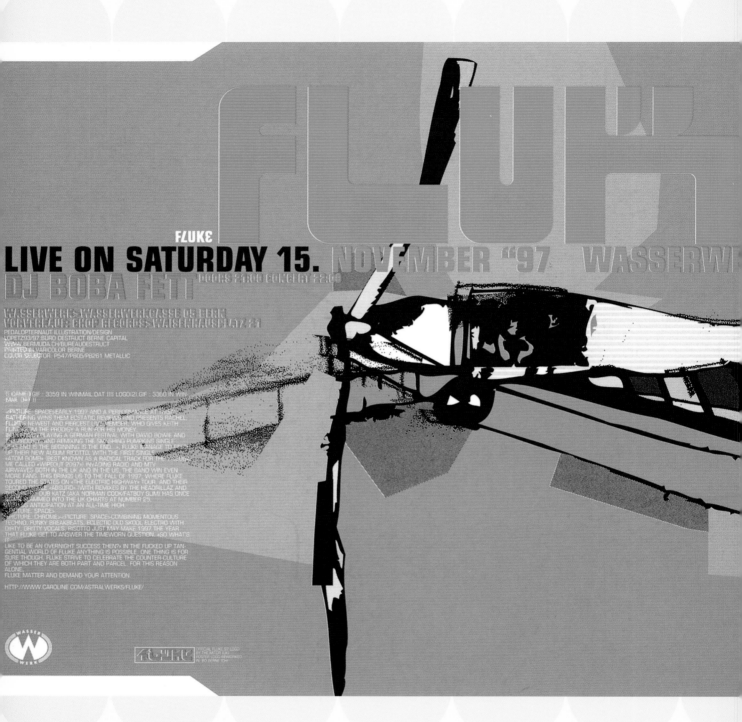

FLUKE

LIVE ON SATURDAY 15. NOVEMBER '97 WASSERWE
DOORS 21:00 CONCERT 22:00

DJ BOBA FETT

WASSERWERK, WASSERWERKGASSE 05 BERN
VORVERKAUF: CROP RECORDS, WAISENHAUSPLATZ 21

PEDALOPTERNAUT ILLUSTRATION/DESIGN
LOPETZ93/97 BURO DESTRUCT BERNE CAPITAL
WWW.BERMUDA.CH/BUREAUDESTRUCT
PRINTED IN VARICOLOR BERNE
COLOR SELECTOR P547/P605/PB261 METALLIC

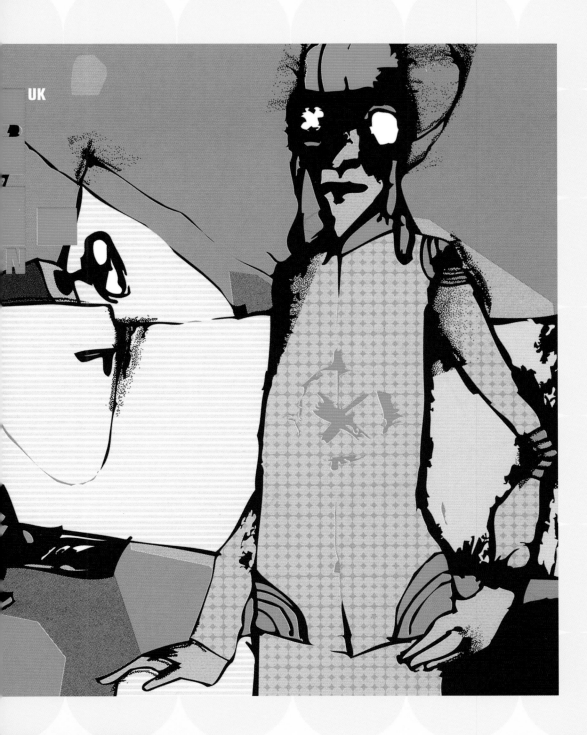

DJ **PESHAY**

LUCKY STRIKE

exkan dalo!

FIESTA VON
TRANCE & HOUSE BIS
RUMBA MIT DJ PACO

SAMSTAG:
BIERHÜBELI NEUBRÜCKSTR.43 23.AUGUST
BERN 20.SEPTEMBER / 18.OKTOBER
29.NOVEMBER / 20.DEZEMBER

MACROTEAM PRESENT: EXKANDALO!

HASTA LA VISTA! TÜRÖFFNUNG: 21:00 UHR DONNERSTAG: 1.JANUAR

dj´s
▶ ll ▶

METALHEADZ/TIMELESS™
DIGITAL/SPIRIT/FLUID

DRUM'N'BASS
REITSCHULE BERN DACHSTOCK

DESIGNERS
David Harlan, Shelby Tiffany
ART DIRECTORS
David Harlan, Shelby Tiffany
DESIGN COMPANY
PopGlory
ILLUSTRATORS
David Harlan, Shelby Tiffany
PHOTOGRAPHERS
David Harlan, Shelby Tiffany,
various video captures
(opposite)
COUNTRY OF ORIGIN
USA
WORK DESCRIPTION
Invitation (below) and program
(opposite) for the California
Institute of the Arts'
graduation ceremony
DIMENSIONS
Invitation:
152 x 216 mm
6 x 8½ in
Program:
356 x 254 mm
14 x 10 in

RIGHT
DESIGNER
David Harlan
ART DIRECTOR
David Harlan
DESIGN COMPANY
PopGlory
ILLUSTRATOR
David Harlan
COUNTRY OF ORIGIN
USA
WORK DESCRIPTION
Front cover for a Reprise
Records compilation CD
DIMENSIONS
127 x 130 mm
5 x 5⅛ in

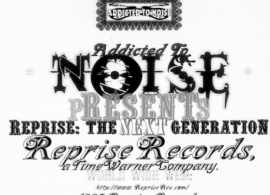

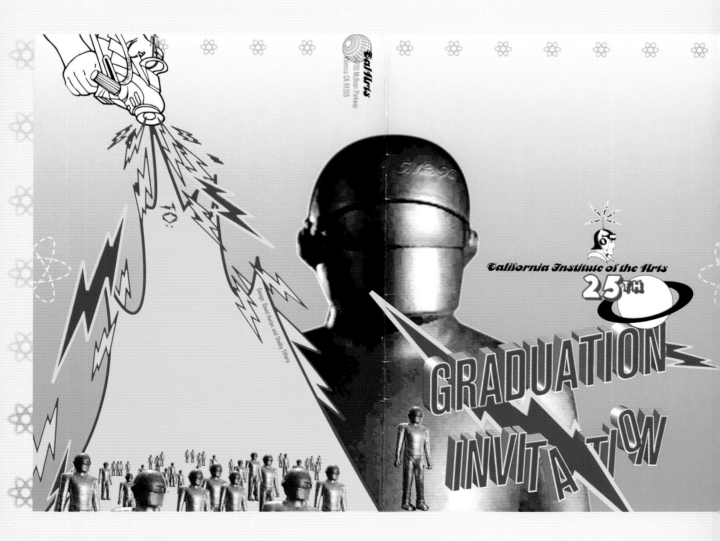

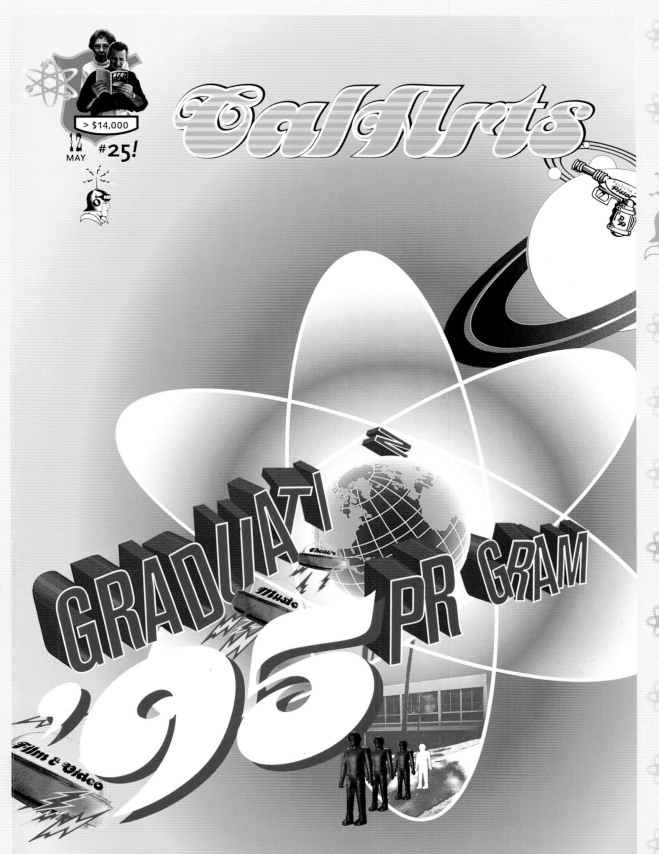

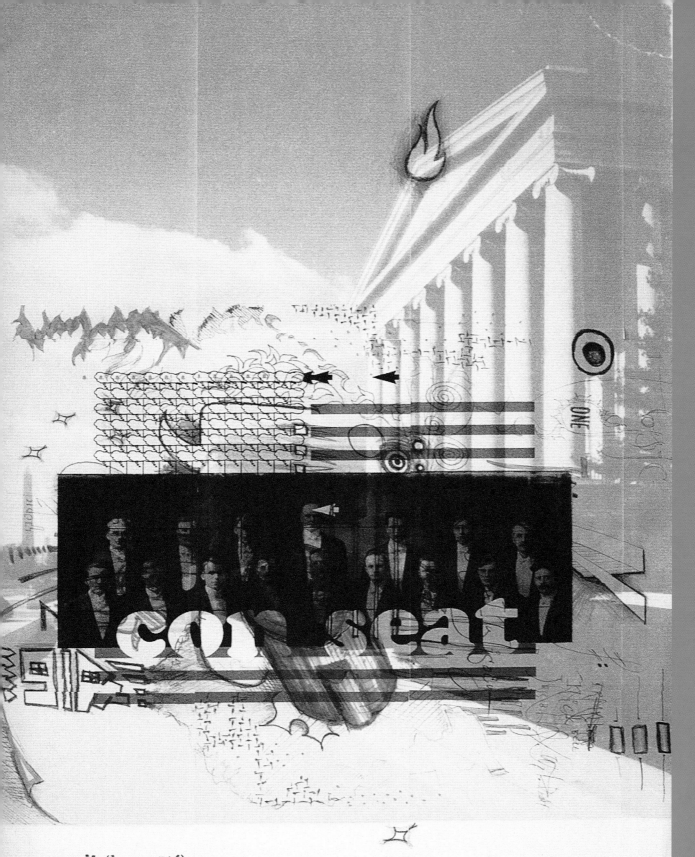

con·ceit (kən sēt′) *n.*
1 *a)* an idea; thought; concept *b)* personal opinion **2** an exaggerated opinion of oneself, one's merits, etc.; vanity **3** *a)* a fanciful or witty expression or notion; often, specif., a striking and elaborate metaphor, sometimes one regarded, esp. formerly, as strained and arbitrary **4** a small, imaginatively designed item

OPPOSITE
DESIGNER
Tony Brock (North Carolina
State University)
ART DIRECTOR
Tony Brock
ILLUSTRATOR
Tony Brock
COUNTRY OF ORIGIN
USA
WORK DESCRIPTION
Self-published poster
examining views of personal
style in contemporary graphic
design
DIMENSIONS
610 x 965 mm
24 x 38 in

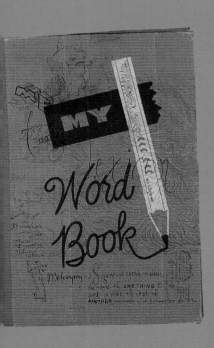

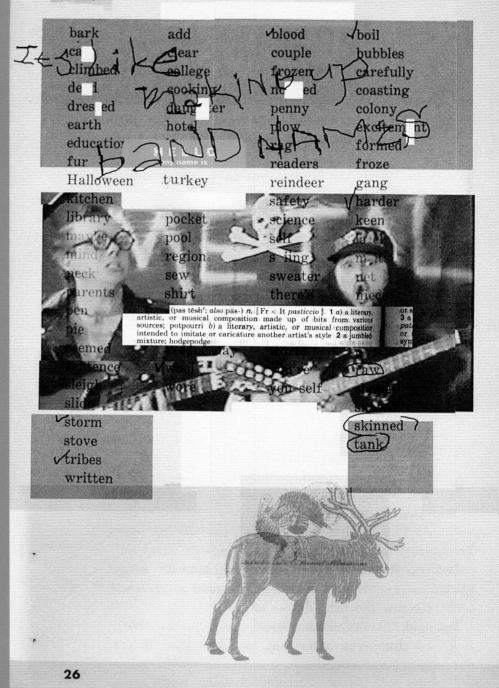

ABOVE AND PAGE 162
DESIGNER
Tony Brock (North Carolina
State University)
ART DIRECTOR
Tony Brock
ILLUSTRATOR
Tony Brock
COUNTRY OF ORIGIN
USA

WORK DESCRIPTION
Front cover and pages from
My Word Book – a lexicon
developed from readings in
cultural studies and design
DIMENSIONS
508 x 711 mm
20 x 28 in

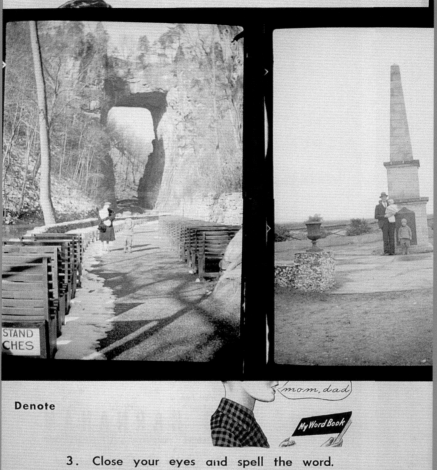

OPPOSITE AND PAGES 164–5
DESIGNER
Andrew Blauvelt (North Carolina
State University)
ART DIRECTOR
Andrew Blauvelt
DESIGN COMPANY
Andrew Blauvelt Graphic Design
PHOTOGRAPHERS
Andrew Blauvelt,
Deborah Bright
COUNTRY OF ORIGIN
USA

WORK DESCRIPTION
Two posters announcing *All That
is Solid* – an installation by
Deborah Bright examining the
plight of industrial society
DIMENSIONS
457 x 610 mm
18 x 24 in

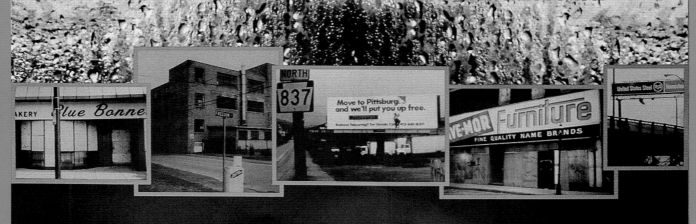

All that is solid an installation by Deborah Bright

Atlanta College of Art Gallery
February 24 – March 9, 1997

Non-Profit Organization
U.S. Postage
PAID
Permit #3069
Atlanta, GA

The Atlanta College of Art
The Woodruff Arts Center
1280 Peachtree Street, N.E.
Atlanta, GA 30309

Gallery Hours:
Monday: Closed
Tuesday, Wednesday & Saturday: 10-5pm
Thursday & Friday: 10-9pm
Sunday: 12-5pm

404-733-5050 (phone)

All that is solid an installation by Deborah Bright

January 24 – March 9, 1997

Opening reception for the artist:
Friday, January 24, 1997, 5:30-8:00pm
Atlanta College of Art Gallery

Panel Discussion: "Repackaged: A Discussion of
America's Industrial History"
Thursday, January 23, 1997, 7:00-8:30pm
Hill Auditorium, Atlanta College of Art

Panelists include: Chris Seppeler, Gallery Director; Deborah
Bright, artist; Charles Rutheiser, anthropologist; and others
to be announced.

Continuing support for The Atlanta College of Art Gallery is funded, in part, by
the Georgia Council for the Arts; the Fulton County Arts Council; and the City
of Atlanta Bureau of Cultural Affairs; as well as generous contributions to the
College by individuals, foundations, and corporations.

 FULTON COUNTY ARTS COUNCIL

Deborah Bright is associate professor of photography at the Rhode Island
School of Design. She has received international recognition for her artwork,
including exhibitions at the National Museum of American Art, the Victoria and
Albert Museum, the Vancouver Art Gallery, Boston Institute of Contemporary
Art, and the Carpenter Museum of Contemporary Photography. Her critical
writing on photography and cultural issues has been published in Afterimage,
Art Journal, exposure, Views, and unhooped in important collections of
photographic criticism. In 1991, Bright was awarded a Bunting Fellowship in
the Sciences. Currently she is editing a collection of essays and critical essays on
photography and sexuality, The Passionate Camera, to be published by
Routledge in 1997.

All that is solid explores the repackaging of the United States' industrial heritage for tourist and affluent consumption in the post-industrial era. As a long-time resident of the former core regions of U.S. industrial production (Chicago and New England), Bright has witnessed the conversion of factory complexes into gentrified condominiums, shopping malls and high-tech office parks.

Meanwhile, entire cities, towns and regions which once depended on manufacturing have been left to fall into destitution. Lawrence, MA, site of the famous "Bread and Roses" strike of 1912, now resembles a third world city — sixty percent of its residents live on public assistance. In contrast, its sister mill-city, Lowell, was transformed by federal, state and private investment into a National Park where tourists can "see what mill life was like."

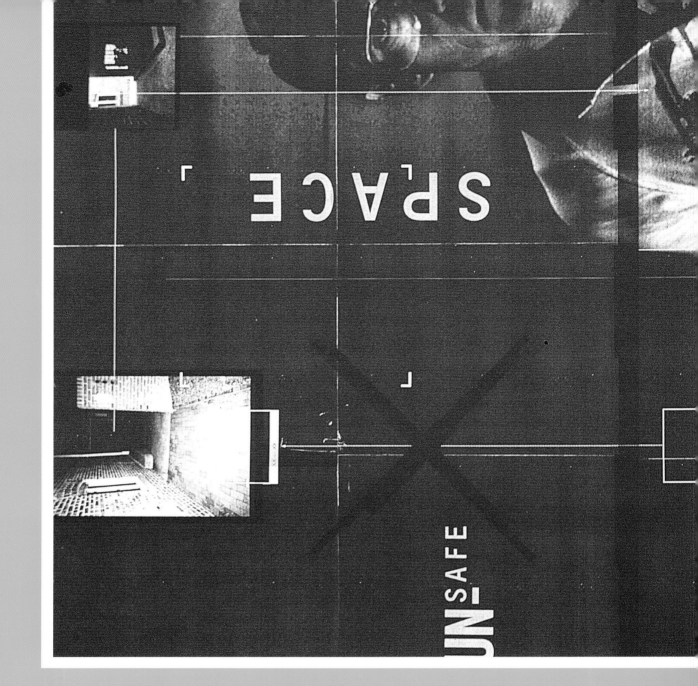

SPACE

UN_SAFE

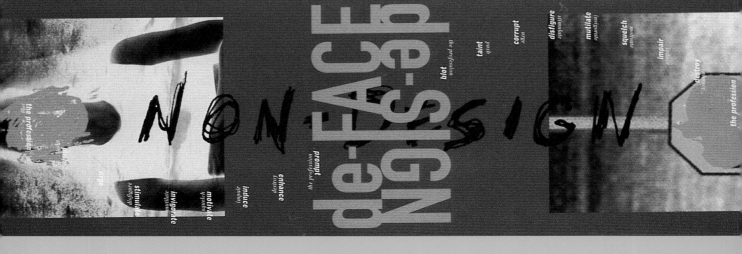

de-FACE

de-sign

blot
the profession

taint
quod

corrupt
akin

disfigure
impugn

mutilate
squander

squelch
quotient

impair
impede

destroy

the profession

prompt
the profession

enhance
krump

induce
spader

motivate
spader

invigorate
impinge

stimulate
amp-

the profession

NON DESIGN

ABOVE
DESIGNER
David Kasparek (North Carolina
State University)
ART DIRECTOR
David Kasparek
COUNTRY OF ORIGIN
USA
WORK DESCRIPTION
Poster questioning the pros
and cons of 'pro-active design'
– part of a project assigned by
visiting designer Nick Bell
DIMENSIONS
254 x 838 mm
10 x 33 in

DESIGNER
David Kasparek (North Carolina
State University)
ART DIRECTOR
David Kasparek
PHOTOGRAPHER
David Kasparek
COUNTRY OF ORIGIN
USA
WORK DESCRIPTION
One of a series of posters
about safety in on-campus
housing
DIMENSIONS
610 x 1219 mm
24 x 48 in

DESIGNER
David Kasparek (North Carolina
State University)

ART DIRECTOR
David Kasparek

ILLUSTRATOR
David Kasparek

COUNTRY OF ORIGIN
USA

WORK DESCRIPTION
Mixed-media postcard design
inspired by a 'cheat sheet'
found on campus

DIMENSIONS
127 x 152 mm
5 x 6 in

DESIGNER
David Kasparek (North Carolina
State University)

ART DIRECTOR
David Kasparek

COUNTRY OF ORIGIN
USA

WORK DESCRIPTION
Flash card – part of a studio
project to interpret key terms
in theoretical design discourse

DIMENSIONS
127 x 178 mm
5 x 7 in

PAGES 172–5
DESIGNERS
Lisa Mazur, Anke Stohlmann
ART DIRECTOR
Paula Scher
DESIGN COMPANY
Pentagram Design
COUNTRY OF ORIGIN
USA

PAGES 172–3
WORK DESCRIPTION
Posters in the tradition of
old-fashioned English theater
announcements for the New
York Shakespeare Festival in
Central Park 1996–7
DIMENSIONS
1207 x 1753 mm (left)
48 x 69 in
1067 x 2134 mm (right)
42 x 84 in

PAGES 174–5
PHOTOGRAPHER
Tar (Insurrection)
WORK DESCRIPTION
Posters for the 1996–7 Public
Theater season designed to
reflect street typography,
juxtaposing photography
and type
DIMENSIONS
762 x 1168 mm
30 x 46 in

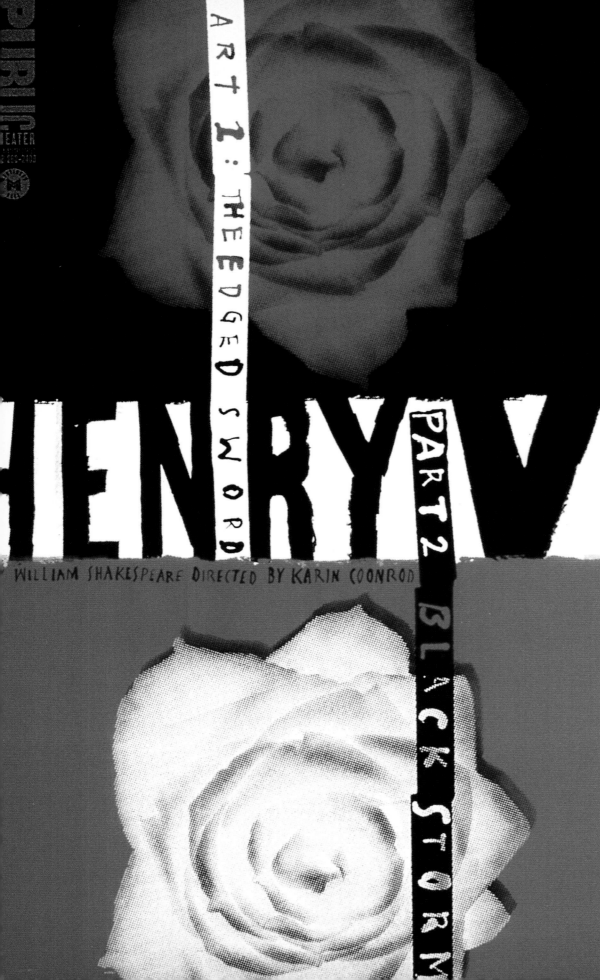

HERRON SCHOOL of ART IUPUI
3701 North Pennsylvania Street
Indianapolis, Indiana 46202

U.S. POSTAGE PAID
PERMIT #5245
Indianapolis, IN 46202

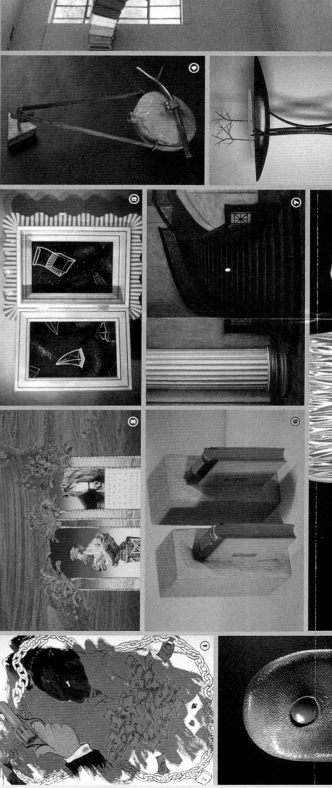

HERRON SCHOOL of ART

IUPUI

1997–1998

VISITING ARTIST PROGRAM & GALLERY EXHIBITION SCHEDULE

STRENGTH OF PARACHUTES

Herron Gallery Exhibition Schedule

FALL 1997

AUGUST 27 THROUGH SEPTEMBER 27
Opening: Wednesday, August 27 [5:00 – 7:00pm]
① **ROBERT COLESCOTT**

Paintings, drawings, and prints by the artist chosen to represent the United States at the 1997 Venice Biennale. A student of Fernand Léger, Colescott is considered by many the most important figurative painter of his generation. Colescott's work is represented in the permanent collections of most of the country's prominent museums including: The Metropolitan Museum of Art, The Museum of Modern Art, The Whitney Museum of American Art and the Hirshhorn Museum and Sculpture Garden. [ABOVE: *Alternatives*, acrylic on panel]

OCTOBER 8 THROUGH NOVEMBER 15
Opening: Wednesday, October 8 [5:00 – 7:00pm]
⑥ **UNBOUND: ART IN BOOKFORM
– BOOK AS ARTFORM**

An exhibit of contemporary sculptural works which will feature artists Mark Arctander, Amos Kennedy, Ronald Leax, Buzz Spector and Margaret Wharton. Each of these artists has utilized the book as a central motif or symbol. This exhibit will also explore book-related works such as hand-printed books, rare books, artists' books, comic books, and more. [ABOVE: Mark Arctander, *Book End*]

DECEMBER 3 THROUGH DECEMBER 27
Opening: Wednesday, December 3 [5:00 – 9:00pm]
STUDENT EXHIBITION

This annual exhibition of work created by more than 200 students includes pieces that encompass a variety of media: painting, sculpture, photography, ceramics, woodworking, printmaking and visual communication.

GALLERY HOURS:
Monday, Tuesday, Wednesday 10 – 5
Thursday 12 – 8
Friday, Saturday 10 – 3
Sunday closed

GALLERY PHONE 920.2420 • GALLERY OFFICE 920.2421

SPRING 1998

JANUARY 14 THROUGH FEBRUARY 14
Opening: Wednesday, January 14 [5:00 – 7:00pm]
**SMALL WORKS: THE BUTLER INSTITUTE
OF AMERICAN ART**

Drawn from the permanent collection of the nation's oldest museum, solely devoted to the acquisition of works by American artists, this exhibit will include works by Aaron Bohrod, Roy Lichtenstein, Reginald Marsh, Joan Mitchell, Horace Pippin, and Andy Warhol.

&

**ROADWORKS: PHOTOGRAPHY
BY LINDA McCARTNEY**

Most popularly known as the wife of ex-Beatle Paul McCartney, Linda McCartney has been a photographer for over thirty years. The works (gelatin & iris prints) in this exhibit span the majority of that time, and chronicle the many roastings McCartney has taken in search of her candid, offbeat images.

MARCH 11 THROUGH APRIL 11
Opening: Wednesday, March 11 [5:00 – 7:00pm]
**TIME ON THEIR HANDS:
THE TRAMP ART TRADITION**

The first in a series of Herron exhibits that will examine "self-taught art." "Tramp Art" is the term generally given to works produced by people put out of work (and often migrant) by the Great Depression of the 1930s. These highly decorative, but often useful, one-of-a-kind objects celebrate the patience, and resourcefulness of their anonymous creators. This exhibit will examine an American wood-working tradition too often overlooked.

APRIL 22 THROUGH MAY 16
Opening: Wednesday, April 22 [5:00 – 9:00pm]
SENIOR EXHIBITION

This annual exhibition of work is produced by the entire graduating class surveys all media from painting to visual communication. Each student is represented by three or four major works or projects completed during the year. The show extends throughout the gallery and various other locations within the Museum Building of the Herron School of Art.

Herron Visiting Artist Program • Lecture Series

FALL 1997

September 18, Thursday [2:30pm]
PAUL SASSO
–woodworker–
above: [actual cabinet]
③

September 23, Tuesday [6:00pm]
ELLEN DISSANAYAKE
–independent scholar–
Emma Distinguished Visiting Professor of Fine Arts at Ball State University.
Title: 1997– "Is Art Innate?"
⑤

September 25, Thursday [2:30pm]
DAVID NELSON
–sculptor–
above: [unforgiven–Colman] with Green Disaster, steel, wood, water]
④

October 9, Thursday [2:30pm]
EVA KWONG
–ceramist–
above: Nude II
⑧

October 15, Wednesday [10:30am]
WAYNE KIMBALL
–printmaker–
above: [Portraiture of a man and his horse, the horse having fallen the man, lithograph]
②

November 6, Thursday [10:30am]
DANIEL LOEWENSTEIN
–sculptor–
above: [Frying Buttress II, [something about being feminine]]
⑥

November 17, Monday [6:00pm]
BARBARA DE GENEVIEVE
–photographer and video artist–
above: Untitled ["Someone's flesh is under my fingernails"]
⑨

SPRING 1998

February 12, Thursday [2:30pm]
VALERIE EICKMEIER
–sculptor–
above: Export Trees, wood, resin, steel]
⑩

March 9, Monday [7:00pm]
DAVID KLAMEN
–painter–
above: Untitled, [oil on linen]
⑦

April 7, Tuesday [2:30pm]
AL WASCO
–interactive media artist–

All lectures are free and open to the public. All lectures are in the Herron auditorium, located in the Museum Building, 1701 North Pennsylvania Street. The auditorium is wheelchair accessible. **For more information, contact the *Visiting Artist Program* at 317.920.2460.**

With the support of the Pricefrom(?) Henry, ... (?) Foundation, Indiana Arts Commission, and National Endowment for the Arts.

PAGES 176–9
DESIGNERS
Elisabeth Charman, Brad Trost
DESIGN COMPANY
loft 219
PHOTOGRAPHER
Brad Trost (pages 178–9)

COUNTRY OF ORIGIN
USA
WORK DESCRIPTION
Posters announcing the Herron School of Art visiting artist series 1997–8 and 1996–7 (pages 178–9)

DIMENSIONS
1997–8:
610 x 914 mm
24 x 36 in
1996–7:
495 x 635 mm
19½ x 25 in

177

Herron School of Art|IUPUI
1701 North Pennsylvania Street
Indianapolis, IN 46202-1414

HERRON SCHOOL OF ART

VISITING ARTIST SERIES + EXHIBITION SCHEDULE

Herron school of ART

IUPUI

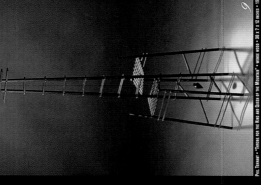

DEBORAH BUTTERFIELD • "LARA" • BRONZE WITH PATINA • 76 x 84 x 31 INCHES • 1990

PEG FIERKE • "CANYON DE CHELLY" • OIL ON CANVAS • 70 x 102 INCHES • 1995

GLADYS NILSSON • "LITTLE KLEEMATE" • MIXED MEDIA ON PAPER • 2@ 8.5 x 5.5 INCHES • 1993

JIM NUTT • "SIT AND WAIT" • c/SIP • 10 x 13 INCHES • 1978

CHRISTOPHER BROWN • "MIRROR" • OIL ON LINEN • 88 x 95 INCHES • 1995

TOM LOESER • 6 LAMPS • 1987

PHYLLIS McGIBBON • "INCUBATING SHADOWS (REMEMBERING CAIRO)" • MIXED MEDIA INSTALLATION • 20 x 20 x 12 FEET • 1992

JEANNE DUNNING • "HAND HOLE" • CIBACHROME • 29.5 x 27.5 INCHES • 1994

PHIL TENNANT • "THROW FOR THE KING AND QUEEN OF THE MOUNTAIN" • WEINE WOOD • 30 x 7 x 12 INCHES • 19

Herron Visiting Artists Program. Lecture Series.

1996–1997

August 26, Monday
TAL STREETER
—"GIANT SCULPTURES AND KITES"—
—CO-SPONSORED BY THE
INDIANAPOLIS MUSEUM OF ART—
11:00 a.m.

October 7, Monday
KATHRYN HIXSON
—EDITOR, NEW ART EXAMINER—
"ISSUES IN CONTEMPORARY ART
SEEN THROUGH CHICAGO WORK"—
7:00 p.m.

October 29, Tuesday
PEG FIERKE
—PAINTER AND PRINTMAKER—
1:00 p.m.

November 4, Monday
GLADYS NILSSON
—MIXED MEDIA IN CONJUNCTION
WITH "GLADYS NILSSON AND JIM NUTT:
WORKS ON PAPER"—
7:00 p.m.

November 6, Wednesday
CHRISTOPHER BROWN
—PAINTER—
7:00 p.m.

January 14, Tuesday
RONDA KASL
—CURATOR AT THE INDIANAPOLIS MUSEUM OF ART—
"GOYA AND HIS CONTEMPORARIES"—
1:00 p.m.

January 16, Thursday
TOM LOESER
—STUDIO ART FURNITURE—
1:00 p.m.

January 22, Wednesday
PHYLLIS McGIBBON
—WELLS COLLEGE—
MEDIA INCLUDING PRINTS, DRAWINGS, BOOKS,
AND SITE-SPECIFIC INSTALLATIONS—
11:00 a.m.

February 27, Thursday
PEG BRAND
—"FEMINISM AND AESTHETICS"—KEYNOTE SPEECH FOR
A SYMPOSIUM ON "UNFRAMING THE VISUAL ARTS:
FEMINIST INFLUENCE IN AMERICAN CULTURE TODAY."—
—CO-SPONSORED BY WOMEN'S STUDIES
AND AMERICAN STUDIES AT IUPUI—
1:00 p.m.

March 5, Wednesday
JEANNE DUNNING
—CREATES PHOTOGRAPHS AND VIDEOTAPES—
7:00 p.m.

April 9, Wednesday
PHIL TENNANT
—WOODWORKER—
1:00 p.m.

1996• August	September	October	November	December	1997• January	February	March	April	May

Herron Gallery Exhibition Schedule.

DEBORAH BUTTERFIELD/JOHN BUCK
EXHIBITION DATES August 23–September 26
RECEPTION August 23, 5–9p.m.

TEACHER'S PETS
SELECTIONS FROM HERRON
FACULTY COLLECTIONS
EXHIBITION DATES
October 11–October 26
RECEPTION October 11, 5–8p.m.

GLADYS NILSSON AND JIM NUTT
WORKS ON PAPER
EXHIBITION DATES November 1–December 12
RECEPTION November 1, 5–8p.m.

CLAYFEST
EXHIBITION DATES January 17–February 8
RECEPTION TBA

PAINTERS CHOOSE PAINTERS
EXHIBITION DATES February 14–March 20
RECEPTION February 14, 5–8p.m.
Herron Painting Faculty Invitational-selections TBA

STUDENT SHOW
—HERRON SCHOOL OF ART—
EXHIBITION DATES March 28–April 17
RECEPTION March 28, 7–9p.m.

SENIOR SHOW
—HERRON SCHOOL OF ART—
EXHIBITION DATES April 24–May 13
RECEPTION April 24
—following the Honors & Awards program.

Gallery Hours: Monday, Tuesday, Wednesday: 10am–5pm • Thursday: 10am–2pm • Friday, Saturday: 10am–2pm • Sunday: Closed

OPPOSITE
DESIGNER
Bob Aufuldish
DESIGN COMPANY
Aufuldish & Warinner
COUNTRY OF ORIGIN
USA
WORK DESCRIPTION
Announcement for 'Re(f)use' –
an exhibition of objects made
from recycled and/or reused
materials at the California
College of Arts and Crafts Oliver
Art Center
DIMENSIONS
152 x 229 mm
6 x 9 in

DESIGNER
Bob Aufuldish
DESIGN COMPANY
Aufuldish & Warinner
COUNTRY OF ORIGIN
USA
WORK DESCRIPTION
Front cover (left) and spreads
(below right, center, and left)
from a catalog for 'Ceramic Still
Life' – an exhibition at the
California College of Arts and
Crafts Oliver Art Center
DIMENSIONS
76 x 114 mm
3 x 4½ in

we now add environmental responsibility to the established design criteria of function, aesthetics and economics.

Tuesday, September 9, 5:30–7:30 pm.

opening reception

September 9–October 31, 1997

Tecoah and Thomas Bruce Galleries

cal vase and pieces of fruit. An oversize platter supports Clayton Bailey's jugs and jars. The forms recall early New England earthenware but the strange noises produced by *Laboratory Still Life* (1990-95) reflect Bailey's consistent additions of unexpected sensory elements to his work. Two colorful, super realistic birds perched on tree stumps in Annette Corcoran's *Redstart Pair* (1997) look as though they should chirp.

The presentation choice for Juta Savage and James Shrosbree is a three-foot high table with thin legs of wood or metal. Both seem less than sturdy which sets up a tension between objects and their support. More stable in appearance is the table in Helaine Melville's life-size *A Slice of Life–Mom's Kitchen*. Surrounded by kitchen implements, the all-white work is a ghost-like environment, perhaps a memory of a special place in her past.

Like an advertisement for a restaurant's menu, a few fruits with wine and a goblet

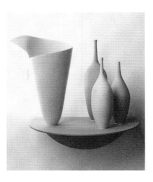

ELSA RADY *Still Life #56-1*
1995 PORCELAIN,
PAINTED ALUMINUM SHELF

e composition of contemporary y allows the artist to incorporate deas and concerns. Some artists his mode use what appears to be ble ware, while others use repli- , bottles, fruit, cloth and writing combined in different settings elationships.

cally, in painting, the still life consisted of a number of these ually arranged on a desk or table, n trompe l'oeil accuracy. One sev- ntury Dutch painting showed the a meal. Left in disarray, the set-

PAGES 182–7
DESIGNER
Stefan Sagmeister
DESIGN COMPANY
Sagmeister Inc.
ILLUSTRATORS
Dalton Portella (Paint Box),
Stefan Sagmeister,
Peggy Chuang,
Kazumi Matsumoto,
Raphael Rüdisser
PHOTOGRAPHER
Bela Borsodi
COUNTRY OF ORIGIN
USA

WORK DESCRIPTION
Fold-out invitation/poster for
the 1997 biennial conference of
the American Institute of
Graphic Arts, New Orleans
DIMENSIONS
965 x 660 mm
38 x 26 in

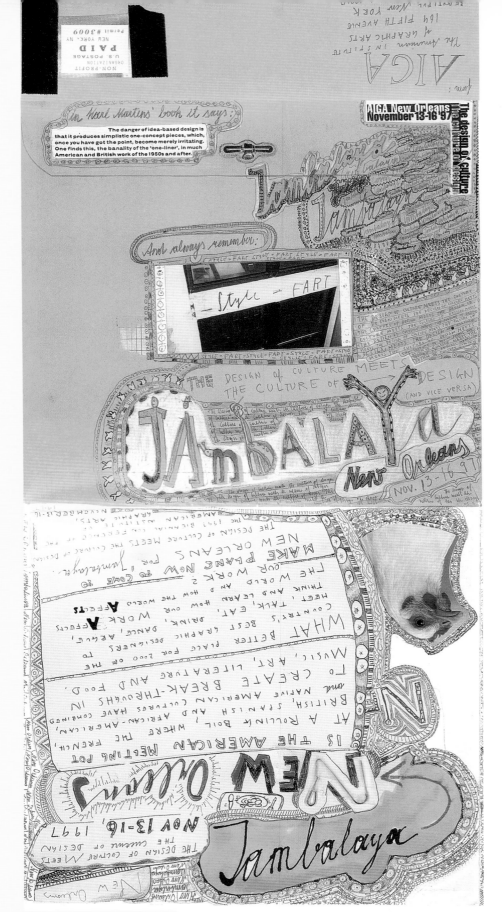

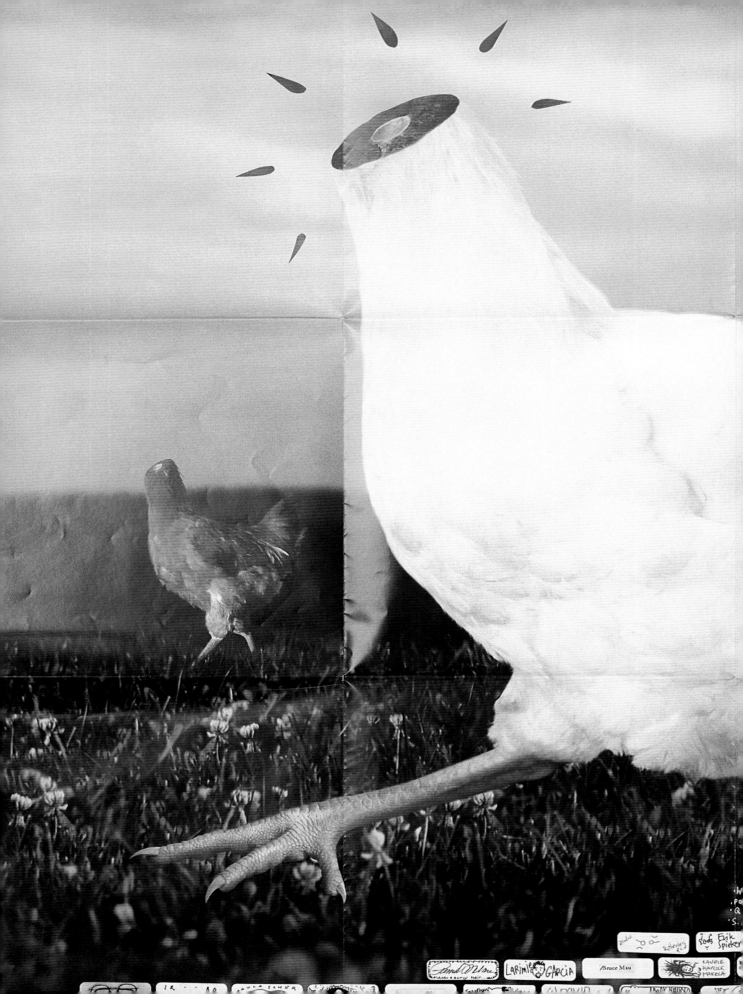

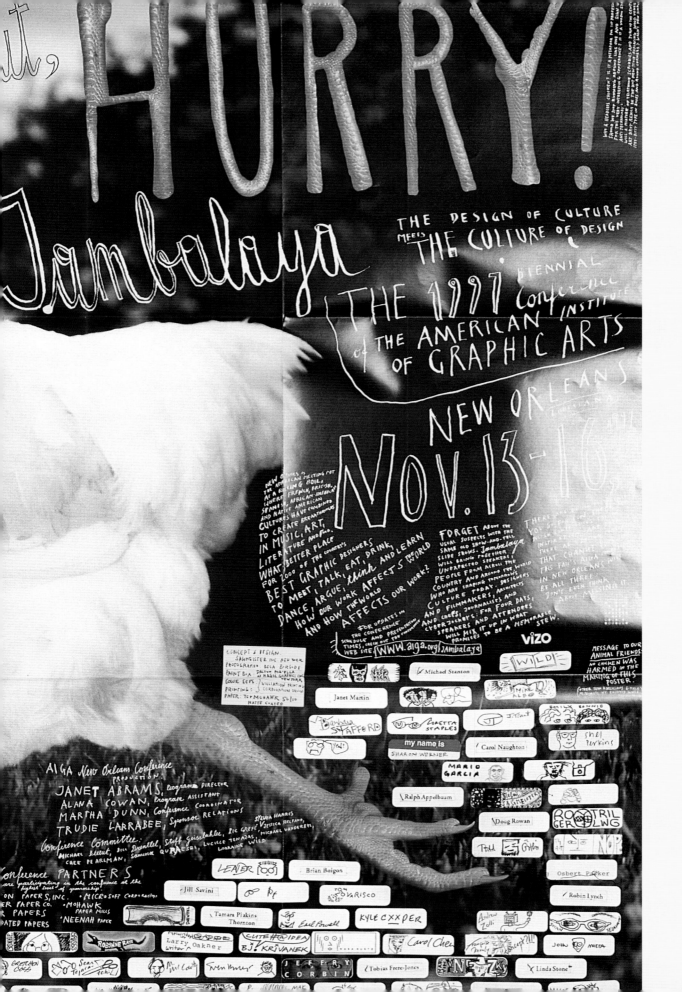

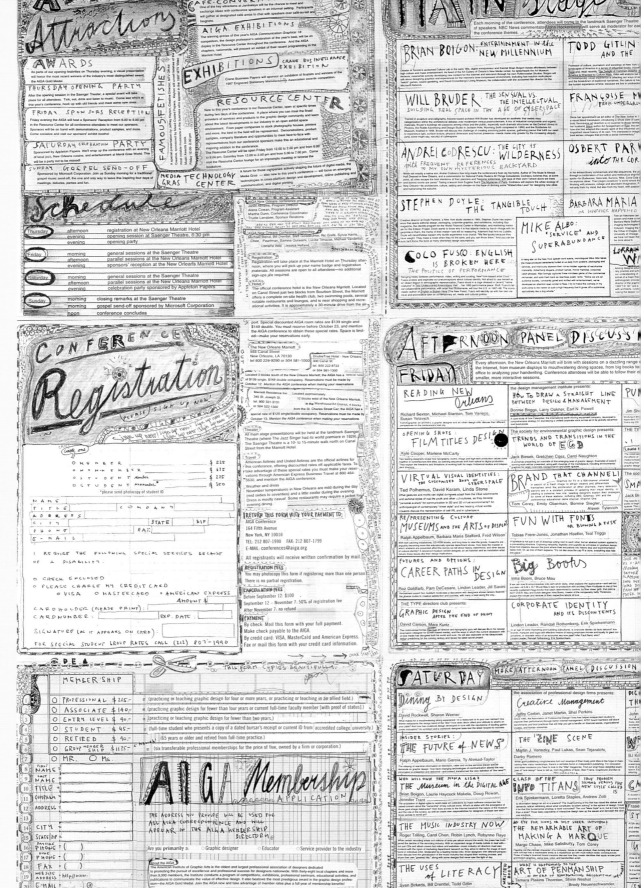

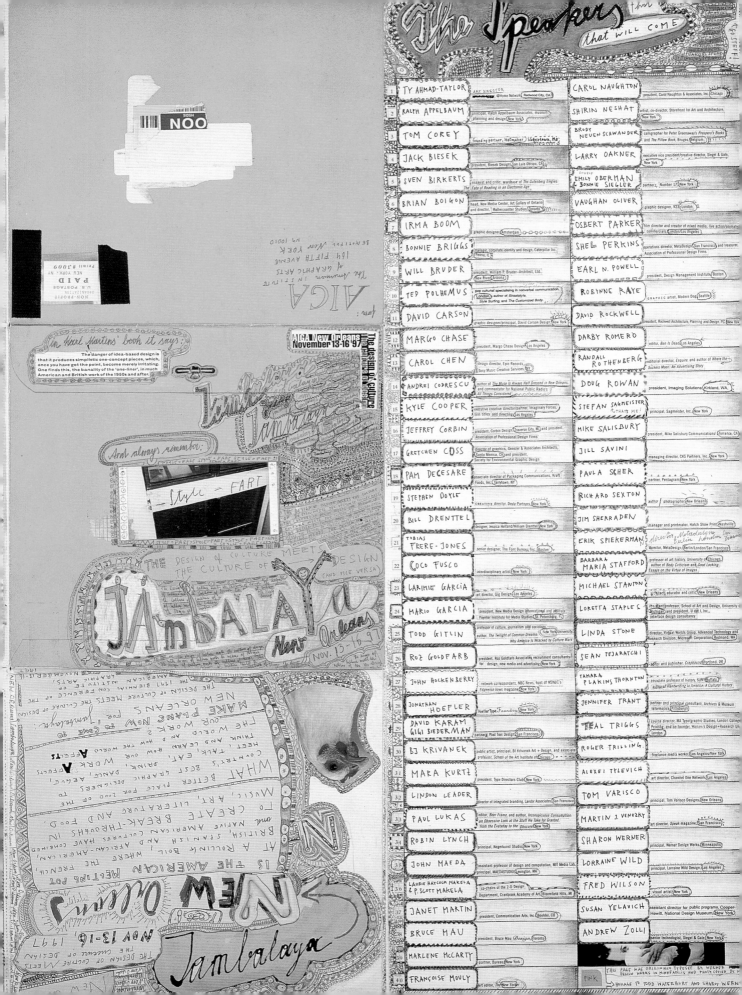

AIGA New Orleans
November 13-16 97
The design of culture

THE DESIGN OF CULTURE MEETS THE CULTURE OF DESIGN (AND VICE VERSA)

JAMBALAYA New Orleans NOV. 13-16 97

In Karel Martens' book it says: The danger of idea-based design is that it produces simplistic one-concept pieces, which, once you have got the point, become merely irritating. One finds this, the banality of the 'one-liner', in much American and British work of the 1950s and after.

And always remember: — Style = FART

#	Speaker	Description	Speaker	Description
1	TY AHMAD-TAYLOR	ART DIRECTOR, @Home Network, Redwood City, CA	CAROL NAUGHTON	president, Carol Naughton & Associates, Inc, Chicago
2	RALPH APPELBAUM	principal, Ralph Appelbaum Associates, museum planning and design, New York	SHIRIN NESHAT	artist, co-director, Storefront for Art and Architecture, New York
3	TOM COREY	founding partner, Hatmaker, Watertown, MA	BRODY NEUENSCHWANDER	calligrapher for Peter Greenaway's Prospero's Books and The Pillow Book, Bruges, Belgium
4	JACK BIESEK	president, Biesek Design, San Luis Obispo, CA	LARRY OAKNER	executive vice president/creative director, Siegel & Gale, New York
5	SVEN BIRKERTS	essayist and critic, author of The Gutenberg Elegies: The Fate of Reading in an Electronic Age	EMILY OBERMAN & BONNIE SIEGLER	partners, Number 17, New York
6	BRIAN BOIGON	head, New Media Center, Art Gallery of Ontario and director, Rollercoaster Studios, Toronto	VAUGHAN OLIVER	graphic designer, V23, London
7	IRMA BOOM	graphic designer, Amsterdam	OSBERT PARKER	film director and creator of mixed media, live action/animated commercials, London/Los Angeles
8	BONNIE BRIGGS	manager, corporate identity and design, Caterpillar Inc., Peoria, IL	SHEL PERKINS	operations director, MetaDesign, San Francisco and treasurer, Association of Professional Design Firms
9	WILL BRUDER	president, William P. Bruder–Architect, Ltd., New River, Arizona	EARL N. POWELL	president, Design Management Institute, Boston
10	TED POLHEMUS	pop cultural specialising in nonverbal communication, London, author of Streetstyle, Style Surfing, and The Customized Body	ROBYNNE RAYE	GRAPHIC artist, Modern Dog, Seattle
11	DAVID CARSON	graphic designer/principal, David Carson Design, New York	DAVID ROCKWELL	president, Rockwell Architecture, Planning and Design, P.C. New York
12	MARGO CHASE	president, Margo Chase Design, Los Angeles	DARBY ROMERO	editor, Ben Is Dead, Los Angeles
13	CAROL CHEN	design director, Epic Records, Sony Music Creative Services, NY	RANDALL ROTHENBERG	editorial director, Esquire, and author of Where the Suckers Moon: An Advertising Story
14	ANDREI CODRESCU	author of The Muse Is Always Half Dressed in New Orleans, and commentator for National Public Radio's All Things Considered	DOUG ROWAN	president, Imaging Solutions, Kirkland, WA
15	KYLE COOPER	executive creative director/partner, Imaginary Forces, film titles and directing, Los Angeles	STEFAN SAGMEISTER (THAT'S ME!)	principal, Sagmeister, Inc, New York
16	JEFFREY CORBIN	president, Corbin Design, Traverse City, MI, and president, Association of Professional Design Firms	MIKE SALISBURY	president, Mike Salisbury Communications, Torrance, CA
17	GRETCHEN COSS	director of graphics, Gensler & Associates Architects, Santa Monica, CA, and president, Society for Environmental Graphic Design	JILL SAVINI	managing director, CKS Partners, Inc, New York
18	PAM DECESARE	associate director of Packaging Communications, Kraft Foods, Inc, Tarrytown, NY	PAULA SCHER	partner, Pentagram, New York
19	STEPHEN DOYLE	CREATIVE director, Doyle Partners, New York	RICHARD SEXTON	author/photographer, New Orleans
20	BILL DRENTTEL	Designer, Jessica Helfand/William Drenttel, New York	JIM SHERRADEN	manager and printmaker, Hatch Show Print, Nashville
21	TOBIAS FRERE-JONES	senior designer, The Font Bureau, Inc., Boston	ERIK SPIEKERMAN	director, MetaDesign, Berlin/London/San Francisco
22	COCO FUSCO	interdisciplinary artist, New York	BARBARA MARIA STAFFORD	professor of art history, University of Chicago, author of Body Criticism and Good Looking: Essays on the Virtue of Images
23	LARIMIE GARCIA	art director, Gig Design, Los Angeles	MICHAEL STANTON	architect, educator and critic, New Orleans
24	MARIO GARCIA	president, New Media Design International and affiliate, Poynter Institute for Media Studies, St. Petersburg, FL	LORETTA STAPLES	assistant professor, School of Art and Design, University of Michigan, and president, U dot I, Inc., interface design consultancy
25	TODD GITLIN	professor of culture, journalism and sociology, author, The Twilight of Common Dreams: Why America Is Wracked by Culture Wars, New York University	LINDA STONE	director, Virtual Worlds Group, Advanced Technology and Research Division, Microsoft Corporation, Redmond, WA
26	ROZ GOLDFARB	president, Roz Goldfarb Associates, recruitment consultants for design, new media and advertising, New York	SEAN TEJARATCHI	editor and publisher, Craphound, Portland, OR
27	JOHN HOCKENBERRY	network correspondent, NBC News, host of MSNBC's Edgewise news magazine, New York	TAMARA PLAKINS THORNTON	associate professor of history, SUNY Buffalo, author, Handwriting in America: A Cultural History
28	JONATHAN HOEFLER	Hoefler Type Foundry, New York	JENNIFER TRANT	partner and principal consultant, Archives & Museum Informatics, Pittsburgh
29	DAVID KARAM, GIGI BIEDERMAN	partners, Post Tool Design, San Francisco	TEAL TRIGGS	course director, MA Typographical Studies, London College Printing, and co-founder, Women's Design+Research Unit, London
30	BJ KRIVANEK	public artist, principal, BJ Krivanek Art + Design, and associate professor, School of the Art Institute of Chicago	ROGER TRILLING	freelance media worker, Los Angeles/New York
31	MARA KURTZ	president, Type Directors Club, New York	ALEXEI TYLEVICH	art director, Channel One Network, Los Angeles
32	LINDON LEADER	director of integrated branding, Landor Associates, San Francisco	TOM VARISCO	principal, Tom Varisco Designs, New Orleans
33	PAUL LUKAS	editor, Beer Frame, and author, Inconspicuous Consumption: an Obsessive Look at the Stuff We Take for Granted, from the Everyday to the Obscure, New York	MARTIN J. VENEZKY	art director, Speak magazine, San Francisco
34	ROBIN LYNCH	principal, Negerkunst Studio, New York	SHARON WERNER	principal, Werner Design Werks, Minneapolis
35	JOHN MAEDA	assistant professor of design and computation, MIT Media Lab, principal, MAEDASTUDIO, Lexington, MA	LORRAINE WILD	principal, Lorraine Wild Design, Los Angeles
36	LAURIE HAYCOCK MAKELA & P. SCOTT MAKELA	co-chairs of the 2-D Design Department, Cranbrook Academy of Art, Bloomfield Hills, MI	FRED WILSON	visual artist, New York
37	JANET MARTIN	president, Communication Arts, Inc, Boulder, CO	SUSAN YELAVICH	assistant director for public programs, Cooper-Hewitt, National Design Museum, New York
38	BRUCE MAU	president, Bruce Mau Design, Toronto	ANDREW ZOLLI	senior technologist, Siegel & Gale
39	MARLENE McCARTY	partner, Bureau, New York		
40	FRANÇOISE MOULY	art editor, The New Yorker		

THE DESIGN OF CULTURE MEETS THE CULTURE OF DESIGN IN NEW ORLEANS! MAKE PLANS NOW FOR "Jambalaya," OUR WORK + THINK AND LEARN, EAT, TALK, EAT, DRINK, DANCE, FEEL HOW OUR WORLD AFFECTS A WORK AFFECTS!

WHAT BETTER PLACE FOR 2000 OF THE COUNTRY'S BEST GRAPHIC DESIGNERS TO MEET, ART, LITERATURE AND FOOD. TO CREATE BREAK-THROUGHS IN NATIVE AMERICAN CULTURES HAVE COMBINED BRITISH, SPANISH AND AFRICAN-AMERICAN, AT A ROLLING BOIL, WHERE THE FRENCH, IS THE AMERICAN MEETING POT.

NEW ORLEANS Jambalaya Nov 13-16, 1997 THE DESIGN OF CULTURE MEETS

THIS PAGE WAS ORIGINALLY TYPESET BY WERNER DESIGN WERKS IN MINNEAPOLIS AND PHOTO COPIED BY... HOMAGE TO TODD WATERBURY AND SHARON WERNER. PINK

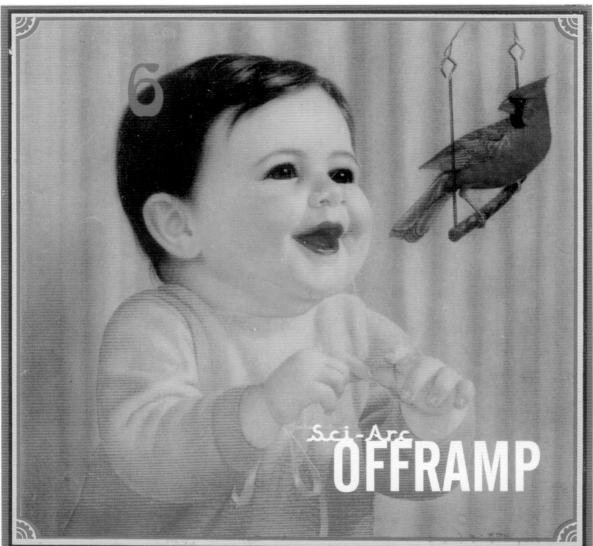

Sci-Arc
OFFRAMP

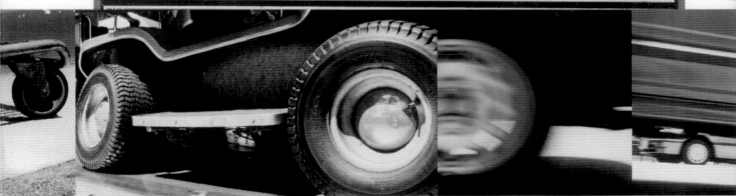

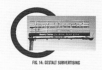

FIG. 14: GESTALT SUBVERTISING

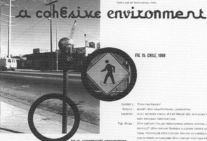

no longer a cohesive environment

FIG. 15: CHILE, 1968

FIG.12: SUBORDINATE ARCHITECTURE

DESIGNERS
Cover:
Beth Elliott,
Denise Gonzales Crisp,
Sibylle Hagmann
Spreads:
Weston Bingham, Bele Ducke,
Beth Elliott, Dave Ewald,
Denise Gonzales Crisp,
Jens Gehlhaar,
Sibylle Hagmann, Kevin Lyons
Unpublished fonts:
Weston Bingham, Joel Decker,
Jens Gehlhaar, Sibylle Hagmann
(California Institute of the Arts
Graduate Graphic Design
Students)
COUNTRY OF ORIGIN
USA
WORK DESCRIPTION
Front cover (opposite) and
spreads from *Offramp 6* – a
magazine edited by Southern
California Institute of
Architecture (SCI-Arc)
DIMENSIONS
235 x 298 mm
9¼ x 11¾ in

189

 FIELD REPORT

Subsequent Heading #: UC. Doc. 059501 - revs. 119502
Subsequent Heading title: Transparent Narrative of Infrastructure
—notes on inciting a Neo-Mannerist revolt
Field Officer: Ferguson, J. Michael № UC01
Exhibits Listing Field Anomalies: A – R
Exhibit Description: Urban Fiction (78.2% analytical subjectivity)
Summary: Exhibits describe current six month status report of area and community surrounding experimental metro station design at Vermont and Santa Monica Boulevards. Number of pictorial supplements included—(04)

FIG. 01: MINI-MALL—A COLLAGE OF URBAN FUNCTIONS INTO A NON-HIERARCHICAL FRAME (SEE EXHIBIT A)

Urban CAMOUFLAGE

Art & Camouflage are twins...
The one makes something unreal recognizable...the other makes something real unrecognizable.
—H.B. Cott [1]

by Michael Ferguson

Camouflage, the military act of concealment, dates back to 4th century B.C. during a battle between the Thebans and Spartans. The Thebans, largely outnumbered, sent out a small calvary which stirred up a dense dry dust cloud, obscuring them upon attack and aiding them to victory. Modern applications of camouflage date to WW1 and are rumored to have roots aligned with cubist art. While strolling along Boulevard Raspail, Gertrude Stein and Pablo Picasso watched as a convoy of camouflaged cannons passed by. "C'est nous qui avons fait ça!", exclaimed Picasso "It is we who have made this!" [1] *see fig. 06*

Exhibit A: Minimal(L)
Subject: (event) Retail Infrastructure of the type IV category
Location: Corner of Vermont and Santa Monica Blvds.
Typ. Usage: Omni-present non-hierarchical frame, housing a collage of programmatic activities. Popular location for Chinese donut shops, and some of LA's best restaurants. Often identified as major factor for the decline of the American city.
Camouflage Type: Minimalist Dazzle (compression of elements)
Suspected Nonconformance: Minimal reconfigure on 5 point parts:
1: Pilotis: structure is elevated on large yellow concrete piloti that allow parking underneath. 2: Roof Garden: more parking, hvac, two unclaimed lawn chairs. 3: Free plan: party walls freed from structure of bldg.- allows for flexibility of leaseable space. 4: Free facade: tenants are 'free' to incorporate their own storefronts and tertiary signage into the structural frame of the bldg. 5: Ribbon windows: pragmatically converted into ribbon lightbox signage.
01//Kodak 5032 TMX
view of subway/mini-mall looking south (Vermont Ave. removed for viewing convenience.)

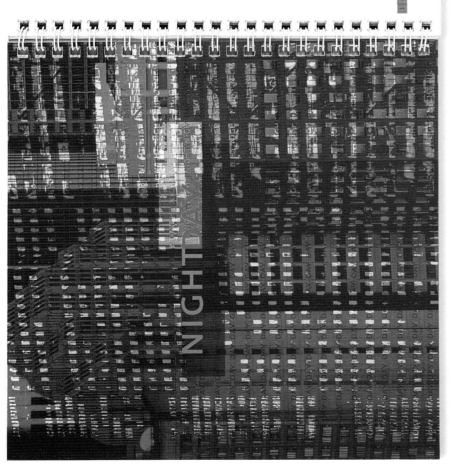

spelling. Many of at today's Western languages, j w rather their traditional spelling are ly from practical point of language. Broke old systems edit don't use silent letters, all the letters are pronounced. A more true phonetic writing is used by the Eastern-European languages. The Slavic languages use more characters in order to avoid ambiguities in spelling. The Slovak language, for example, uses up to 44 signs, nearly twice as many as English. Although written Slovak is closely linked to its pronunciation, Slovak too has a significant number of exceptions in writing. A "pure" phonetic language would probably use even more characters. ¶

1.5 graphical picture, by the French artist Pierre di Scholl a letter system conference in Berlin. A de-

NIGHT DAY

Thanks to low-priced com- tvare a situácie, v ktorej sa ence," says namom je previazaná. Typografia môže puters and user-friendly nachádzame. Z rozhovoru Phil Baines, a pripraviť čitateľa na to, čo má od textu software, almost anyone v novinách môže, naprí- London-based očakávať, alebo naopak. prekvapiť ne- can create a typeface. This klad, čitateľ získať iba 20% typographer. očakávaným. Neočakávané riešenia majú has resulted in a very informácií zachytených David Byrne, oveľa efektívnejší dosah, znepokojujú, wobbly quality of type de- v texte. Pisateľ sa môže-the multita- alebo nadchnú publikum. Avšak pre au- sign. Some of new typefa- snažiť obohatiť rozhovor lented artist, tora je omnoho riskantnejšie pohybovať ces are considered illegible.¶ fotografiami a popisom mi- writes in a asa za hranicou očakávania. Pôsobenie za Illegibility is a topic in esta rozhovoru. Ani to ne- book on David jej limitmi je to, čo nazývame kreativi- graphic design which has musí stačiť. Ako môžeme Carson: "Da- ta a najsilnejšie myšlienky ovplyvňujú been discussed many ti- preniesť rozhovor, ktorý je vid's work co- spoločnosť.¶ mes. The word "illegible" plný emócií a je viaczmy- mmunicates. Navrhovanie experimentálnych fontov has changed its meaning to selný na stranu textu? But on a level nie je pokusom o komplikovanie procesu "not communicative eno- Odpovedou na túto otázku beyond wo- čítania. Naopak, je to pokus o zbliženie ugh". In judging legibility, môže byť efektívnejšie po- rds. On a le- čitateľa a pisateľa. Používanie veľkej people talk about what užívanie typografie. Vhod- vel that by- zbierky fontov môže pomôcť pri nájdení they don't see rather than nym kombinovaním textu, passes the lo- toho "pravého" pre špecifickú príležitosť. talking about what they do obrazov a grafických prv- gical, ratio- Reč je farebnejšia ako čierno biely text. see. Illegible type may so- kov dosiahneme plniť vi- nal centers of je prirodzene emotívna a expresívna. metimes convey more me- zuálny zážitok. Čitateľ ma the brain and Dialog obsahuje okrem slov obrovské aming than a text set in the možnosť pozerať sa na rov- goes straight množstvo iných informácií. Gestá, mimi- most readable typeface. naků informáciu z rôznych to the part ka a tón hlasu, sú pre poslucháčov rozho- Thanks to designers like pohľadov a vybrať si ten, that under- dujúce. Už malá zmena v hlase ho- David Carson legibility has ktorý mu najviac vyhovu- stands with- voriaceho môže znamenať veľký posun acquired a new meaning. je. Text je síce lineárny, no out think- vo význame predneseného. Tónom hlasu offering us new visual ex- sam čítateľ rozhodne, kto- ing. "¶ Conte- v texte sa môže stuť písmo. Správne vy- perience. "Legibility pre- rým smerom. Vizuálna zlož- mporary gra- braté písmo prenáša farbu pocitov: čas- sents information as facts ka nema za úlohu zdvojná- phic design ku, sarkazmus, nadradenosť, uvoľnenie, rather than as experi- sobiť jeho význam, s vyz- is about cre- sterilnosť atď., vlastnosti, ktoré inak

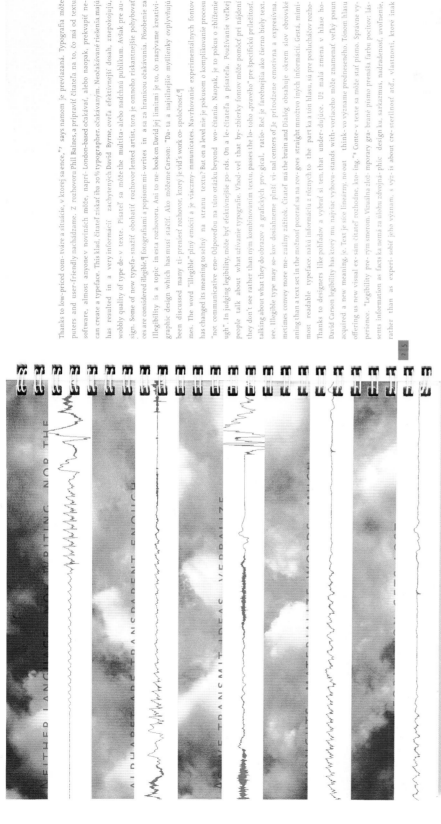

2 5

PAGES 190-3
DESIGNER
Peter Bil'ak
ART DIRECTOR
Peter Bil'ak
ILLUSTRATOR
Peter Bil'ak
PHOTOGRAPHERS
Peter Bil'ak, PhotoDisc
COUNTRY OF ORIGIN
Slovakia

WORK DESCRIPTION
Spreads and acetate sell from
Transparency – a book on
language and typography
DIMENSIONS
210 x 210 mm
8¼ x 8¼ in

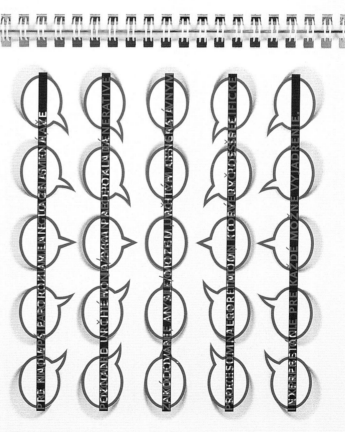

nature of the Latin alphabet, there have been many attempts to illustrate the language. Guillaume Apollinaire's calligrams are a good example of using the expressive values of writing to enhance a text. The main difference in the work of the futurists or the dadaists is differentiation of role. It is not the author of the text who affects the way of reading it, it is a designer—a person from a different background. If the author of the text and author of its visual representation is not the same person, the task of analyzing the intent and visualizing becomes extraordinarily complex.¶

Ideally, form matches content. More often, however, one dominates the other. It is not clear which one is more important in the process of reading. Human beings tend to judge experience as a sensory whole; we do not separate experiences into discrete parts. Therefore, we cannot separate images from text; they only exist bound together. Images, then, ha-

CITY
SCAP
ES
THE
CITY AS VISUAL
NARRATIVE

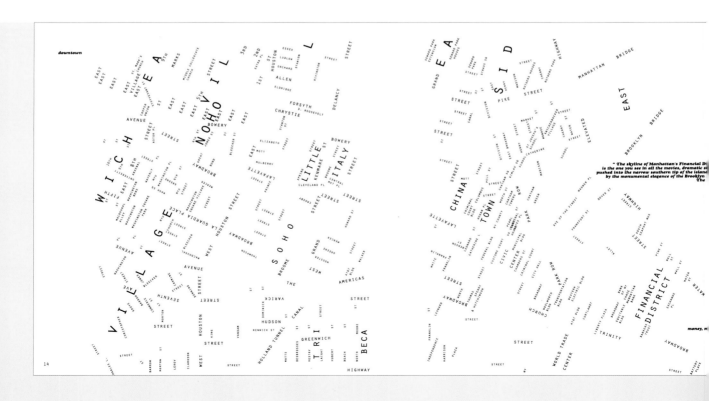

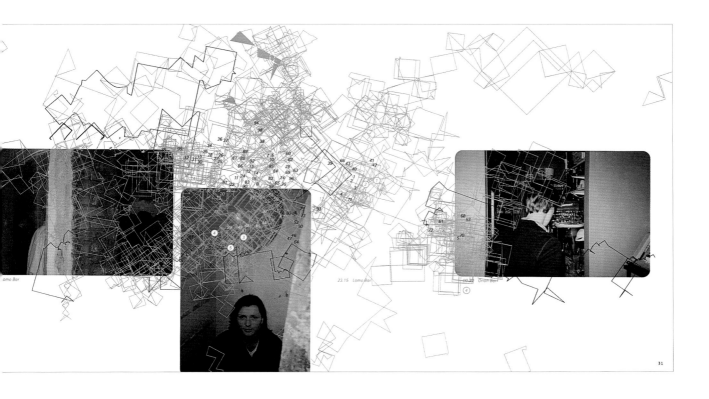

31

PAGES 194–7
DESIGNER
**Antonia Henschel
(Central Saint Martin's College
of Art and Design)**
ART DIRECTOR
Antonia Henschel
PHOTOGRAPHER
Antonia Henschel
COUNTRY OF ORIGIN
UK

WORK DESCRIPTION
Cover (opposite, top) and
spreads from *Cityscapes* –
an experimental magazine
investigating the city and
its visual significance
DIMENSIONS
280 x 280 mm
11 x 11 in

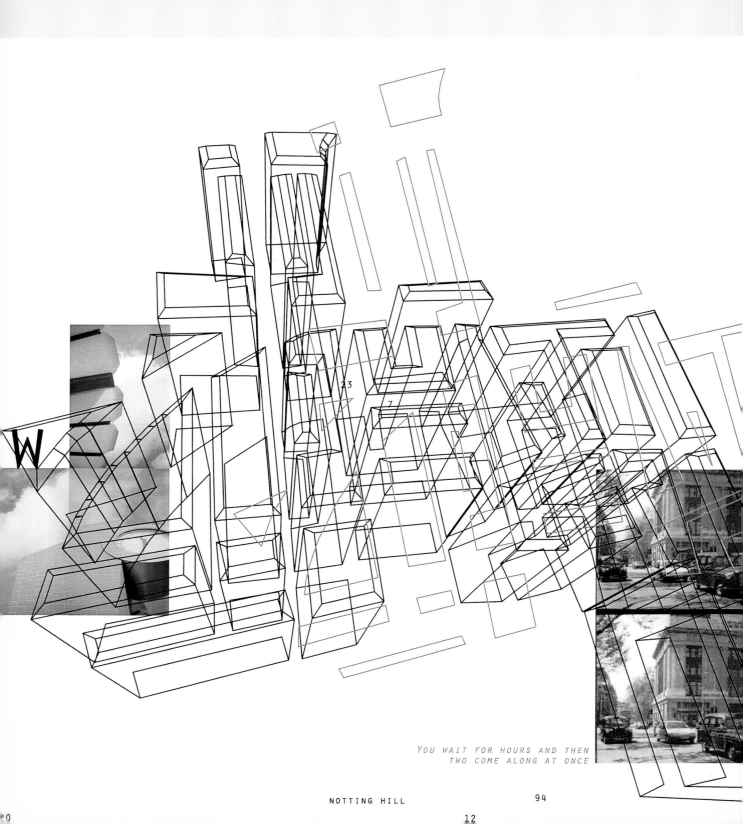

YOU WAIT FOR HOURS AND THEN
TWO COME ALONG AT ONCE

NOTTING HILL

94

12

PAGES 198–9
DESIGNERS
Mark Breslin, Philip O' Dwyer
ART DIRECTORS
Mark Breslin, Mark Hough,
Philip O' Dwyer,
DESIGN COMPANY
State
COUNTRY OF ORIGIN
UK

WORK DESCRIPTION
Poster announcing the
onedotzero digital film
festival at the ICA in London
DIMENSIONS
594 x 820 mm
23⅜ x 32¼ in

23 7

MAIN HISTORICAL EVENTS

1066 BATTLE OF HASTINGS
1086 DOMESDAY BOOK

1215 MAGNA CARTA
1216 FIRST PARLIAMENT

1348-49 BLACK DEATH
1381 PEASANT'S REVOLT

1415 BATTLE OF AGINCOURT
1492 COLUMBUS-AMERICA

1509-47 HENRY VIII

1558-1603 ELIZABETH I
1588 SPANISH ARMADA
1603-25 JAMES I

1645-49 CIVIL WAR
1649-60 COMMONWEALTH
1665 GREAT PLAGUE
1666 FIRE OF LONDON

DATE BUILDINGS

1078 TOWER OF LONDON
1106 SOUTHWARK CATHEDRAL
1120 ST MARGARET WESTMINSTER
1123 ST BARTHOLOMEW THE GREAT
1160 TEMPLE CHURCH
1205 ST HELEN'S BISHOPSGATE
1245 WESTMINSTER ABBEY BEGUN
1297 LAMBETH PALACE
1300 ST ETHELDRA
1300 ELTHAM PALACE
1350 TEMPLE CHURCH
1390 WESTMINSTER ABBEY NAVE
1394 WESTMINSTER HALL
1400 LINCOLN'S INN
1411 BISHOP'S PALACE, FULHAM
1411 GUILDHALL
1492 LINCOLN'S INN
1503 HENRY VII'S CHAPEL
1514 HAMPTON COURT PALACE
1520 ST ANDREW UNDERSHAFT
1530 ST JAMES'S PALACE
1586 STAPLE INN
1590 HOLLAND HOUSE
1607 CHARLTON HOUSE
1616 QUEEN'S HOUSE, GREENWICH
1619 BANQUETING HOUSE, WHITEHALL
1619 LINCOLN'S INN CHAPEL
1623 QUEEN'S CHAPEL
1631 ST PAUL'S COVENT GARDEN
1640 LINCOLN'S INN FIELDS
1640 LINDSEY HOUSE
1661 KENSINGTON PALACE
1665 GREENWICH PALACE
1670 ST MICHAEL CORNHILL
1670 ST LAWRENCE JEWRY
1670 ST MARY-AT-HILL
1670 ST BRIDE, FLEET STREET
1671 ST MARY-LE-BOW
1671 ST MAGNUS
1672 MONUMENT
1674 ST STEPHEN WALBROOK
1675 ST JAMES GARLICKHITHE
1676 ST PAUL'S CATHEDRAL
1677 ST JAMES'S PICCADILLY
1677 ST ANNE ST AGNES
1677 CHRIST CHURCH,NEWGATE STREET
1681 ST MARTIN, LUDGATE HILL
1681 ST MARY ABCHURCH
1682 ROYAL HOSPITAL, CHELSEA
1683 ST MARY ALDERMARY
1685 ST CLEMENT EASTCHEAP
1689 ST ANDREW-BY-THE-WARDROBE

ARCHITECTURAL CHRONOLOGY

THE URBANIZATION OF NOTTING HILL, THE AREA TO THE NORTH OF HOLLAND PARK AVENUE, BEGAN IN THE FIRST HALF OF THE NINETEENTH CENTURY, WHEN THE LEAFY AVENUES AND MAJESTIC CRESCENTS OF THE NORLAND AND LADBROKE ESTATES WERE LAID OUT. IN THOSE DAYS, THE AREA WAS STILL KNOWN AS THE POTTERIES (AFTER THE GRAVEL PITS AND POTTERY WORKS ON WALMER ROAD) OR THE PIGGERIES(AFTER THE DISTRICT'S THREE-TO-ONE RATIO OF PIGS TO PEOPLE). EVEN FORTY YEARS AGO NOTTING HILL WAS DESCRIBED AS "A MASSIVE SLUM, FULL OF MULTI-OCCUPIED HOUSES, CRAWLING WITH RATS AND RUBBISH", AND POPULATED BY OFFSHOOTS OF THE SOHO VICE AND CRIME RACKETS. THESE INSALUBRIOUS DWELLINGS BECAME HOME TO A LARGE CONTINGENT OF AFRO-CARIBBEAN IMMIGRANTS, WHO HAD TOCOMPETE FOR JOBS AND LIVING SPACE WITH THE AREA'S SIMILARLY DOWNTRODDEN WHITE RESIDENTS.
FOR FOUR DAYS IN AUGUST 1958, PEMBRIDGE ROAD BECAME THE EPICENTRE OF THE COUNTRY'S FIRST RACE RIOTS, WHEN BUS-LOADS OF WHITES ATTACKED WEST INDIAN HOMES IN THE AREA. THE NOTTING HILL CARNIVAL BEGAN UNOFFICIALLY THE NEXT YEAR AS A RESPONSE TO THE RIOTS: IN 1965 IT TOOK TO THE STREETS AND HAS SINCE GROWN INTO THE WORLD'S BIGGEST STREET FESTIVAL OUTSIDE RIO.